UNFRAMED

UNFRAMED

Practices and politics of women's contemporary painting

edited by
Rosemary Betterton

I.B. TAURIS
LONDON · NEW YORK

Published in 2004 by I.B.Tauris & Co Ltd
6 Salem Road, London W2 4BU
175 Fifth Avenue, New York NY 10010
www.ibtauris.com

In the United States of America and in Canada distributed by
Palgrave Macmillan, a division of St Martin's Press
175 Fifth Avenue, New York NY 10010

ISBN 1 86064 771 5 hardback
ISBN 1 86064 772 3 paperback

A full CIP record for this book is available from the British Library
A full CIP record for this book is available from the Library of Congress

Library of Congress catalog card: available

Typeset in Melior by Steve Tribe, Andover
Printed and bound in Great Britain by MPG Books Ltd, Bodmin

CONTENTS

FIGURES

NOTES ON CONTRIBUTORS

Rosemary Betterton is author of *An Intimate Distance: Women, Artists and the Body* (Routledge, 1996) and edited *Looking On: Images of Femininity in the Visual Arts and Media* (Pandora Press, 1987). She has also contributed chapters to G. Pollock (ed.), *Generations and Geographies in the Visual Arts: Feminist Readings* (Routledge, 1996), K. Deepwell (ed.), *Women Artists and Modernism* (Manchester University Press, 1998), N. Foster & P. Florence (eds), *Differential Aesthetics: Art Practices, Philosophy and Feminist Understandings* (Ashgate, 2000) and A. Jones (ed.), *Feminist Visual Theory* (Routledge, 2002). She is Reader in Women's Studies at Lancaster University, UK, and is currently researching for a book on maternal embodiment in visual culture.

Barbara Bolt is a practising artist, writer on art and art critic. In addition to her exhibition work, her published articles include: 'Impulsive Practices: Painting and the Logic of Sensation' (1997), *Social Semiotics*, vol.7, no.3; 'Shedding Light for the Matter' (2000), *Hypatia*, vol.15, no.2; 'Screen_Imag(in)ings: Towards a Digital Aesthetics', *http://artweb.imago.com.au/screen_image*; 'Working Hot: Materialising Practices' (2000), in P. Florence & N. Foster (eds), *Differential Aesthetics: Art Practices, Philosophy and Feminist Understandings* (Ashgate, 2000); 'The unremarked representationalist pre-conceptions of art education in Australia' (2001), *Australian Art Education*, vol.24, no.1; and 'The Techno-sublime', published in 2002 in *Refactory* (English) *http://www.sfca.unimelb.edu.au/refractory/* and *Teknocultura* (Spanish) *http://teknokultura.rrp.upr.edu/*. She is a lecturer in Art and Design at the University of Sunshine Coast, Australia. Currently her practice is informed by her theorizing of the Techno-sublime.

Joan Borsa is a curator and writer, author of 'Frida Kahlo: Marginalisation and the Critical Female Subject', *Third Text*

(1990), and curator and editor of *Anne Harbuz: Inside Community, Outside Convention*, Saskatewan, Canada 1999. She is completing a PhD at Concordia University, Montreal, Canada.

Rebecca Fortnum is a painter, curator and writer. Her solo exhibitions include: *Contra Diction*, Winchester 1993; *Third Person,* Kapil Jariwala Gallery, London 1996; and *Solipsist*, Angel Row Gallery, Nottingham 2000; as well as contributions to numerous group shows. She has written on women's contemporary painting in the *Women Artists Slide Library Journal* and *Women's Art Magazine/Make.* She is currently Senior Lecturer at Wimbledon School of Art.

Lubaina Himid is a painter, curator and writer. She has exhibited widely in Britain and abroad and her work is included in private and public collections. Her solo exhibitions include *Revenge*, 1992, Rochdale Art Gallery; *Beach House*, Wrexham Arts Centre, 1995; *Venetian Maps*, Preston City Art Gallery, 1998; *Zanzibar*, Oriel Mostyn Gallery, Wales, 1999; *Plan B*, Tate St. Ives, 1999; *Double Life*, Bolton Museum and Art Gallery, 2001; and *Inside the Visible*, The Leprosy Museum, Bergen, Norway, 2002. She is Professor of Contemporary Art at the University of Central Lancashire.

Rosa Lee is a painter and lecturer. She trained at St Martin's School of Art (1983–6) and the Royal College of Art (1986–8). The year after her MA graduation was spent in a dizzying sojourn as Visiting Fellow in Painting at Winchester School of Art (1988–9). Since then, she has exhibited widely in solo and group shows, most recently in *Warped: painting and the feminine*, curated by Maggie Ayliffe (Angel Row Gallery, Nottingham and on tour in the UK, 2001), and in *Temps Fantomal*, curated by Montreal artist, Lorraine Simms (Galerie Optica, Montreal, 2002). She lives and works in London with her long-suffering partner, Mark Graham, and son Nathan.

Marsha Meskimmon is Reader in Art History and Theory at Loughborough University and her research focuses on women's art, feminist aesthetics and questions of epistemology. She is author of *The Art of Reflection: Women's Self-Portraiture in the*

Twentieth Century (1996), *We Weren't Modern Enough: Women Artists and the Limits of German Modernism* (1999) and *Women Making Art: History, Subjectivity, Aesthetics* (2003).

Partou is an award-winning artist who was born in Tehran, Persia (now Iran) in 1958. She has degrees from the University of Warwick, and the Slade School of Fine Art, having completed her PhD at Falmouth College of Arts in 2001. Her solo exhibitions include *Landscape and Edifice*, Saltram House, Devon, 1996; *Church Paintings*, Newlyn Art Gallery, Cornwall, 1998; *Place and Persona*, Royal Cornwall Museum, Truro, 1999; and *Portraits of Absence*, Art Space Gallery, London, 2002.

Alison Rowley is an artist and art historian and Lecturer in Art History, Theory and Fine Art at the University of Leeds. Her research centres on issues of painting and sexual difference and draws upon feminist scholarship in the fields of art history, philosophy and psychoanalysis. She has published on the work of Jenny Saville, Dorothea Tanning, Bridget Riley and Bracha Lichtenberg Ettinger.

Pam Skelton is an artist and Senior Lecturer in Fine Art at Central St Martins College of Art and Design. Her works in paintings and video installations have principally explored history as spaces of ruptures and dislocations caught within and between, time, memory and event. Her solo exhibitions include *Groundplans*, 1989; *Dangerous Places, Ponar*, 1994; *Pamela Hurwitz and her friends*, 2001; and *Ghost Town*, 2001. She is co-editor of *Private Views: Spaces and Gender in Contemporary Art from Britain and Estonia* (WAL and I.B.Tauris, 2000).

ACKNOWLEDGEMENTS

I wish to thank my editor, Philippa Brewster, for her positive support for the book from start to finish, and Susan Lawson for her patience and good humour during its delayed final stages. My thanks go to the friends and colleagues who have commented on the drafts of Chapter 4, as well as those research students whom I have supervised and examined, whose commitment to painting *and* theory sparked the idea for this book. But, above all, my thanks go to the writers, without whose enthusiasm, commitment and creative contribution the book would not have taken shape, as well as to all the artists who have generously given permission for their work to be reproduced.

The authors and the publishers wish to thank the various copyright holders for their permission to reproduce the illustrations appearing in this book: figures 18 & 19 courtesy Jay Jopling/White Cube (London); figure 28 Dorothy Charabin, North Battleford; figure 29 Mendel Art Gallery, Saskatoon; figure 30 Saskatchewan Arts Board, Regina; figure 31 Mackenzie Art Gallery, Regina. All other works are reproduced by permission of the artist.

UNFRAMING WOMEN'S PAINTING

Rosemary Betterton

Painting, as many commentators and critics have concluded – and bemoaned – over the last few years, has ceased to be central to current critical debates about contemporary art in the western world.[1] Equally, gender issues that had been foregrounded by women's movements over the previous 30 years are deemed irretrievably passé or, at best, irrelevant to the making of new art.[2] The twin peaks of postmodernism and post-feminism, however ill defined, appear to have overshadowed any serious consideration of the contemporary practices and politics of women who paint. This book is an attempt to redress that balance and to rebut two propositions – that painting and feminism are dead – by exploring the current state of making and thinking about painting by women. It aims to reclaim a space for different practices of women's painting and to assert that these are important if we are concerned with the current meanings of both art and gender.

While the writers in this book all address painting in some respect, the essays also engage with performance, sculpture, installation, photography, video and digital media – in other words, they refuse the traditional categorization of art based on methods and materials. By writing 'from within the practice' (Fortnum 2003) and attending to its specificities, they are, at the same time, able to challenge narrow, media-based defini-tions.[3] Instead, the focus here is on practices and ideas, on forms of enquiry that may lend themselves to different kinds of

procedures and productions than those envisaged within modernist canons of painting in the twentieth century.

All the writers in some sense position their accounts of painterly practice in relation – and often in opposition – to the contested histories of modernism. They explore different potentialities for painting outside the modernist paradigm of purity, unity and disembodiment of vision. Instead, they propose models of painting practice that offer a means of engaging with and in the world, are performative rather than representational, necessarily gendered and embodied, are capable of transgressing the boundaries between old and new visual technologies, and of rejecting canon formations to engage with different histories and identities. In so doing, they move debates beyond a sterile set of oppositions between abstraction and realism, feminist or non-feminist genres, traditional or new media, modernist or postmodernist painting, for such binaries, as Marsha Meskimmon suggests, are simply inadequate to contain the complexities of contemporary practice by women. Running through each of the essays is a commitment to the serious project of painting as an encounter with the world, which can both reveal it and bring it into being.

ENCOUNTERS...

This book began from a number of encounters – with artists, with theories, with cultural practices and with art works – that have continued to inform its making and framing. I began by thinking of the book as being structured in thematic sections, but as the draft chapters began to arrive by post and e-mail, I realized that they came together more aptly as a kind of multi-layered conversation between writers and artists. The conceptual and material links between the essays – by authors whose work was not necessarily known to each other – were astonishing, and these rather than any preconceived structure have shaped the final form of the book. This introduction engages with the themes that have emerged across, within and between the ten chapters of the book as they came together.

While my first encounter with painting was as a child, my encounters with painters came much later, as a writer and as a teacher in an art college in the 1980s and 1990s in dialogue with

colleagues and students. These discussions about feminism, art practice, subjectivity and identity have been obtained over the last two decades. More specifically, some of my conversations about painting were in dialogue with artists and writers in this book: with Pam Skelton and Joan Borsa in connection with the former's exhibition *Groundplans* in 1989; with nine women painters, who included Rebecca Fortnum and Rosa Lee, for a group exhibition of their work entitled *dis(parities)* in 1992, with Lubaina Himid, following a series of exhibitions of black women's art that she curated in the 1980s, including *The Thin Black Line*, and with Barb Bolt when I read her PhD thesis in 2000.[4] Talking with artists enables a different kind of understanding of practice than one that is gained solely from looking at art works or reading about them. Of course, it does not guarantee the 'truth' of their work, but it can give access to the working processes through which decisions are taken and marks made: as Rosa Lee and Barb Bolt suggest, this process is not always a conscious one during the 'heat' of making a painting, and may only be recognized in retrospect.

As important as the dialogue between artists, critics and historians, is the dialogue between artists themselves. Several of the writers here – Rebecca Fortnum, Pam Skelton and Rosa Lee – have chosen to situate their work in 'conversation' with other artists with whom they share common concerns. This sense of a continuous flow and exchange of ideas across distinct and unique practices is, I think, one of the strengths of this collection, and one that, I hope, will continue beyond its pages.[5]

Another kind of encounter that informs the book is one between art historians and theorists, with whose writing on painting I have engaged, and sometimes disagreed. They include Marsha Meskimmon and Alison Rowley writing here, and also Katy Deepwell, Briony Fer, Rosalind Krauss and Griselda Pollock, all of whose work has helped me to think through the ways in which contemporary painting practices by women are meaningful – and why they matter.[6] But, while there have been sporadic attempts to address the relations between women, painting and feminism over the last decade, there has been no sustained critical analysis of women's painting and it remains, as Fran Lloyd has commented, 'one of the most undervalued sites of feminist practice in Britain'. (Lloyd 2000: 37)[7] Why is

this? Part of the reason must go back to the sustained critique of painting as a reactionary masculinist discourse by feminist artists such as Judy Chicago and critical theorists like Griselda Pollock since the early 1970s.[8] Indeed, many women artists at the time consciously rejected painting in favour of less 'tainted' media such as performance, video or installation.[9] But, two decades later – and at a point when new media have themselves become orthodoxy in curatorial practices – it seems apt to begin to reconsider painting as practice that is being engendered and embodied by women in new ways.

One of the ways in which painting practices, and the debates about them, have changed over the last two decades is the extent to which they now address issues of inter-cultural exchange.[10] The cross-cultural encounters within these essays are many and complex. Marsha Meskimmon's essay on the work of an indigenous Australian artist, Judy Watson, Joan Borsa writing about Ukrainian Canadian artist, Ann Harbuz, and Lubaina Himid making work in a former leprosy hospital in Bergen, Norway, each demonstrate the significance of 'boundaries, temp-oralities, identities, spaces, territories and subject positions' to the making of art. (Skelton 2003) While for Meskimmon, Borsa, Himid and Skelton, issues of racial and cultural identities and histories are crucial, for other writers like Partou and Rosa Lee, their respective Iranian and Chinese identities are an implicit factor in their work, alongside gender and generation. The attention given to the specificities of race and place, to culture and identity, again marks this kind of painting out from the modernist assumption of a universalized aesthetic or a postmodernist play of signifiers detached from histories and politics – the 'play' here is a serious one. (Lee 2003)

Above all, it has been the encounter with paintings themselves that has fuelled my own need to write about them. So, what is at stake in my continuing attachment to painting as a meaningful practice? Part of the answer lies in my own intellectual formation as an art historian, tutored by scholars who communicated their own passion for painting, as well as in my own (suppressed) desire to become a painter from an early age.[11] But, why do I, as a feminist, still invest desires and pleasures in paintings? I now think that the answer lies less in questions of political content or address, albeit still important, and more in issues of gendered

spectatorship and embodiment. By evoking my sense of being a carnal subject, a female subject in a fleshy body, painting *can* begin to articulate the complex pleasures and displeasures attached to looking as (and being) a woman. And it is the material qualities of paint, its sensuousness and colour, its ambiguity and resistance, over and above the signified meaning of a specific painting that continue to haunt me. To be sure, this is not an argument for formalism: the sensuous qualities of a Willem de Kooning painting only blind me temporally to its misogyny but, equally, my disappointment at seeing Georgia O'Keeffe's stunning images in the 'flesh' stems from their lack of material presence *as* paint. Without losing a sense of the critical subjectivity that is central to any feminist practice, I want to avoid the pitfalls of certain strands of feminist criticism that asserted in the past that the destruction of visual pleasure was, in itself, a feminist act.[12]

PRACTICES...

Barb Bolt, Rosa Lee, Marsha Meskimmon and Alison Rowley each describe ways of making and seeing paintings that do not involve conventional symbolic representations, which privilege visuality – and language – over other kinds of somatic experience. As Barb Bolt explains, paintings can be understood, in C.S. Peirce's term, as 'dynamic objects'; that is, they exceed pure signification and can be understood as bringing something new into being as: 'a pressure on, or pulse in, the see-able'. (Bolt 2003) Thus, she argues, paintings are not merely images, but materializations that can have an insistent presence as objects, which is why a slide or a photograph is never enough. Drawing on a wide range of theoretical and visual references from Deleuze to Merleau-Ponty, Cezanne to indigenous Australian painting, Bolt argues that 'materiality insinuates itself and cuts across the visual language', in a kind of 'visual stutter' that makes a painting more than just a sign. (Bolt 2003)

While painting is not unique in this respect – the same claims can be made of other kinds of art and craft – it *is* also mimetic. Rosa Lee proposes the concept of *mimesis*, not as imitation but as the tracing of our bodies in the world. This, she suggests, could be the model of or for a painting practice that seeks

'compassionate involvement' with, rather than abstraction from, its context. (Marks 2000: 141) For Lee as for Bolt, painting is a means of an engagement with and a bringing into *being in the work* something that has previously not existed, rather than a re-presentation of a pre-existent event, object or idea. (Lee 2003) Both in her own work and in that of the other painters whom she discusses, Jo Bruton, Katie Pratt, Beth Harland and Nicky May, Lee identifies characteristics that exceed the purely visual and relate to somatic senses of touch, rhythm and gesture, as well as different kinds of vision.

The concept of materialization, a process of bringing something into being over time, is also central to Marsha Meskimmon's discussion of the work of the indigenous Australian artist Judy Watson. She describes Watson's practice as one of the 'en-worlding' of the 'as yet unseen'. (Meskimmon 2003) This process is not finished at the point of production and continues to materialize within the inter-subjective 'event' that is constituted through engagement with other bodies in the space of a gallery or the site of the work. She describes the experience of walking through and on Watson's *Koori Floor* (1994), which is literally 'unframed', as one that is more akin to that of performance than of an object. The idea of performativity is one shared by Bolt, Lee and also Alison Rowley in her detailed engagement with Lily Briscoe's 'painting' in Virgina Woolf's *To The Lighthouse*. In the words of the critic, and friend of Woolf, Roger Fry, the aim of artists is 'not to imitate life, but to find an equivalent for life. They aim not at illusion but at reality'. (Fry 1920/1928: 239) For Lily Briscoe, as for Eva Hesse, the act of making art is 'absurd' or 'impossible', but it is also fundamentally necessary to her existence. In Woolf's novel, Rowley suggests, the act of painting (as of writing) is figured as 'bound up with some sort of love. At its close a painting finally emerges as a response to "emptiness" ... It is a practice, in which some sort of retrieval is attempted'. (Rowley 2003)[13] The idea of painting as a practice of desire is one that many of the writers here share. This may be a desire to retrieve the self, as in Partou's case, or to move beyond the boundaries of self towards forgotten others in the work of Susan Hiller, Lubaina Himid and Pam Skelton. In all the essays, however, painting is described as a complex practice

that engages with the psychic and the somatic; it is ongoing and relational and, at the same time, located in specific times and places. This implies two key shifts in our former understanding. The first is from a focus on painting primarily as a system of signs within semiotic analysis, to a concept of painting as having an indexical relation to the world: it is simultaneously both a trace and a material presence. The second shift is from thinking about painting solely as an 'object', towards an understanding of painting as an inter-subjective process: 'a practice of co-emergence involving the play of objects, bodies, materials, technologies and discourse'. (Bolt 2003). And, within western culture, of course, this practice is always gendered.

POLITICS...

All the writers in this book are in their thirties, forties or fifties; that is, they belong to the generation of women whose lives have been touched and transformed by second-wave feminism. In particular, the maxim that the 'personal is political' has meant that their professional practices, whether painting or writing, is connected to their broader sense of gender politics. For Rebecca Fortnum, this involves using her art 'as a way of reflecting and understanding [her] place in world', but one that engages with psychic and bodily memories and emotions, rather than producing polemical paintings. Not all the writers choose to address this issue as explicitly as Fortnum but, for each author, the question of what it means to produce work as an embodied, sexed, raced, classed and historically situated subject is implicit in their writing. As Marsha Meskimmon points out, both the embodiment of subjects and the situatedness of knowledges have been crucial concepts in recent feminist theory.[14] And, while these ideas are not new, in the context of painting theory, they offer a powerful means of disrupting existing aesthetic and political categories.

In perhaps the most authoritative analysis of feminism and painting from the last decade, Griselda Pollock suggests 'women share the fantasy of the creative self, desire that privileged space of imaginary freedom called the studio' according to the masculine modernist tradition, but that this is a profoundly

contradictory position. (Pollock 1992: 145) Her view carries weight and is often cited, not least within this book. (Borsa 2003) Yet the diverse practices described here demonstrate that the studio is still a crucial site of experiment and enquiry for women, from Lubaina Himid's description of 'the large and warm, but dark and brooding studio in Preston' where she makes her paintings, to Partou's intense scrutiny of her own female body in the studio, to Rosa Lee's account of the solitary 'dance' of work: 'all those days spent stretching and sizing canvases, priming, and waiting'. (Lee 2003)[15] Far from being a 'privileged space of imaginary freedom', for many women painting is an arduous, repetitive and isolated practice. For Partou, it also is by 'a naked female body stating *herself* in paint' that she can challenge the male artist's right to monopolise the symbolic space of the studio. (Partou 2003) In exploring what it means to paint from – and with – a female body, she renders explicit issues of gender, nudity and the assumed identity of the artist. By reasserting her own socially gendered I/eye, Partou does not simply occupy the body and space of the male artist, but displaces him in a 'political and intimate project' of *self*-representation as both the subject and object of her work. At the same time, her series of self-portraits resist any fixed ontology; unlike the linearity of an autobiography that bears 'the privilege of a final narration', they adopt a 'position of anti-definition'. (Partou 2003) From a similar perspective, Rebecca Fortnum discusses Sam Taylor Wood's video, *A Gesture Towards Action Painting* (1992), as both a piss-take of and an homage to Hans Namuth's famous film of Jackson Pollock at work in his studio. In so doing, she displaces the myth of male genius and parodies one of Modernism's most enduring images of the male – indeed hyper-masculine – artist at work. While Taylor Wood does not describe her work as feminist, it nevertheless re-enacts a founding moment of feminist art practice: the displacement of the male by the female body of the creator.[16]

While most of the writers do not address issues of gendered identity so directly, they are all engaged at some level with questions of spectatorship and embodiment. In my own chapter on Susan Hiller's painted works, I explore a concept of aesthetics that is both embodied and gendered, arguing that her works not only engender an awareness of embodiment on the part of the

spectator, but that they reconfigure bodily and psychic identities differently. For Rebecca Fortnum, too, 'the spectator is the site where the work happens.' In her complex account of the viewer's engagement with the paintings of Jane Harris, she explains how 'looking at painting is a serial activity' that unfolds over time and, is materially situated. (Fortnum 2003)

Fortnum also raises the question of the ethical and political relations between the artist, her work and her audience: to whom is the artist responsible, herself or her audience; for her own subjectivity or that of others? What is the ethical responsibility of the audience in the viewing process? Fortnum implies that such dichotomies are false, the 'personal' need not be the 'confessional'; 'self expression' can allow room for others to enter the argument.

CONCEPTS THAT TRAVEL

Two broad conceptual frameworks underpin many of the chapters in this book, namely psychoanalytic theory and phenomenology. It is not surprising that psychoanalysis, with its attention to unconscious processes, subjectivity, affect, creativity, desire, loss and spectatorship, has been a powerfully explanatory framework for painting. Indeed, as Alison Rowley shows, psychoanalysis and painting came together in the founding theories of twentieth-century modernism, as articulated by Roger Fry and Virginia Woolf in the 1920s. But many feminists have also engaged more critically with psychoanalytic theory as a predominantly male discourse and it is to the feminist critic of Freud and Lacan, Luce Irigaray, that Partou turns for her analysis of the creative female subject. These tensions within and between feminism and psychoanalytic theory have been productive ground for thinking through the relations between gender and the gaze, subjectivity and painting.[17] More recently, feminist cultural critics and artists have also turned to phenomenology, particularly the writings of Merleau-Ponty, in order to explore issues of embodiment, tactility and the relations of being in the world.[18] These concerns are addressed in a number of ways here: by Barb Bolt, in her investigation of Cezanne's 'little sensations'; in my chapter on responses to Susan Hiller's work; in Marsha Meskimmon's concept of 'intercorporeality',

and in Rosa Lee's account of 'haptic visuality'. Each of these essays seeks ways of explaining the relations between painting, vision and embodiment by drawing on the concepts of Merleau-Ponty and other writers who address ideas of the sensorium and (visual) language.

What is fascinating is how similar terms and concepts are put to work in different ways by the artists and writers. Thus notions of performativity, drawn from Judith Butler's and Gilles Deleuze's writings, and performance are used variously by Bolt, Meskimmon and Fortnum. This is not to suggest any one particular reading of theory is 'correct' as against another, but rather to show the usefulness of concepts in relation to the different spaces and practices in which they are used. One example of such 'concepts that travel' is that of mimesis. For Bolt, mimesis is linked to the critique of painting as a representational practice and what was perceived to be the crisis of mimetic representation in modernist art. On the contrary, for Rosa Lee, drawing on the ideas of Walter Benjamin, mimesis is itself embodied: 'Acts of mimesis, perceived as mediated by the body, directly challenge the assumption that symbolic representation be accepted as the sole source of meaning.' (Lee 2003) Partou adopts Irigaray's notion of mimesis as a strategy by which women can disrupt or 'jam' the machinery of male discourse in order to speak as women (*parler leur sexe*). These different usages suggest just how complex is the relation between painting and theory at the start of the twenty-first century.

HISTORIES

A new kind of history painting is another theme that emerges from these essays, particularly in the chapters by Marsha Meskimmon, Pam Skelton, Lubaina Himid and Joan Borsa. If, traditionally, history is the story told by the victorious – and history painting celebrates the deeds of winners – here it is the stories of the enslaved, the exiled, the dispossessed and the murdered that are told. Judy Watson's *low tide walk* is a painted journey that is also a testament to her family and clan. In the context of the contested histories and identities of post-settlement Australia, this is not an attempt to recover the violent past of her family's dispossession from their land, but to trace

the connections to the present through a kind of 'corporeal topography'. (Meskimmon 2003) In Pam Skelton's discussion of her own work and that of Suzanne Treister and Rachel Garfield, the pressure to reveal undisclosed or suppressed histories breaks through old barriers between still and moving images. For a post-war generation of Jewish women living with family histories that are unspoken or ignored, the desire to remember and witness the Holocaust and its aftermath is powerful. In different ways, Treister, Garfield and Skelton's painted, video and digital works exorcise their personal ghosts, but also move beyond these to create new figurations of humanity that can travel across boundaries of time, race and identity.[19] They negotiate the troubled histories of holocaust and diaspora, in order to re-negotiate relations between the past and the present in a struggle, as Skelton puts it, 'between remembering and forgetting'. (Skelton 2003) In 'Rosalind Brodsky', Treister creates a time-traveller who is investigator of and witness to the last century's genocide, while Rachel Garfield addresses a longer history of racism within Enlightenment thought in order to disturb our certainties and stereotypes. Skelton's own video work, *Ghost Town*, archives the history of the ghetto below the streets of today's Warsaw, uncovering a disturbing connection between education and genocide. As in her earlier works, these 'Dangerous Places' lie just below a calm surface. Each artist's work addresses us as viewers with the question that Rebecca Fortnum also poses: 'should we watch differently, feel more, if we are watching real, rather than acted trauma?' (Fortnum 2003) Such a question, as she suggests, confronts us with our own responsibilities in the act of looking.

The ethical responsibilities of artist and audience are also issues that Lubaina Himid's recent work addresses. In her painting series, *Plan B* (1999), she explores the idea of the 'danger zone', asking: 'How do people escape from danger when they are already in a safe place?' (Himid 2003) Her paintings, made in the context of the bombing of Baghdad and Belgrade as well as of natural disasters, ask us to consider how we respond to imagined as well as experienced dangers that are literally 'brought home' to us. She explores this in the writings of women artists and writers who lived through the Second World War, but it is perhaps even more pertinent in the aftermath of the

World Trade Center bombings in New York, when mediatized images of terror filled all our homes. For Himid, a new kind of history painting makes it crucial that the viewer enters into dialogue with the work; we are invited to speak back and take responsibility for what we witness.

Her work is also about journeys in time and space, both real and imagined, addressing issues of family, community and identity. These include her mother and aunt in *Double Life*, a sense of community with other creative women in *Plan B* and the displaced community of former leprosy patients in Bergen in *Inside the Visible*, attached to their remembered lives through the scraps and icons of familiar objects. They are also figurations of imagined community to whom Himid gives voice: 'They were individuals, real, idiosyncratic, sexual, thinking people. They had memories, hopes, families.' (Himid 2003) As in her imaginary 'e-mails' between white Manchester cotton-workers and black slave cotton pickers, she invests her unknown subjects with a specific humanity.

There is a strong resonance between Himid's documentation of the traces and memories of unknown lives and Joan Borsa's account of the ways in which Ann Harbuz's paintings describe 'distinct spatial, cultural, social, temporal divisions [that] point to what it means to inhabit specific bodies and locations'. (Borsa 2003) Harbuz paints the working lives of the expatriate Ukrainian community in contemporary Saskatchewan, to which Borsa's mother also belonged. She explores the subjects of identity, family, motherhood, labour and nation in works that are apparently 'at the margins', in ways that allow us to re-imagine and re-inscribe the specificities of identities and community, which cut across a globalized, mediated culture. Borsa's account of Harbuz's work addresses 'the blind spots within our critical responses to unorthodox or marginal forms of expression'. (Borsa 2003) She challenges the relegation of Harbuz's work to the doubtful status of 'folk' or 'naïve' art, instead arguing for the complexity with which the themes of identity, location and difference are addressed in her paintings.

The modernist canon formation that excludes the local and the personal, the female and the marginal is subjected to a strong critique by Borsa, one which stands in different ways for many of the works by other artists discussed here. Such works, as Pam

Skelton puts it, demonstrate the continuing capacity of painting – alongside newer media – 'to disturb, uncover and reveal' history. (Skelton 2003) In exploring the boundaries of time, space and memory, these artists demonstrate that painting is capable of communicating difficult and challenging public themes, as well as those that are more personal and subjective. Borsa's essay finishes with a set of questions that take us back to the problematic of painting raised initially by Barb Bolt and Alison Rowley: what does it mean to produce a painting? What kind of activity is it and how is it situated in the world? Is making painting still a risky business for women? How can we avoid performing within an art world whose categories and conventions of curatorial practice have become increasingly homogenized? This book offers, I hope, one space where a critical engagement with debates about gender and painting can take place, and a diversity of theoretical, practical and imaginative explorations be opened up.

NOTES

1. Ivan Massow, former Chairman of the Institute of Contemporary Arts, London, notoriously denounced contemporary art as 'pretentious, self indulgent, craft-less tat', for which he was forced to resign his position. (*New Statesman*, 2001) His views echo those of populist London art critics like David Lee and Brian Sewell, as well as more considered commentators such as Julian Stallabrass in *High Art Lite* (2000). This debate surfaces annually with the Turner Prize, which has in recent years been consistently awarded to conceptual and new media artists, the exception being the painter Chris Ofili in 1998.

2. See I. Whelehan (2000) *Overloaded: Popular Culture and the Future of Feminism*, London: The Women's Press. There has been relatively little attention paid to questions of gender in the extensive discussions of 'New British Art'. See H. Reitmaier (1998) in D. McCorquodale, N. Siderlin and J. Stallabrass (eds) *Occupational Hazard: Critical Writing on Recent British Art*, London: Black Dog Press; and R. Betterton (2000a) 'Undutiful Daughters: Avant-Gardism and Gendered Consumption in Recent British Art', *Visual Culture In Britain*, vol.1:1.

3. All references to the writers are from their chapters in this book, unless otherwise stated.

4. Pam Skelton, *Groundplans* (1989) Benjamin Rhodes Gallery,
 London, and Ikon Gallery, Birmingham; *dis(parities)* (1992)
 Mappin Art Gallery, Sheffield and Herbert Art Gallery, Coventry;
 The Thin Black Line (1985) Institute of Contemporary Arts,
 London; B. Bolt (2000) *Materializing Practices: the Work of Art
 as Productive Materiality.*

5. There will be a conference reviewing the themes of the book
 following its publication in 2003.

6. The following have been key influences on my thinking about
 women and painting: Meskimmon (1996) *The Art of Reflection:
 Women Artists' Self-Portraiture in the Twentieth Century*;
 Rowley (1996) 'On viewing three paintings by Jenny Saville:
 rethinking a feminist practice of painting' in Pollock (ed.),
 *Generations and Geographies in the Visual Arts: Feminist
 Readings*, London: Routledge; Deepwell (1995) *New Feminist
 Art Criticism*, Manchester: Manchester University Press; Fer
 (1997) *On Abstract Art*, New Haven & London: Yale University
 Press; Krauss (1994) *The Optical Unconscious*, Massachusetts
 & London: MIT Press; and Pollock (1999) *Differencing the Canon:
 Feminist Desires and the Writing of Art's Histories*, London:
 Routledge.

7. See Betterton (2000b: 281–98) for a more extended discussion
 of this topic.

8. See J. Chicago (1973) *Through the Flower* and G. Pollock (1992)
 'Painting, Feminism, History', in M. Barratt & A. Phillips (eds),
 De-Stabilising Theory: Contemporary Feminist Debates.

9. See Cate Elwes discussion of her own move into performance
 and video in the 1970s in C. Elwes (2000) *VideoLoupe.*

10. This is not to say that issues of gender, culture and ethnicity
 were not present in the women's art movement of the 1970s,
 particularly in the USA, but in Britain they only began to be
 articulated in the early 1980s; see Himid (1985).

11. I am grateful to the boundless enthusiasm for painting of
 Professor Richard Verdi, now Director of the Barber Institute
 for Fine Arts, Birmingham University, then tutor at the
 University of Manchester. Unfortunately, my encounter with art
 history led to my own abandonment of painting.

12. See in particular L. Mulvey (1989) *Visual and Other Pleasures*,
 pp.111–26.

13. Rowley identifies this with Woolf's reading of Freud, and
 particularly his account of the infant's game of *fort-da*, in which
 symbolically he acts out losing and regaining his mother. Thus
 for Lily Briscoe, the first mark 'shatters' the canvas, while each

subsequent one is a means of 'remaking that original state'. (Rowley 2003) It is no coincidence that her first attempt to paint Mrs Ramsay is in the form of a Madonna and Child.

14. See, for example, E. Grosz (1994) *Volatile Bodies: Towards a Corporeal Feminism*, Bloomington: University of Indiana Press; and D. Haraway (1991) 'Situated Knowledge', in *Simians, Cyborgs and Women*, London: Free Association Books.

15. Pollock curiously ignored her own earlier statement when she discussed Himid's *Revenge,* 1991, as history painting in G. Pollock (1999) *Differencing the Canon: Feminist Desire and the Writing of Art's Histories*, London: Routledge.

16. This can be seen most literally in Monica Sjoo's painting *God giving Birth* (1970), which shows a female goddess figure in the act of giving birth to a baby.

17. See for example Fer (1997) and Krauss (1994).

18. See Sobchack (1992), Vasseleu (1998) and Marks (2000).

19. Donna Haraway discusses the potential of new feminist 'figurations' in Haraway (1997).

CHAPTER 1

'BEFORE HER TIME?'
Lily Briscoe and painting now

Alison Rowley

For how could one express in words these emotions of the body?
express that emptiness there?

Virginia Woolf, 1920[1]

AS DIFFICULT AS A CÉZANNE

In April 1939, Virginia Woolf began the autobiographical essay 'A
Sketch of the Past' as a break from work on her biography of the
art critic and painter Roger Fry. Not far into the essay, she writes:

May 15th 1939. The drudgery of making a coherent life of Roger has once
more become intolerable, and so I turn for a few days' respite to May
1895. The little platform of present time on which I stand is, so far as the
weather is concerned, damp and chilly. I look up at my skylight – over
the litter of *Athenaeum* articles, Fry letters – all strewn with sand from
the house that is being pulled down next door – I look up and see, as if
reflecting it, a sky the colour of dirty water. And the inner landscape is
much of a piece. Last night Mark Gertler dined here and denounced the
vulgarity, the inferiority of what he called 'literature'; compared with the
integrity of painting. 'For it always deals with Mr and Mrs Brown,' – he
said – with the personal, the trivial, that is; a criticism which has its
sting and its chill, like the May sky. Yet if one could give a sense of my
mother's personality one would have to be an artist. It would be as
difficult to do that, as it should be done, as to paint a Cézanne.

(Woolf 1989: 94–9)

This passage contains several chains of association which intersect at the point where Woolf conjoins two things – the idea of giving a 'sense' of her mother's personality and the image of a Cézanne painting. The concluding two sentences of the passage are an astonishing acknowledgement by Woolf, at the very beginning of a project, deeply concerned with describing what she can remember of the presence and personality of her mother, of the futility of attempting this through the act of writing. Why did she think it could only be done in painting? And why only in the particular kind of painting signified by the name Cézanne? What constitutes the difficulty involved in this kind of painting, and why does Woolf link this difficulty to the task of giving a 'sense' of her mother's personality? These are the questions I want to begin to pursue by tracking the associative links from which the conjunction of these two ideas emerges in a process of memoir writing conceived at its outset as a 'sketch'.[2]

Virginia Woolf first met Roger Fry in 1910, the year in which, at the invitation of the directors of the Grafton Gallery, he brought together the exhibition of modern French art, entitled *Manet and the Post-Impressionists*. It opened to 'paroxysms of rage and laughter' from the public, and a violent division of opinion about the value of the work among critics and contemporary British artists. (Woolf 1969: 153) The exhibition ran from 8 November 1910 to 15 January 1911. Fourteen years later, on 18 May 1924, in a lecture delivered to the Cambridge Heretics Society called 'Character in Fiction', Virginia Woolf asserted that 'on or about December 1910 human character changed'.[3] The lecture reworks and expands an earlier essay on modern fiction written partly as a response to Arnold Bennett's review of her 1923 novel *Jacob's Room*, in which he criticized her handling of character. At issue is the question of realism. (Bennett 1923) In 'Character in Fiction', Woolf argues that the conventions of Edwardian novel writing in which a character is built from minutely detailed observations of the circumstances of her life are no longer adequate for the contemporary writer:

I knew that if I began describing the cancer and the calico of my Mrs Brown, that vision to which I cling though I know of no way of imparting it to you, would have been dulled and tarnished forever.

That is what I mean by saying that the Edwardian tools are the wrong
ones for us to use. They have given us a house in the hope that we
might be able to deduce the human beings who live there... But if you
hold that novels are in the first place about people, and only second
about the houses they live in, that is the wrong way to set about it.
Therefore you see the Georgian writer had to begin by throwing away
the method that was in use at the moment. He was left alone there
facing Mrs Brown without any method of conveying her to the reader.

(Woolf 1924, McNeille 1988: 141)

In the preface to the catalogue of the second *Post-Impressionist
Exhibition*, held in 1912, Roger Fry reviewed the English public's
response to the previous 1910 show. He argued that their sense
of outrage arose from a misunderstanding of what the artists set
out to do:

The difficulty springs from a deep-rooted conviction, due to long
established custom, that the aim of painting is the descriptive imitation
of natural forms. Now these artists do not seek to give what can, after
all, be but a pale reflex of actual appearance, but to arouse the con-
viction of a new and definite reality. They do not seek to imitate form,
but to create form; not to imitate life, but to find an equivalent for life...
In fact, they aim not at illusion but at reality.

(Fry 1928a: 238–9)

Roger Fry's arrival on the scene in Bloomsbury at the beginning
of 1910 shifted 'everyone's conversational attention' from
philosophy to art. (Lee 1996: 239) Woolf's formal experiments
in fiction, then, developed alongside the attempts of art critics
(Clive Bell as well as Roger Fry) to interpret and explain new
French painting and sculpture in the context of its first exposure
in England. The essay 'Character in Fiction' registers the impact
(signified as the unexplained reference to December 1910) of
the exhibition *Manet and the Post-Impressionists*. If Woolf's
'vision' of the reality of Mrs Brown was to be achieved, new
'tools', on the analogy with those developed in the field of visual
art, had to be forged in the discipline of fiction writing.

It is not hard, therefore, to imagine the painful impact on
Woolf of Mark Gertler's comment at dinner 1939, so close, as
we now know, to the end of her working life. When the painter

aims at her his denunciation of literature as inferior compared
to the 'integrity' of painting, he does so with deadly accuracy
with his reference to 'Mr and Mrs Brown'. That Woolf took his
comment as a judgement of the failure of her own efforts in
literature we might take as signified by the image in which she
registers its effect: 'a criticism which had its sting, and its chill,
like the May sky'. In the passage immediately preceding the
Gertler episode, Woolf writes of her mother's death early in the
morning of 5 May 1895 as follows:

I leaned out of the nursery window the morning she died. It was about
six, I suppose. I saw Dr Seton walk away up the street with his head
bent and his hands clasped behind his back. I got a feeling of calm,
sadness, and finality. It was a beautiful blue spring morning, and very
still. That brings back the feeling that everything had come to an end.

 (Woolf 1989: 94)

Here, in this small section of 'A Sketch of the Past', a meditation
on death, memory, the problems of writing a 'coherent' life, a
sense of failure in the practice of art, but also the idea of art as
a practice in which some sort of retrieval is attempted ends with
the invocation of the name Cézanne. Why might this be?

 Again we can look for an answer to Woolf's association with
Roger Fry and what in her biography of the critic she describes
as his 'excitement' about Cézanne. In the essay 'Retrospect', Fry
expresses his growing dissatisfaction with the absence of
'structural design' in the work of the Impressionists and writes
of his belated discovery of Cézanne who had, to his mind,
worked out the problem of 'how to use the modern vision with
the constructive design of the old masters'. (Fry 1928a: 238–9)

 The extent to which Fry's enthusiasm for Cézanne permeated
Bloomsbury can be gauged from an entry Woolf made in her
diary for 18 April 1918. She records a visit to the home of
Maynard Keynes, made in the company of Fry and her sister
Vanessa Bell, to look at a still life by Cézanne he had recently
purchased.

[S]o to Gordon Sqre; where first the new Delacroix & then the Cézanne
were produced. There are 6 apples in the Cézanne picture. What can 6
apples *not* be? I began to wonder. There's their relationship to each

other, & their colour, & their solidity. To Roger & Nessa, moreover, it was
a far more intricate question than this. It was a question of pure paint or
mixed; if pure which colour: emerald or veridian; & then the laying on
of the paint; & the time he'd spent, and how he'd altered it and why, &
when he'd painted it – we carried it into the next room, & Lord! How it
showed up the pictures there, as if you put a real stone among sham
ones; the canvas of the others seemed scraped with a thin layer of rather
cheap paint. The apples positively got redder & rounder and greener.

(Bell 1977: 140–1)

In Woolf's slightly irritable account of the two painters'
professional scrutiny of the detail of the painting's material
surface we nevertheless have evidence of the writer's exposure
to an explication of the nature of the technical procedures
entailed in making such a painting. A description, that is, at a
strictly material level, of its difficulty.

In her essay, '"Inevitable relations": Aesthetic revelations from
Cézanne to Woolf', Rebecca Stott rightly argues that while the
lecture 'Character in Fiction' was as near as Virginia Woolf ever
came to an aesthetic manifesto,[4] it is in the novel *To the
Lighthouse* that she, 'dramatizes many of the aesthetic problems
which she had discussed in that lecture'. (Stott 1992: 97) In her
painter character Lily Briscoe's rejection of the 'pale, elegant,
semi-transparent' style of the 'Paunceforte' school as inadequate
as an approach to the scene that presents itself to her to be
painted, Stott recognizes Fry's critique of Impressionism:

They, or rather some of them, reduced the artistic vision to a continuous
patchwork or mosaic of coloured patches without architectural frame-
work or structural coherence.

(Fry 1928b: 11)

Woolf has Lily Briscoe express her frustration with the progress
of her painting in images close to Fry's in that passage from 'Art
and Life':

She could have wept. It was bad, it was infinitely bad! She could have
done it differently of course; the colour could have been thinned down
and faded; the shapes etherealized; that was how Paunceforte would
have seen it. But then she did not see it like that. She saw the colour

burning on a framework of steel; the light of a butterfly's wing lying
upon the arches of a cathedral.

<div align="right">(Woolf 1977: 48)</div>

Woolf's abiding fear about her experiments with narrative
structure in her search to write the reality of character as a
succession of 'moments of being' was that the novels would read
as 'pale', 'semi-transparent'. (Woolf 1977: 22) If the modern
novelist was best advised to look to technical developments in
contemporary European painting as a source for the discovery
of new linguistic tools, Fry's architectonic conception of the
work of Cézanne appealed to Woolf's concerns about structure
in her own novel writing. But which areas of Cézanne's work in
particular offered Woolf possibilities in this struggle in the
middle years of 1920s? A closer examination of the writer's
description of what Lily Briscoe's painting looks like and her
conception of what it is 'of' will help us to determine this.

 Lily Briscoe begins a painting out of doors. She is on holiday.
She sets up her easel at the edge of the lawn of a house on a
cliff-top overlooking the sea. She looks towards the house. The
scene she faces involves the figure of the woman of whom she
is a guest, Mrs Ramsay, sitting in a window with her son James.
But the painting is not a portrait in the conventional sense, as
Lily attempts to explain to her holiday companion, the scientist
William Bankes:

What did she wish to indicate by the triangular purple shape, 'just
there?' he asked.

It was Mrs Ramsay reading to James, she said. She knew his objection –
that no one could tell it for a human shape. But she had made no
attempt at likeness, she said. For what reason had she introduced them
then? he asked. Why indeed? – except that if there, in that corner, it was
bright, here, in this, she felt the need of darkness. Simple, obvious,
commonplace, as it was, Mr Bankes was interested. Mother and child
then – objects of universal veneration, and in this case the mother was
famous for her beauty – might be reduced, he pondered, to a purple
shadow without irreverence.

But the picture was not of them, she said. Or not in his sense. There
were other senses too, in which one might reverence them. By a shadow

here and a light there, for instance. Her tribute took that form, if, as she
vaguely supposed, a picture must be a tribute. A mother and child might
be reduced to a shadow without irreverence. A light here required a
shadow there.

(Woolf 1977: 52)

Not concerned with accomplishing a likeness, Lily describes her
practice of painting as a response to the power of something
she had once seen clearly. She names it the power of the vision
of her picture, which she must now 'grope for amongst hedges
and houses, and mothers and children'. At the close of Lily's
conversation with William Bankes, Woolf describes the painting
as 'a few random marks scrawled upon the canvas', which her
fictional painter, in desperation, judges 'infinitely bad'. This
first painting is eventually abandoned. The second, which Lily
begins at the opening of the third section of the novel, is
described only twice: once as a collection of 'brown running
nervous lines', the painting's starting point; and then again in
the final paragraph of the novel immediately before the painter
draws the famous line in the centre of the composition and
declares it finished: 'There it was – her picture. Yes, with all its
green and blues, its lines running up and across, its attempt at
something.' (Woolf 1977: 191)

Gone now is the purple triangular shape of the first work, the
allusion to Raphael's compositional structure in his treatment
of the theme of Madonna and Child, and art history's paradigm
of all mother and child pictures. Lily's attempt at something in
painting that crucially involves Mrs Ramsay as its subject ends
up closer to the genre of landscape than it does to that of
portraiture. Put more directly, the picture Lily Briscoe finally
paints is not a Cézanne portrait but a Cézanne landscape. In the
physical absence of Mrs Ramsay in the second half of the novel,
Lily is quite literally left with only hedges and houses amongst
which to grope for her 'something' in paint.

But what is this 'something'? What, in more precise terms, is
the nature of the thing Lily struggles for? What does Woolf
understand as the subject matter of the painting, and what
bearing does her experience of the work of Cézanne have on
that understanding? At the moment Lily Briscoe picks up her
brush to begin the painting, Woolf introduces an image followed

> She could see it all so clearly, so commandingly, when she looked: it
> was when she took her brush in hand that the whole thing changed. It
> was in that moment's flight between the picture and her canvas that the
> demons set on her who often brought her to the verge of tears and made
> this passage from conception to work as dreadful as any down a dark
> passage for a child. Such she often felt herself – struggling against
> terrific odds to maintain her courage; to say: 'But this is what I see: this
> is what I see', and so to clasp some miserable remnant of her vision to
> her breast, which a thousand forces did their best to pluck from her.
>
> (Woolf 1977: 23)

The idea is about the nature and the naming of love:

> And it was then too, in that chill and windy way, as she began to paint,
> that there forced themselves upon her other things, her own inadequacy,
> her insignificance, keeping house for her father off the Brompton Road,
> and had much ado to control her impulse to fling herself (thank Heaven
> she had always resisted so far) at Mrs Ramsay's knee and say to her –
> but what could one say to her? 'I'm in love with you'? No, that was not
> true. 'I'm in love with this all', waving her hand at the hedge, at the
> house, at the children? It was absurd, it was impossible. One could not
> say what one meant.
>
> (Woolf 1977: 23)

At the novel's outset, then, the act of painting is figured by Woolf
as bound up with some sort of beginning and some sort of love.
At its close, a painting finally emerges as a response to an
'emptiness' impossible to express in words (by Lily to a different
companion, whose profession is the crafting of words, the poet,
Mr Carmichael). All three experiences as they arise in the activity
of painting substantially involve what Lily Briscoe calls 'these
emotions of the body'. What are we to make of this description?

THE PAINTER AND PSYCHOANALYSIS

In 'A Sketch of the Past', Woolf writes of the genesis of *To the
Lighthouse* as follows:

It is perfectly true that she obsessed me, in spite of the fact that she died when I was thirteen, until I was forty-four. Then one day walking around Tavistock Square I made up, as I sometimes make up my books, *To the Lighthouse*; in a great, apparently involuntary, rush... Why then? I have no notion. But I wrote the book very quickly; and when it was written, I ceased to be obsessed by my mother.

I suppose I did for myself what psycho-analysts do for their patients. I expressed some very long felt and deeply felt emotion. And in express- ing it I explained it and then laid it to rest. But what is the meaning of 'explained' it?

(Woolf 1989: 90)

If the 1924 essay 'Character in Fiction' signals Woolf's engagement with the emergence in her circle of an aesthetic discourse around developments in early twentieth-century French visual art, her description in 1939 of the sudden eruption of *To the Lighthouse* flags the other culturally significant discourse to which she was historically and personally so close: psychoanalytic thought and its development and promotion in London in the 1920s. Interest in psychoanalysis took particularly firm root in London's literary world in the early years of the 1920s. For Woolf it was close to home in the literal sense. Her brother and sister-in-law, Adrian and Karin Stephen trained as psychoanalysts in the mid 1920s, and in 1922 James Strachey, brother of Leonard Woolf and Virginia's close friend Lytton Strachey, persuaded them to take over publication of the *International Psycho-Analytical Library* at the Hogarth Press. Yet in spite of her proximity to the debates within Bloomsbury around the effect of psychoanalytic thinking on aesthetic practices, and regardless of her physical proximity to Freud's texts, packing them for distribution at the Hogarth press, Woolf claims to have avoided reading his work until 1939.[5] She did, though, register her reservations about the infiltration of psychoanalysis into the field of fiction writing in a 1920 article called 'Freudian Fiction', in which she reviewed a novel by J.D. Beresford called *An Imperfect Mother*. Woolf's primary objection to the novel was the writer's transformation of 'characters' into 'cases' through the application of a 'patent key that opens every door, that simplifies rather than complicates, detracts rather than enriches'. (Abel 1989: 17)

In the essay *The Artist and Psycho-Analysis*, Roger Fry
mounted a far weightier challenge to what he saw as the
uninformed colonization of visual art by Freudian psycho-
analysis and its offshoots. The paper, initially presented to the
British Psychological Society, was published by the Hogarth
Press as one of their *Hogarth Essays* series in 1924, the year
Woolf delivered her 'Character in Fiction' lecture at Cambridge.
The fundamental argument of Fry's paper is that psychologists
are ignorant of the distinctive practice that characterizes a work
of art as such. He believes that confusion has arisen because
two distinct types of activity have been classed together under
the single category of 'art'. The first, according to Freud's
analysis of the artist's engagement with fantasy life, aims to
create, 'a fantasy-world in which the fulfilment of wishes is
realized': (Fry 1924: 4)

There is, in fact, a path from phantasy back again to reality, and that is
– art. The artist has also an introverted disposition and has not far to go
to become neurotic. He is one who is urged on by instinctive needs
which are too clamorous; he longs to attain to honour, power, riches
fame, and the love of women; but he lacks the means of achieving these
gratifications. So, like any other with an unsatisfied longing, he turns
away from reality and transfers all his interest, and all his libido too, on
to the creation of his wishes in life.[6]

In Fry's characterization, the second type of artistic activity is
concerned with 'the contemplation of formal relations':

I believe this latter activity to be as much detached from the instinctive
life as any human activity that we know; to be in that respect on a par
with science. I consider this latter the distinctive esthetic activity. I
admit to some extent the two aims may both appear in any given work
of art but I believe them to be fundamentally different, if not in their
origins, at least in their functions.

(Fry 1924: 4)

Art whose subject matter (as opposed to its system of formal
relations) bears a direct relation to wishes unattainable in every
day life is, according to Fry, available for interpretation by the
psychoanalyst in gross 'psycho-biographic' terms.[7]

For Fry 'artistic feeling' is a sensitiveness to purely formal relations when the artist's 'whole attention is directed towards establishing the completest relationship of all the parts within the system of the work of art'. In the viewer, the contemplation of the results of such an attention on the part of the artist gives rise to: 'a special emotion which does not depend upon the association of the form with anything else what ever':

[N]o one who has a real understanding of the art of painting attaches any importance to what we call the subject of a picture – what is represented. To one who feels the language of pictorial form all depends on *how* it is presented, *nothing* on what.

(Fry 1924: 16)

Fry chooses to illustrate his point with the example of Cézanne: 'Cézanne who, most of us believe to be the greatest artist of modern times expressed some of his grandest conceptions in pictures of fruit and crockery on a kitchen table.' (Fry 1924: 16)

Nevertheless, an interesting question does arise for Fry from his consideration of relations between art and psychoanalysis. 'What,' he wonders, 'is the psychological meaning of this emotion about forms, (which I will call the passion for beauty)...?' He is willing to concede that the love of abstract beauty might ultimately derive from the libido. The question then is: 'what is the source of the affective quality of certain systems of formal design...?' (Fry 1924: 19) He follows the question with a speculation:

Now, from our definition of this pure beauty, the emotional tone is not due to any recognizable reminiscence or suggestion of the emotional experiences of life; but I sometimes wonder if it nevertheless does not get its force from arousing some very deep, very vague, and immensely generalized reminiscences... It seems to derive an emotional energy from the very conditions of our existence by its revelation of an emotional significance in time and space. Or it may be that art really calls up, as it were, the residual traces left on the spirit by the different emotions of life, without ever recalling the actual experiences, so that we get an echo of the emotion without the limitation and particular direction which it had in experience.

(Fry 1924: 19–20)

Fry concludes the essay by calling upon the psychoanalysts
to step in and investigate his wild amateur speculations with
their 'precise technique' and 'methodical control'. I want to
argue that such an investigation was in fact undertaken and
appeared in print not long after Fry delivered the challenge in
his paper: but not in the field of psychoanalysis. It appeared in
1927, in the exercise of another kind of 'precise technique' and
'methodical control' dedicated to the reinvention of character
in fiction. It is to the text of *To the Lighthouse* that we must
turn for a dramatic conceptualization of links at a *structural*
level between psychic processes and formal relations in painting,
the existence of which Fry can only intuit in *The Artist and
Psycho-Analysis*.

We know that Virginia Woolf read the proofs of *The Artist
and Psycho-Analysis*. In a letter to Fry, dated 22 September 1924,
she wrote:

[S]o I must write off at once and say how it fills me with admiration and
stirs up in me, as you alone do, all sorts of bats and tadpoles – ideas, I
mean, which have clung to my roof and lodged in my mind, and now
I'm all alive with pleasure.

(Nicolson 1976: 132)

The bats and tadpoles, I would like to wager, were stirred up by
Fry's question about the source of the emotion about forms. In
May, just four months earlier, in her 'Character in Fiction'
lecture, Woolf could only make passing reference to the first
Post-Impressionist exhibition. She was familiar with the
technical procedures underlying formal innovations in new
French painting from her years of conversation with Fry, her
sister Vanessa Bell and the other painters of her circle. But at
that time she had no clear idea how these tools for the
signification of 'a new and definite reality' in the visual arts
might be translated for use in the field of fiction. How could
they be mobilized to construct the reality of character as she
experienced and imagined it as a woman writing novels in the
middle of the 1920s? *The Artist and Psycho-Analysis* signalled
a way. It was Woolf's cue to imaginatively concretize Fry's
generalized speculations, to parallel an account of the
'distinctive esthetic activity' of painting (exemplified by

Cézanne) with a story of human emotions experienced in response to tangible events, situations and memories.

'YET IF ONE COULD GIVE A SENSE OF MY MOTHER'S PERSONALITY ONE WOULD HAVE TO BE AN ARTIST'

Fry's characterization of art as wish-fulfilment in *The Artist and Psycho-Analysis* was based upon Freud's remarks about the artist's relation to fantasy life in his *Introductory Lectures on Psycho-Analysis*, first published in English in 1922. In the same year, however, the Hogarth Press published *Beyond the Pleasure Principle* as the first volume of the *International Psycho-Analytical Library*. It is in this essay that we find Freud's speculations about the psychic roots of artistic activity at precisely the structural level Fry demands in *The Artist and Psycho-Analysis*. Furthermore, there is an extraordinary parallel between the material with which Freud worked in *Beyond the Pleasure Principle* and the themes Woolf explored in *To the Lighthouse*.

Beyond the Pleasure Principle famously contains Freud's account and interpretation of the repetitious activity of his eighteen-month-old grandson, Ernst, during the absence of his mother. The child throws out of sight, and then retrieves, a wooden reel attached to a piece of string. He accompanies the actions with the sounds 'o-o-o-o' and 'a-a-a-a', interpreted by Freud as the German words *fort* ('gone') and *da* ('here'). The painful anxiety produced by the mother's absence drives the child towards symbol formation and language:

It was related to the child's cultural achievement – the instinctual renunciation (that is, the renunciation of instinctual satisfaction) which he had made in allowing his mother to go away without protesting. He compensated himself for this, as it were, by himself staging the disappearance and return of the objects within his reach...

(Freud 1973: 15–6)

Freud speculates that the child's play may also satisfy an impulse suppressed in his actual life and that throwing away the toy is an act of revenge on his mother for leaving him. At the end of the analysis of Ernst's game, Freud makes the following observation:

Finally a reminder may be added that the artistic play and artistic
imitation carried out by adults, which unlike children's, are aimed at an
audience, do not spare the spectators (for instance, in tragedy) the most
painful experiences and yet can be felt by them as highly enjoyable.

He suggests:

The consideration of these cases and situations, which have a yield of
pleasure as their final outcome, should be undertaken by some system
of aesthetics with an economic approach to its subject matter.

(Freud 1973: 16)

This reads like the reverse of Fry's challenge to the psycho-
analysts to scientifically investigate the psychic structures
underpinning the source of satisfaction derived from the
contemplation of certain systems of formal design.

To my mind, what we have in 1927 with *To the Lighthouse* is
a site where the two systems, aesthetic and psychoanalytic at
their most basic structural level, can be seen to co-emerge. The
narrative of Lily Briscoe figures the economic nature of an
aesthetic system at its simplest and clearest, the binary mark/
unmarked-ground relation of the painting process:

Where to begin? – that was the question; at what point to make the first
mark? One line placed on the canvas committed her to innumerable
risks, to frequent and irrevocable decisions.

(Woolf 1977: 147)

Nowhere is the problem of the articulation of pictorial space
more evidently a question of fundamental structural relations
between mark and unmarked ground than in the landscape
watercolour studies of Cézanne's last years.[8] In the work of Lily
Briscoe, this basic aesthetic operation is linked to psychic yields
of unpleasure and pleasure related to experiences of the
unavailability/absence of the mother. She in effect plays the
adult, artistic game of *fort/da* as a response to the unavailability
as desired object in life/actual loss in death of Mrs Ramsay. She
finally achieves the fabrication of a cultural object (the painting)
by 'instinctual renunciation'/actual loss of the pleasure afforded
by the material presence of the mother's body.

In general, Woolf's narrative appears to parallel Freud's observation that it is the absence of the maternal body that motivates the activity of symbolic substitution, in terms of both object symbols, painting and language (the fantasy scenarios that accompany the activity). But if Woolf did know something of Freud's ideas in *Beyond the Pleasure Principle*, exploring them in fiction through the character of Lily Briscoe, she has already made a significant transposition from a masculine to a feminine player. Does this difference make any difference? Let us now look more carefully at Woolf's description of Lily Briscoe's painting process and start by returning to the two passages that seem to link painting with the ideas of beginnings, and of 'love'. Lily stands on the lawn concentrating on her motif:

She could see it all so clearly, so commandingly, when she looked: it was when she took her brush in hand that the whole thing changed. It was in that moment's flight between the picture and her canvas that the demons set on her who often brought her to the verge of tears and made this passage from conception to work as dreadful as any down a dark passage for a child. Such she often felt herself – struggling against terrific odds to maintain her courage; to say: 'But this is what I see: this is what I see', and so to clasp some miserable remnant of her vision to her breast, which a thousand forces did their best to pluck from her.

(Woolf 1977: 22–3)

Lily is faced with a new, unmarked canvas, for the painter the space of unlimited possibilities and, simultaneously, a field always already complete. The first mark quite literally shatters the integrity of the canvas – terrifyingly. It is as Lily moves to paint that the second thought, the one about love arises:

And it was then too, in that chill and windy way, as she began to paint, that there forced themselves upon her other things, her own inadequacy, her insignificance, keeping house for her father off the Brompton Road, and had much ado to control her impulse to fling herself (thank Heaven she had always resisted so far) at Mrs Ramsay's knee and say to her – but what could one say to her? 'I'm in love with you'? No, that was not true. 'I'm in love with this all', waving her hand at the hedge, at the house, at the children? It was absurd, it was impossible. One could not say what one meant.

(Woolf 1977: 22–3)

If the first mark divides an always already unified field, each subsequent one must be a move towards remaking that original state. With the images Woolf chooses as the thoughts to accompany Lily's start on her painting, she unequivocally equates unmarked canvas with the body of the mother generally, in the birth metaphor, and specifically with the character of Mrs Ramsay as the mother figure in the narrative. As Lily makes her first mark, the image of her subjectivity as separate and different from Mrs Ramsay comes into Lily's mind, signified in this woman-to-woman relation as *class*. Desiring complete knowledge of her difference, Lily wants to be in Mrs Ramsay's space, to be, in the act of painting, (re)emerged in the 'this all', hedge, house, children, that carries with it a quality of emotion impossible to convey in words, for which the word 'love' stands only as an inadequate approximation. But her beginning turns out, by her own judgement, to be 'infinitely bad' and the memory image that accompanies her despair at what she sees on the canvas carries the psychic material underpinning the perceived formal failure. The setting is Lily's bedroom late at night, the event the arrival of Mrs Ramsay and a moment of physical intimacy between the two women:

Sitting on the floor with her arms around Mrs Ramsay's knees, close as she could get, smiling to think that Mrs Ramsay would never know the reason for that pressure, she imagined how in the chambers of the mind and heart of the woman who was, physically, touching her, were stood, like the treasures in the tombs of kings, tablets bearing sacred inscript-ions, which if one could spell them out would teach one everything, but they would never be offered openly, never made public. What art was there, known to love or cunning, by which one pressed through into those secret chambers? What device for becoming, like waters poured into one jar, inextricably the same, one with the object one adored? Could the body achieve it, or the mind, subtly mingling in the intricate passages of the brain? or the heart? Could loving, as people called it, make her and Mrs Ramsay one? For it was not knowledge but unity she desired, not inscriptions on tablets, nothing that could be written in any language known to men, but intimacy itself, which is knowledge, she had thought, leaning her head on Mrs Ramsay's knee.

Nothing happened. Nothing! Nothing! as she leant her head against Mrs Ramsay's knee.

(Woolf 1977: 50–1)

This is a richly condensed passage full of ideas. Two are significant for the present argument. First, there is the link made between knowledge and its linguistic symbolization. The body of Mrs Ramsay is likened to a tomb concealing tablets bearing sacred writings, laws, or a system that reveals but also strictly defines the rules and limits of knowledge. But, like the tombs of Egyptian kings, this chamber must be broken open for its secrets to be revealed. Echoes here of the revenge-mastery dimension of Freud's *fort/da*: language acquisition by violent expulsion of the material presence of the mother. But it is not knowledge of this kind that Lily desires, 'nothing that could be written in any language known to men', and Woolf's locution here is explicitly gendered: she writes known to 'men' and not 'man', as universal signifier of all human kind. There is knowledge, she intuits, connected specifically to women. But it obviously cannot be found in achieving unity, in a complete merging of mind/body, of self and other 'like waters poured into one jar'. And physical intimacy, which Lily 'had' thought of as knowledge, fails utterly: 'And yet, she knew knowledge and wisdom were stored in Mrs Ramsay's heart.' (Woolf 1977: 51)

On canvas, Lily's problem is, unsurprisingly, 'how to connect this mass on the right hand with that on the left'. She considers two solutions: 'she might do it by bringing the line of the branch across so; or break the vacancy in the foreground with an object (James perhaps) so'. Her reason for rejecting both these options is, on the face of it, a little more surprising: 'But the danger was that by doing that the unity of the whole might be broken.' (Woolf 1977: 53) From the bedroom scene, we know that 'nothing had happened' in terms of accessing what Mrs Ramsay knew in unity as physical proximity – one reason why the mass on the right is separated by a space from the other on the left. But in this state the painting already has, we are told, a unity that would be broken by doing something about an empty space in the foreground. So why does anything else *have* to be done, why can't Lily call it finished there and then? Because, I suggest, the 'unity' she is thinking of here is the cultural definition of wholeness as a system of two differently constituted but complementary unities: the house and the hedge. (Mrs Ramsay's subject of conversation during her nocturnal visit is the advocacy of the 'universal' laws of marriage against Lily's defence of remaining single.) This

translates into an idea of compositional 'wholeness' as a set of historically ratified conventions in painting, a formal system 'known to men' against which Lily measures the look of her picture. It already has a variety of that, but she is compelled to go on, she knows there is another knowledge to be conveyed. But to go on is to go on to make something that is not recognizable as wholeness in painting, it looks like the confirmation of Charles Tansley's whispered words in her ear, 'women can't paint, women can't write'. The profound doubt that this produces in Lily stops her continuing with the work altogether for the remainder of the first part of the novel. Viewed from the perspective of Freud's *fort/da*, transposed into the field of painting, the unity of Lily's picture as a culturally recognizable 'whole' object depends entirely on the vacancy (repression of the maternal body) at its centre; in literal terms unmarked canvas, the ground against which the individual unity of each 'mass' (both masculine and feminine subject position) is defined as such. But for Lily Briscoe this is not the whole of wholeness.

When she takes up again the problem posed by this painting it is ten years later, and after the death of Mrs Ramsay. Trying to manage feelings stirred up by her return to the Ramsay's summer residence, Lily remembers her picture and decides to begin it again. She sets up her easel on the edge of the lawn in the same spot as before, facing the steps and French window, now empty, and its framing 'masses' of wall and hedge. As Mr Ramsay leaves with his son James and daughter Cam on the long-awaited but no longer desired boat trip across the bay to the lighthouse, Lily starts work on a new canvas. She experiences once more the terror of the first mark, its double nature as traumatic and promising represented not metaphorically this time, but directly and explicitly as 'a painful but exciting ecstasy'. Woolf's description of Lily's activity also now more obviously suggests a parallel with little Ernst's game:

With a curious physical sensation, as if she were urged forward and at the same time must hold herself back, she made her first quick decisive stroke. The brush descended. It flickered brown over the white canvas; it left a running mark. A second time she did it – a third time. And so pausing and so flickering, she attained a dancing rhythmical movement, as if pauses were one part of the rhythm and the strokes another, and all

were related; and so, lightly and swiftly pausing, striking, she scored
her canvas with brown running nervous lines which had no sooner
settled there than they enclosed (she felt it looming out at her) a space.

(Woolf 1977: 148)

Lily's idea about the nature of that which looms out at her is
narrated as follows:

For what could be more formidable than that space? Here she was again,
she thought, stepping back to look at it, drawn out of gossip, out of
living, out of community with people into the presence of this formida-
ble ancient enemy of hers – this other thing, this truth, this reality,
which suddenly laid hands on her, emerged stark at the back of appear-
ances and commanded her attention.

(Woolf 1977: 148)

Here, at the level of her symbolic object, her painting, Lily faces
an anxiety figured as absence threatening to overwhelm by the
pressure of its presence. How does she proceed, what form does
her attempt at controlling this experience take? She begins to
model the 'hideously difficult white space' with 'greens and
blues' and as she does so she remembers a scene on the beach
with Mrs Ramsay:

They chose little flat stones and sent them skipping over the waves...
What they said she could not remember, but only she and Charles
throwing stones and Mrs Ramsay watching them. She was highly
conscious of that... When she thought of herself and Charles Tansley
throwing ducks and drakes and of the whole scene on the beach, it
seemed to depend somehow upon Mrs Ramsay sitting under the rock
with a pad on her knee, writing letters... That woman sitting there,
writing under the rock resolved everything into simplicity; made these
angers and irritations fall off like old rags; she brought together this and
that and then this, and so made out of that miserable silliness and spite
(she and Charles Tansley squabbling, sparring, had been silly and
spiteful) something – this scene on the beach for example, this moment
of friendship and liking – which survived, after all these years, com-
plete, so that she dipped into it to refashion her memory of him, and it
stayed in the mind almost like a work of art.

(Woolf 1977: 150)

Almost like the work of art she abandons in part one of the novel in fact, the composition that depended for its wholeness on the complementarity of the individual 'masses' of wall and hedge determined by the 'vacancy in the foreground'.

But rather than it being a problem, an unwanted space, here rearticulated and figured at the level of the fantasy scenario, Lily recognizes its presence as a crucial structural function. The beach memory ends as follows:

What was the meaning of life? That was all – a simple question; one that tended to close in on one with years. The great revelation had never come. The great revelation perhaps never did come. Instead there were little daily miracles, illuminations, matches struck in the dark; here was one. This, that, and the other; herself and Charles Tansley and the breaking wave... Mrs Ramsay making of the moment something permanent (as in the other sphere Lily herself tried to make of the moment something permanent) – this was of the nature of a revelation.

(Woolf 1977: 150–1)

Lily as maker identifies with Mrs Ramsay as a symbolic figure, representing a creative structuring force in the cultural sphere. But this only comes into view for the woman who is *not* her biological daughter at the moment Mrs Ramsay is involved in her own creative activity (letter writing) outside the framework of the family where all is subordinated to the demands of Mr Ramsay as creative intelligence. Again Lily stops work, this time not out of doubt but curiosity; she walks to the edge of the lawn to watch the Ramsay's boat set sail out across the bay. When she returns to her canvas there is a significant change in her response to the problem of white space: 'Heaven be praised for it, the problem of space remained, she thought taking up her brush again. It glared at her. The whole mass of the picture was poised upon that weight.' (Woolf 1977: 159) There follows a very Fry-on-Cézanne-like statement of her intentions to make what sounds more like a watercolour than an oil study:

Beautiful and bright it should be on the surface, feathery and evanescent, one colour melting into another like colours on a butterfly's wing; but beneath the fabric must be clamped together with bolts of iron. It

was to be a thing you could ruffle with your breath; and a thing you could not dislodge with a team of horses.

(Woolf 1977: 159)

As Lily begins to paint, her mind 'throws up' once more the scene on the beach, but now she sees herself not with Charles Tansley under Mrs Ramsay's gaze at some distance from her, but sitting beside the older woman who looks out to sea in silence. The failure of touch to satisfy Lily's desire to become 'one with the object one adored' (and this is a noticeably Freudian articulation of the desire in terms of Woolf's use of the word 'object' rather than 'person') and the failure of intimacy as knowledge marks the nocturnal bedroom scene with Mrs Ramsay. Sight (or more precisely a looking in silence, the condition of the activity of painting) is the sense connected with her acceptance of 'the extreme obscurity of human relationships'. Lily does not search the face of Mrs Ramsay for what she wants. To imagine desired oneness as a meeting or entwining of gazes would be to repeat the failure of the attempt at a tactile merging. But neither does sight here signify total separation – Lily speaks of 'the extreme obscurity of human relations' not their complete unknowability. (Woolf 1977: 159) Sight and obscurity are directly linked in this scene. Mrs Ramsay has put on her spectacles in an attempt to identify an object floating in the sea. 'Is it a boat? Is it a cask?' she asks. The two women sit beside one another looking out to sea in silence and the question remains unanswered. Yet rather than the frustration and dis-appointment experienced in the failure fully to know the 'object one adored' in the bedroom scene, for Lily here 'The moment at least seemed extra-ordinarily fertile'. (Woolf 1977: 160)

And yet it is not before an enormous struggle with a painful sensation of emptiness that Lily completes her painting as she looks at the place in her motif where the figure of Mrs Ramsay once was. This is focused in an extraordinary passage that reads like a dramatic condensation of theoretical speculations in *Beyond the Pleasure Principle*:

The physical sensations that went with the bare look of the steps had become suddenly extremely unpleasant. To want and not to have, sent all up her body a hardness, a hollowness, a strain. And then to want and

not to have – to want and want – how that wrung the heart, and wrung
it again and again! Oh Mrs Ramsay! she called out silently, to that
essence which sat by the boat, that abstract one made of her, that
woman in grey, as if to abuse her for having gone, and then having gone,
come back again. It had seemed so safe, thinking of her. Ghost, air,
nothingness, a thing you could play with easily and safely at any time
of day or night, she had been that, and then suddenly she put her hand
out and wrung the heart thus.

(Woolf 1977: 165)

Yet the solution to her painting seems connected more to the
imagined scene in which Lily sits beside Mrs Ramsay with
something between them that is obscure but fertile, and less to
the fantasy mastery of the pain of her absence implied in the
passage above. In the final paragraph of the novel, Lily looks
at her canvas and draws 'a line there, in the centre' and decides
that it is finished. But where does the line go? Is it a horizontal
or a vertical line? We do not know; Woolf does not make it
clear. Like the object that bobs in the sea it is ambiguous,
oscillating between possibilities: boat/cask, horizontal/vertical.
The problem in Lily's first painting is with a 'vacancy' in the
foreground, associated as I have argued, with Mrs Ramsay. The
second painting is Lily's attempt at some resolution to this
problem and the line marks the moment of the painting's com-
pletion; how, then, does it work according to the logic of
painting as a displaced site of *fort/da* that I have set up and
followed through Lily's narrative? The line breaks a vacancy,
described now not as the 'foreground' but as the 'centre'. Given
the position of the boat/cask in the water in the beach scene, I
want to suggest that this is a centre in depth rather than width,
that is to say in compositional terms the middle distance rather
than foreground. The composition seems now no longer to
depend on the structuring presence as absence of unmarked
ground/maternal body but hinges on a visually ambiguous,
oscillating element that blurs the distinction between figure
and ground.

At the level of the fantasy scenario, knowledge of Mrs Ramsay
for Lily is neither complete nor incomplete. Her presence as a
tactile materiality is *almost* felt – they sit beside one another
but without touching. To see is not a matter of getting a clear

picture of one another; they gaze together but out to sea, their point of mutual concentration an unclear and shifting field. We might elaborate from the perspective of *Beyond the Pleasure Principle* to say that, in the narrative of Lily Briscoe, Woolf represents something (in her own non-psychoanalytic formulation – 'a sense of my mother's personality') that interrupts (and only momentarily – not the great revelation but the little daily miracles) while residing within, the logic of *fort/da* as cultural symbolic substitution conditional upon maternal absence. A maternal psychic/corporeal element moves (like the boat/cask) into and across the picture. It achieves a borderline visibility at the level of Lily's painting as a blurring of the distinction between figure and ground.

So while the model for her painting as the articulation of fundamental figure/ground relations is a late Cézanne watercolour, the 1901–6 *Mount Sainte-Victoire* let's say, the picture Lily actually makes differs from it in that the very clear distinction between mark and unmarked ground in the Cézanne is in some way disturbed. When Vanessa Bell first read *To the Lighthouse*, she wrote her sister a letter and in it she said: 'By the way surely Lily Briscoe must have been rather a good painter – before her time perhaps, but with great gifts really?'[9]

NOTES

1. Woolf (1977) p.165.

2. 'As it happens that I am sick of writing Roger's life, perhaps I will spend two or three mornings making a sketch.' Woolf (1989: 72).

3. Woolf, 'Character in Fiction', first published as an essay in *The Criterion*, July 1924, was substantially derived from a paper read to the Cambridge Heretics on 18 May 1924, reprinted in *The Essays of Virginia Woolf*, vol.3, edited by Andrew McNeillie, London: The Hogarth Press, 1988, pp.420–38.

4. The remark is Quentin Bell's, in *Virginia Woolf: A Biography*, vol.2, London: The Hogarth Press, 1973, p.104.

5. For details of the books typeset by Leonard and Virginia Woolf, see Woolmer (1976).

6. Fry is quoting from Freud in 'Lecture XXIII: Introductory Lectures on Psycho-Analysis', in Strachey (ed.), *The Standard Edition of the Complete Psychological Works of Sigmund Freud*, vol.16, pp.375–6.

7. The term 'psycho-biography' is Griselda Pollock's. See Pollock
 (1989: 13–9).

8. Roger Fry was the first to appreciate some distinctive quality
 in Cezanne's late work. See Reff (1978: 13).

9. Letter dated 11 May 1927, in Appendix to Nicholson (1976: 572–
 3). This essay is an edited version of a chapter of a forthcoming
 book on the work of painter Helen Frankenthaler in the 1950s.
 There I propose that the effect of Frankethaler's soak-stain
 technique is to blur the figure-ground distinction in a way
 anticipated by Woolf in the imaginary painting she narrates in
 her novel.

CHAPTER 2

PAINTING IS NOT A REPRESENTATIONAL PRACTICE

Barb Bolt

'Representation' is such a common term we barely stop to think what is meant when we use it. When we draw, paint, sculpt, take a photograph, or make a video or a digital image, there seems little dispute that what we are involved in is making represent-ations. Thus as viewers and makers of paintings, we rarely pause to question the validity of the assumption that painting *is* a representational practice. However, it is precisely this assumption that I set out to challenge. In this chapter I want to shift the focus to the productive materiality of the performative act in order to question representationalist understandings of painting. Against the position that painting is a representational practice, I argue for a performative understanding of painting. I propose that in the work of painting there is the potential for a mutual reflection between imaging and 'reality'. In the exchange between 'bodies-image', real effects are produced. In this dynamic productivity the performative act of painting produces ontological effects, which are not of a representational kind.[1]

AT THE LEVEL OF PRACTICE

I begin this questioning at the level of actual practice and specifically in relation to the painting of two works, *Reading Fiction*, 1994 (fig. 1) and *Reading Theory*, 1994 (fig. 2).[2] In the heat of making, I question whether I actually set the world before me as an object. I wonder whether, in the practice of painting, I

fix an object for a subject and whether painting is concerned with mastering anything whatsoever. These paintings were done within weeks of each other at a time when I had been making a lot of paintings. They were part of a series. Both are quite large paintings – 0.9m x 0.7m and 1.5m x 1.2m respectively – and they were completed very quickly in an evening session. I want to recall the process of the painting. At first, the painting proceeds according to established principles – blocking in of shapes, establishing a composition, paying attention to proportion and shapes of light and dark – a reiteration of habits of working. However, at some undefinable moment, the painting takes on its own life, a life that seems to have almost nothing to do with my conscious attempts to 'control' it. The 'work' (as verb and noun) takes on its own momentum, its own rhythm and intensity. Within this intense and furious state, I no longer have any awareness of time, of pain, or of making decisions. In the fury of painting, rules give way to the pragmatics of action. The painting takes on a life of its own. It breathes, vibrates, pulsates, shimmers and generally runs away from me. The painting no longer represents, nor does it merely illustrate reading. It performs it. The painting transcends itself and becomes a dissembling presence. In an act of concurrent actual production, it exceeds the sign and becomes, in James Elkins' terms, simultaneously sign and not sign. (Elkins 1998: 45)

The *life* that *Reading Fiction* took on was that of *The English Patient*. I was not aware that my sitter, Estelle, was reading Michael Ondaatje's *English Patient*, and yet in and through the painting the play of light performed the eeriness of the novel:

The villa drifts in darkness. In the hallway by the English patient's room the last candle burns, still alive in the night. Whenever he opens his eyes out of sleep, he sees the odd wavering yellow light. For him now the world is without sound, and even light seems an unneeded thing.

(Ondaatje 1992: 298)

In *Reading Fiction*, it seemed as if the life in the novel had insinuated itself into the painting. The odd wavering yellow light had come to infect the painting, whilst the ragged breath of the dying English patient seemed to make it heave and tremble.

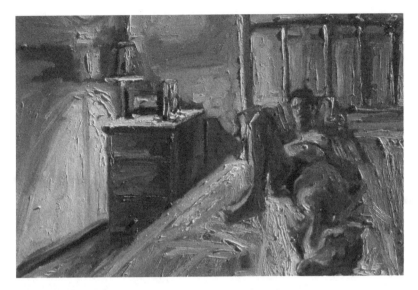

Figure 1: Barb Bolt, Reading Fiction, *oil on linen, 0.9 x 0.7 m. Courtesy of the artist.*

Reading Theory took on a very different life, a different force and intensity. During this painting, my sitter was reading Felix Guattari's theoretical treatise *Chaosmosis* and, uncannily, chaosmosis erupted on the canvas:

> Objects constitute themselves in a transversal vibratory position, conferring on them a soul, a becoming ancestral, animal, vegetal, cosmic. These objectities-subjectities are led to work for themselves... they overlap each other, and invade each other to become collective entities half-thing half-soul, half-man half beast, machine and flux, matter and sign.
>
> (Guattari 1995: 102)

In *Reading Theory*, the face begins to transform. It is no longer human. In Guattari's terms, it is 'a becoming ancestral, animal, vegetal, cosmic'. (Guattari 1995: 102)

Such painting experiences raise a fundamental question. If a painting comes to perform rather than merely represent some other *thing*, what is happening? Through attention to performativity, I want to argue that the material practice of painting can transcend its structure as representation and become more than the medium that bears it. In this way, I wish to extend Dorothea

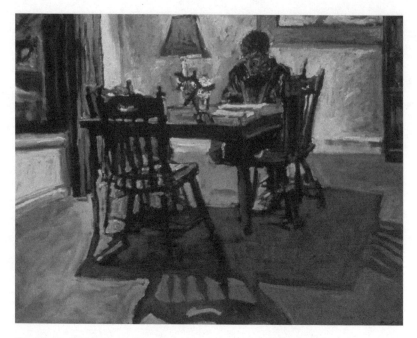

Figure 2: Barb Bolt, Reading Theory, *oil on linen, 1.5 x 1.2 m. Courtesy of the artist.*

Olkowski's provocation 'that in some photographs what is created, what is thought is no longer a sign within a symbolic system but becomes the thing itself', to painting. (Olkowski 1999: 208) I suggest that the performativity of painting involves materialization of the facts of matter.[3]

THEORIZING PERFORMATIVITY

In order to advance my argument for a productive materiality of painting, I want to turn to Gilles Deleuze's understanding of performativity, as developed in *The Logic of Sense* (1990) and 'He stuttered' (1994). Deleuze draws on speech act theory to develop his theory of the performative. He is concerned with an ontology of dynamic change and has developed his under-standing in relation to creative practice. Following Austin (1961), he focuses on the 'positioning of bodies in fields of force', (Olkowski 1999: 227) in order to argue for the transformative potential of language and bodies. In his commitment to an ontology of change through creative practice, Deleuze has

produced a productive turn, in which the dynamic relation between bodies and language inaugurates a double movement. Deleuze terms this dynamic relation, 'flexion'.

For Deleuze, flexion is that 'act of language which fabricates a body for the mind... language transcends itself as it reflects the body'. (Deleuze 1990: 25) In flexion, Deleuze proposes, there is a double transgression that occurs in both language and in flesh:

> If language *imitates* bodies, it is not through onomatopoeia, but through flexion. And if bodies imitate language, it is not through organs, but through flexion... In flexion... there is a double transgression – of language by the flesh and of the flesh by language.
>
> (Deleuze 1990: 286)

The body that writes and is simultaneously written suggests a mutual reflection between bodies and language. As the matter of bodies-language, flexion is a 'monstrosity' that effects deformation at the level of matter rather than form.

Deleuze argues that in the disequilibrium that is produced through the radical performativity of flexion, the system bifurcates and 'language itself can be seen to vibrate and stutter'. (Deleuze 1994: 24) 'Stuttering' is a term Deleuze uses to describe the situation where the performance:

> no longer affects pre-existing words, but, rather itself ushers in the words that it affects; in this case, the words do not exist independently of the stutter, which selects and links them together. It is no longer the individual who stutters in his speech, it is the writer who *stutters in the language system* (*langue*): he causes language as such to stutter.
>
> (Deleuze 1994: 23)

When Deleuze talks of 'stuttering' as the limit of language, he evokes an outside – not as something external to language, but rather as an *outside* of language. The vibration and stuttering of the language occurs in the interaction of the matter of bodies with the language system. This different valency, it can be argued, shifts the notion of performativity from one in which the body is *inscribed* by language to one where the body *becomes* language. In this reconceptualization, the sign is reconfigured by the rhythms and pulsions of the body. Deleuze suggests that:

just as the new language is not external to the language system, the asyntactic limit is not external to language, not outside of it. It is not a painting or a piece of music, but a music of words, a painting with words, a silence within words, as if the words were not disgorging their content – a grandiose vision or a sublime audition. The words paint and sing but only at the limit of the path they trace through their division and combination.

(Deleuze 1994: 28)

A VISUAL STUTTER?

Deleuze frequently uses visual and musical terminology in his elaboration of the literary arts. In his thinking, writers paint with words whilst the words themselves paint and sing. (Deleuze 1994: 28) However, Deleuze's understanding is not metaphoric. Language is set in motion and is made to perform rather than merely describe. In his writing on creativity, Deleuze is particularly concerned with how the writer achieves this transfiguration in language. He argues that the artist becomes:

a foreigner in his own language: he does not mix another language with his, he shapes and sculpts a foreign language that does not pre-exist *within* his own language... The point is to make language itself cry, to make it stutter, mumble or even whisper.

(Deleuze 1994: 25)

Carolyn Chisholm describes this as the 'linguistic performativity of the artist'. (Chisholm 1995: 25)

So what is happening to make language stutter, mumble and whisper? Deleuze argues that in order to make language stutter, mumble or whisper, the writer creates a disjunction between the sound system and the semantic system so that the sound cuts across coded meaning. In performing this disjunction, the writer ruptures meaning, heightening arbitrariness and creating a vertiginous flight. Olkowski proposes that this rupture occurs where language:

participates in a relay between forms of expression (the pure event that inheres or subsists in the proposition) and the actions and passions of bodies in concrete social formations. That is, language (expression/

enunciation) intervenes in circumstances and those circumstances of life are reflected again in language.

<div align="right">(Olkowski 1999: 226)</div>

Whilst treading warily so as not to conflate the verbal with the visual, I suggest that painting can also create a disjuncture as materiality insinuates itself and cuts across the visual language. Where materiality insists, the visual language begins to stutter, mumble and whisper. In this context, the artist can become a stranger in the visual language. Thus Cézanne's struggle to *realize* what Yves Alain Bois terms his 'little sensations', (Bois 1998: 39) exemplifies this condition where an artist becomes a foreigner in the visual language.

In Merleau-Ponty's assertion that Cézanne wanted to see as a newborn in order to paint perception itself, it could be argued that Cézanne put himself in the position of being a foreigner in the language of paint. In abandoning himself to the 'chaos of sensation', (Merleau-Ponty 1993: 63) Cézanne continually re-invented the language of painting. He was always working as a stranger in the language of paint and his efforts produced those 'little sensations' as a material presence. However, is it valid to equate Cézanne's attempt to realize his little sensations with Deleuze's stuttering in language? How might we figure this transfiguration in the work of painting?

MATTER'S INSISTENCE

In an article, entitled 'Matter's Insistence: Tony Scherman's Banquo's funeral' (1996), Andrew Benjamin argues the case that matter disrupts visual narrative. It is this disruption that I would suggest sets the visual language stuttering and vibrating. Benjamin's distinction between paint's presence and the materiality of paint provides us with the vocabulary to begin to elaborate such a proposition. According to Benjamin, paint's presence constitutes the way the content is ordered and presented and, as such, it is inextricably linked to the meanings we derive from a work. (Benjamin 1996: 47) Materiality, on the other hand, is 'the insistence of the medium within the operation of the work's meaning'. (Benjamin 1996: 47) Benjamin argues that it is the operation of matter that causes the disruption of the traditional

categories of interpretation. Materiality produces the *stutter*, which disrupts the visual language and the visual narrative. Benjamin proposes that paint works by staging an appearance. In staging an appearance, he suggests, matter insists. The becoming present that Benjamin identifies involves a material transfiguration. In arguing for a productive materiality in painting, I suggest that it is in the interaction between the matter of bodies and the materiality of the paint that a *visual stutter* is enabled. Accordingly, matter's insistence does not only include the materiality of the medium, but also includes the matter of the artist in a graphic performativity and the matter of the *thing* itself.

How is it possible to suggest that matter's insistence can include the matter of the thing itself? Here we may draw attention to the relation between the sign and the referent. How can an image exceed its structure as representation in a radical material performativity and perform rather than stand for or signify its referent? How energetic can matter be? Is it possible to configure a matrix in which a painting is both a sign and an act of concurrent actual production?

In contemporary visual theory, Ferdinande de Saussure's elaboration of the sign has been influential in problematizing the relation between the sign and its referent. Saussure's linguistically based model is concerned with the arbitrary or conventional relationship between the signifier and the signified in the production of social meaning. Saussure's model has provided art theory with tools for the analysis and interpretation of visual images, a model that can take into account the socially coded nature of images. However, as Benjamin has noted, it is the operation of matter that causes the disruption of the traditional categories of interpretation. Given Saussure's focus on the play between signifier and signified, his model offers no space for exploring the material relation between the sign and its making or between the sign and its referent. According to Theresa de Lauretis, this concern with the arbitrariness of the linguistic sign has caused:

semiology to extend the categorical distinction between language... and reality to all forms and processes of representation, and thus to posit an essential discontinuity between the orders of the symbolic and the real.

(de Lauretis 1987: 39)

In Saussurian semiotics then, the work of the sign bears no relation to the *real*. In being primarily concerned with the play of the signifier, Saussurian semiotics brackets out the process of making – both how signs are made and the relation between signs and their referent.

The philosopher and semiotician, Charles Sanders Peirce, provides a set of conceptual tools that enable us to attend to the matter of practice and to the relation between the sign and the referent. Like Saussure, Peirce agreed on the centrality of the sign in his theory of semiotics. However, in contrast to Saussure, Peirce was interested in the way a sign related to the referent. His notions of the dynamical object and the indexical sign establish a causal link between the referent and its sign. Peirce theorized the connection between the sign and its referent in two ways. Firstly he was interested in the way the outer world enters semiosis. Secondly he was concerned with the dynamical relationship between sign and referent. James Elkins' claim that graphic marks can be understood as 'simultaneously signs and not signs' (Elkins 1998: 45) becomes explicable in the light of Peirce's elaboration of semiosis. For Peirce, as de Lauretis observes, the outer world enters 'into semiosis at both ends of the signifying process: first through the object, more specifically the "dynamic object," and second through the final interpretant'. (de Lauretis 1987: 39)

In visual semiotics, a concern with the reception and inter-pretation of images has focused on the interpretant to the neglect of the dynamic object. In order to develop a theory of practice, however, I believe that we need to excavate Peirce's interest in the way that the outer world enters semiosis through the dynam-ic object. Peirce differentiates between the dynamic object and the immediate object. According to Peirce, the immediate object operates in the realm of ideas; it is the object as represented or denoted. On the other hand, the dynamic object is external to the sign but nonetheless is an insistent pressure on the sign. Defined this way, Peirce's immediate object operates within the sphere of representation as defined by Heidegger. Anne Fread-man argues that the dynamic object has the capacity to surprise:

Surprise is the counter to predictability, the always already known, the only thing with the power to change our minds/signs/theories, the as-

yet-unsaid impinging on the talked-over, the site of discontinuity and
the place for questions.

<div align="right">(Freadman 1986: 101)</div>

In visual terms, this is the as-yet-unseen, in Elkins' terms, the
unpresentable, the unpicturable, the inconceivable and the
unseeable, impinging on the seen and represented. It operates
as a pressure on, or pulse in, the seeable.[4] The insistence of the
dynamic object constitutes a key energy of the painting. Thus a
painting is not just the coded, immediate object. A painting also
bears the pressure of the dynamic object. In this way the dynamic
object prevents the painting from being reduced to just a sign.

Peirce's theory of semiosis and transformation is predicated
on this pressure from outside the immediate object. In his
eclectic philosophy, we live in two worlds, 'a world of fact and
a world of fancy... we call the world of fancy the internal world,
the world of fact the external world'. (Peirce 1.321)[5] Were it not
for the 'garment of contentment and habituation', he continues,
a person would find his 'internal world rudely disturbed and
his fiats set at naught by brutal inroads of ideas from without'.
(Peirce 1.321)

Peirce's *fact* is to be understood in a very specific way. It bears
no relation to logic or rationality. Rather, Peirce's fact relates to
the pressure of the dynamic object in constituting meaning and
effects. In imaging, the dynamic object insists that its presence
is felt. Its pressure and vibrations erupt as the work of painting.
Although he refers to ideas from without, fact is not the fact of
conceptual thought, nor is a sign. It seems to me that fact is the
pressure of matter as sensation. Francis Bacon discusses the link
between fact and sensation in his interviews with David
Sylvester.[6] In the Sylvester interviews, Bacon refers to what he
calls the brutality of fact. For him, the brutality of fact is 'where
painting is returning fact onto the nervous system in a more
violent way'. (Bacon in Sylvester 1988: 59) Francis Bacon's
reference to the brutality of fact does not relate to violence *in
painting*, but rather is concerned with the violence *of paint*. It
is a question of the way paint's materiality comes to affect us as
beings. Bacon alludes to this when he argues that the task of an
artist is to 'set a trap by which you hope to trap this living fact
alive'. (Bacon in Sylvester 1988: 57)

Cézanne also subscribes to this in his proclamation that 'I have a hold of my motif'. (Cézanne quoted in Merleau-Ponty 1993: 67) For him, fact had to be 'caught alive in a net'. (Merleau-Ponty 1993: 67) While both artists betray a representationalist will to mastery, they both believe that fact should live on in a painting. For Cézanne, the fact materialized within him, 'The landscape thinks itself in me... and I am its consciousness'. (Cézanne quoted in Merleau-Ponty 1993: 67) Thus, rather than asserting his will to mastery, Cézanne abandoned himself to 'the chaos of sensation'. (Merleau-Ponty 1993: 63)

Cézanne's method of working and his doubt about his ability to realize his 'little sensations' reveal something of the relationship between the dynamic object and the immediate object (or the mental representation). Each moment of seeing and marking is a different moment, a different sensation and a different realization of fact. Merleau-Ponty attempts to identify the paradox of Cézanne's working method:

He was pursuing reality without giving up the sensuous surface, with no other guide than the immediate impression of nature, without following the contours, with no outline to enclose the color, with no perspectival or pictorial arrangement.

(Merleau-Ponty 1993: 63)

Emile Bernard called this Cézanne's suicide. As Merleau-Ponty observes, Cézanne 'aimed for reality while denying himself the means to attain it'. (Merleau-Ponty 1993: 63) Thus I would suggest that Cézanne's suicide involved opening himself continually to fact. In doing so, it could be argued that his internal world was continuously disturbed and his 'fiats set at naught by [the] brutal inroads of ideas from without'. (Peirce 1.321)

In this state of openness, Yves Alain Bois suggests that Cézanne's touch:

was the bridge between his pigment and the substances, forms, and the spatiality of the world... [I]t was what allowed him to conceive his paintings as worlds under construction, similar – in their mode of existence for our perception – to nature itself.

(Bois 1998: 39)

Bois continues, noting that 'to look at a Cézanne is to see simultaneously its molecular surface and the depicted object in the act of germinating under our very eyes'. (Bois 1998: 39) In Bois's reference to the depicted object there is a resonance with Peirce's immediate object. Simultaneously, we become aware of its molecular surface germinating under our very eyes. I would suggest that this molecularity is the felt pressure of the Peircian dynamic object.

In Cézanne's paintings, we become aware that a picture is not separate from its production. A picture emerges simultaneously, as both a sign and not a sign. This dynamic relation figures material practice in terms of co-emergence rather than mastery. In a co-emergent practice, matter is not impressed upon, but rather matter enters into process in the dynamic interplay through which meaning and effects emerge. A picture emerges in and through the play of the matter of objects (the dynamic object), the matter of bodies, the materials of production and the matter of discourse. It is not just, as Saussurian semiotics would have it, a play of signs. Yet it remains to be seen how this productivity is materialized as a trace or index in the work itself. If the fact *is* alive, where is the evidence of this in a visual work? How can we map or experience its effects?

PERFORMATIVE INDICES

Peirce's categorization of signs as iconic, symbolic and indexical opens the sign to an exteriority that allows for the effect of the dynamic object. In Peirce's trichotomy, the icon represents its object by virtue of likeness; the symbol represents objects by virtue of a rule, convention or code; and the index represents its object by virtue of being really affected by it. (Greenlee 1973: 70) In this system, it is the index, with its causal relation to its object that opens the sign to the dynamic object.

The dynamical quality of the index can be demonstrated in a profound way in the dot paintings of indigenous Australian painters. In providing a vehicle through which to keep the Dreaming alive, dot paintings not only derive their energy from their symbolic or storytelling role; for indigenous Australian painters there is a direct causal or indexical link between the

landscape, the body and their paintings. Jamatji artist Julie Dowling describes this connection:

Each step means there's another step to go on and this part of the country is this part of the picture so that as you are acting out the dot, dot, dot, dot, dot; even the action in itself is quite rhythmical, but when you bring that into connection with the heartbeat and also I'm telling a story now; this dot connects with this dot; this story is about this... the whole connection with the land comes from the process up.

(Author interview with Julie Dowling, April 1997)

The paintings produce a performativity where the language mimes the motions of the body and the landscape. In these paintings, explains John Welchman, the 'dot', is 'a trace of/on the ceremonial site; a granular magnification of the original sand support; and a daub on the surface of the body'. (Welchman 1996: 257) Viewed at a distance, the dot matrix creates an oscillation and a pulsation. Under very close scrutiny, each dot is still palpable. However this palpability has nothing to do with the painting's iconic or symbolic value. It is an index of, or materialization of, the country in the painting. For Arrernte elder Wenten Rubuntja: 'The landscape painting is the country itself, with *Tywerrenge* [sacred things or law] himself. That original Dreaming, he came up from the body of the landscape.' (Rubuntja in Ruff 2002: 35)

Peirce's 'indexical' sign, with its causal relation between the 'thing' and its sign, points to a way of considering the 'matter' of things: the matter of the body in process and the matter of the materiality of the work. The index does not produce 'meaning' in the same way as the symbol.[7] The index has 'real' material effects. It allows us to 'witness' in a very different way the process of materialization that occurs in the interaction between the matter of bodies, the matter of materials, technologies and the cultural. It is the actual modification of the sign by the object that gives the index its quality. (Peirce 1955: 102) This takes us beyond the sign to the facts of matter.

Whilst the indexical quality of cultural objects has been central to many non-western cultures, including indigenous Australian culture, such interest has waxed and waned in western culture. In many non-western societies, the power of

the index is never disputed. (Taussig 1993) In early Christian and medieval societies, there was also a belief in the effective force of the index. The veneration of the Shroud of Turin and other religious relics, exemplifies the belief in the power of images to perform. However, the belief in the power of images, and consequently the force of the index, was dislodged by a mode of thought that posited images as substitutes or signs that stood in for their object.

Despite this shift in the mode of thought, there has been a renewed interest in the 'index' in contemporary art. This revival has become evident in artists' use of objects in and as the work. In particular, indexical elements provide the key to the being of collage, assemblage, performance art and environmental art. However, this resurgence of interest is accompanied by quite a different belief structure from that which was evident in medieval society.

In 'A Paradigm Shift in Twentieth Century Art' (1998), Tony Bond argues that the contemporary engagement with the index has produced a paradigm shift in art practice. He traces this engagement to two different impetuses. Firstly, he argues, interest in the index was stimulated by an avant-garde reaction to the crisis in mimetic representation. As a result of this crisis, artists came to use *real* objects and elements instead of illusionism. Secondly, there has been a renewed interest in medieval beliefs in the force of the index. In medieval religious art, as Bond observes, 'the medieval icon could function as a holy object with spiritual power over and above its pictorial/iconic content. If the medieval icon contained a piece of the cross or part of a bone or a saint, contact with it could deliver real effects'. (Bond 1998: 2)

Picasso's collages exemplify the avant-garde engagement with the index. In his collage, *La Suze*, for example, the bottle label 'Suze' is taken from an actual bottle of Suze.[8] In this case, the signifier is also the referent. However, whilst the use of indexical elements in his collages may enrich the social meanings that a viewer can derive from the work, Picasso does not claim that the index carries with it any power other than its symbolic richness. This contrasts with contemporary work that in some way acknowledges a medieval belief in the force of the index. Ecological feminist art practices – for example the work of Ana

Mendieta – and shamanistic tendencies – such as in the performances of Joseph Beuys – exemplify this second impetus.[9]

The difference between contemporary avant-garde applications of the index, and indigenous Australian and eco-feminist attention to the index, points to quite a different understanding of its power or force.[10] The latter, as Bond suggests, is grounded in the medieval belief in the power of the index. These contrasting interests in the index raise a question: in a secular culture, where the work of art no longer is ascribed such power, is it possible to reinstate the image with a dynamical force akin to the relic?

THE POWER OF IMAGING

Peirce's elaboration of the index helps us to address this question. Peirce first used the notion of the index to theorize the relationship between the photograph and its object. (Freadman 1986: 97) The link between the photograph and its object or referent has been complicated by darkroom and digital manipulation, but there remains, particularly in family photographs, a belief in the existence of the referent. In asserting that there is no denying the referent, Olkowski makes the comment that:

in certain photographs, those that are loved, the fact that the photograph is literally an emanation of a real body, that light is the carnal medium, that the image is extracted, mounted, expressed by the action of light and the body touches me with its rays, attests to the fact that what I see is a reality and not the product of any schema.

(Olkowski 1999: 209)

Activating Roland Barthes' notion of the *punctum*, Olkowski argues that it is the *punctum* that provides this expansive force in a photograph.[11] This force becomes 'more than the photographic medium that bears it so that what you see, what is created, what is thought is no longer a sign within a symbolic system but becomes the thing itself'. (Olkowski 1999: 208) In photography, by reference to the physics of light, it is possible to plot the trajectory from the referent to the photograph. In collage, the referent can become identical with the sign. But what of painting?

What is its relation to the referent? And how can a painting, like
a photograph, become more than the medium that bears it?

I want to return to the performativity of indigenous Australian
painting and to Deleuze's understanding of flexion, and propose
that in painting there can be a mutual reflection between bodies
and imaging. Indigenous Australian painters believe that there
is a direct causal or indexical link between the landscape, the
body and painting. However, this is a not just a one-way flow of
forces and energies. It involves a mutual reflection between
bodies and language, that is, flexion. Paul Carter has termed the
mutual reflection that characterizes indigenous Australian cult-
ural beliefs 'methexis'.[12] According to the philosopher, Frances
Cornford, methexis involves a participatory relation in which:

> The passage from the divine plane to the human, and from the human to
> the divine, remains permeable and is perpetually traversed. The One
> can go out into the many; the many can lose themselves in reunion with
> the One.
>
> (Cornford 1991: 204)

In the permeability of the passage from the divine plane to
the human and the human to the divine, Carter proposes that
ritual performances such as painting, singing and dancing can
be fundamentally transformative. The passage is productive and
the effects are, for want of a better word, *real*. Kathleen Petyarre
explains this in relation to women's ceremonies:

> The spirits of the country gave women's ceremonies to the old woman.
> The woman sings, then she gives that ceremony to the others to make it
> strong. The old woman is the boss, because the spirits of the country
> have given her the ceremony... The old women sing the ceremonies if
> the people are sick, they sing to heal young girls, or children. The old
> women are also holding their country as they dance.
>
> (Petyarre quoted in Voight 1996: 221)

Performance produces real material effects. It produces rather
than represents reality. As Anna Voight has noted, it is through
sacred ceremonies and adherence to the laws passed down from
the ancestors that people look after their land. (Voight 1996:
221)[13]

But can we extend this proposition to contemporary western painting? In this essay, I have argued that life gets into painting through what Peirce has termed the 'dynamic object'. If we accept that the index stands in dynamical relation to its object, I believe that we can argue that a painting can become more than the medium that bears it. Further, I want to assert that this materialization involves a mutual reflection rather than a one-way causality. In bringing Deleuze's notion of flexion to bear on the matter, I would like to propose that in creative practice there *can* be a mutual reflection between bodies and language. In the performativity of flexion, the body writes and is simultaneously written. In this way, I would argue that just as life gets into images, so imaging also produces reality.[14] According to this proposition, the material practice of painting can transcend its structure as representation and, in the dynamic productivity of the performative act, produce ontological effects.

CONCLUSION

So what might the performativity of flexion actually look like in the making of work and what might be its consequences? The mutual reflection between bodies and language is most famously explored in Oscar Wilde's novel *The Picture of Dorian Gray*. Dorian Gray's Promethean wish that he should stay forever young whilst the image of him grew old, ushered in a chain of events in which the image of Dorian transcended its own structure as representation in a radical performativity:

Surely his wish had not been fulfilled? Such things were impossible. It seemed monstrous even to think of them. And, yet, there was the picture before him, with the touch of cruelty in the mouth.

(Wilde 1980: 34)

Dorian Gray's face remained untarnished and untouched whilst the 'face' on the canvas came to 'bear the burden of his passions and his sins'. (Wilde 1980: 78)

However, it is the musings of artist Basil Hallward, on the process of painting Dorian Gray's portrait, that have provided me with the key to setting forth a thesis on the dynamic productivity of painting. He observes:

Whether it was the Realism of the method, or the mere wonder of your
own personality, thus directly presented to me without mist or veil, I
cannot tell. But I know that as I worked at it, every flake and film of
colour seemed to me to reveal my secret. I grew afraid that others would
know of my idolatry. I felt... that I had told too much, that I had put too
much of myself in it.

(Wilde 1980: 94)

Through the double transgression of flexion, Hallward had put
too much of himself in the picture and, in doing so, he had put
his being in jeopardy.

But what can a work of fiction tell us about the work of fact?[15]
In 1993, in an exhibition subtitled *Drawing as Performance*, I
set up in a gallery space and drew people as they came in. The
exhibition began with a pristine whitewashed gallery space
(walls, window, floors). Over the five-week period of the
exhibition, this space took on a rich palimpsest as people came
and sat for their portraits, stood around watching and talking or
joined in drawing. At one level, there was nothing radical about
this process. Pavement artists are engaged in this spontaneous
activity on streets throughout the world. However, a photograph
taken during the exhibition confirms Hallward's realization that,
in the process of making the work one can give too much of
oneself away. (fig. 3) In the double transgression – of language
by flesh and flesh by language, *I* collapsed into the work. Every
flake and film of charcoal seemed to betray some part of me. I
was becoming other.[16] In this de-formation, I became a
passageway through which my sitter(s) entered into the drawing.
As they came back and took away their drawings, some part of
my being was also taken away.

In 'The Origin of the Work of Art', Martin Heidegger remarked
that the 'artist remains inconsequential as compared to the work,
almost like a passageway that destroys itself in the creative
process for the work to emerge'. (Heidegger 1977b: 166) In the
creative act, the painter no longer sets the world before her/him
as an object, but rather allows a total openness to the being of
art, that is the *work* of art. This openness is expressed in
Cézanne's claim that the 'landscape thinks itself in me... and I
am its consciousness' (Merleau-Ponty 1993: 63) and in Petyarre's
observation that the 'old women are also holding their country

as they dance'. (Voight 1996: 221) In this way, I believe we can begin to understand that painting is a performative not a representational practice.

Figure 3: Barb Bolt, Drawing as Performance, *1993, black & white photograph. Courtesy of the artist.*

NOTES

1. Martin Heidegger offers one of the clearest explications of representation. According to Heidegger, to represent (*vorstellen*) is 'to set out before oneself and to set forth in relation to oneself. Through this, whatever is comes to a stand as object and in that way alone receives the seal of Being'. (Heidegger 1977a: 132) For Heidegger, representation – or representationalism – produces a relationship where, whatever *is,* is figured as an object for man-as-subject. According to Heidegger, this relation is characterized by the will to fixity and mastery. It is this objectification of what *is* by man-as-subject (*subiectum*), that has become the central focus of the critique of representation, in contemporary times. Given the commonly held view that painting *is* a representational practice, this representationalist critique can be extended to include painting.

2. I wish to acknowledge the contribution of Estelle Barrett to this paper. In addition to her patience as a sitter, her observations on the process and subsequently on the paintings have been invaluable in helping me formulate the propositions presented here.

3. In *Bodies That Matter: The Discursive Limits of Sex* (1993), Judith Butler brings together the terms performativity and materialization. In her theory of performativity, Butler is concerned with the way that the performative speech act brings into being that which it names. In her elaboration of performativity, she argues that materialization emerges through performance. Performativity is a 're-iterative and citational practice by which discourse produces the effects it names'. (Butler 1993: 2) While her project specifically addresses the way in which sex and gender are materialized, there are parallels between this and the way in which 'art' becomes materialized. See Bolt (2000) 'Working hot: materializing practices' for an extended discussion of the possibilities and limits of applying Butler's understanding of performativity and materialization to an understanding of art practice.

4. Krauss's article 'The Im/pulse to See' (1988a) explores the pressure on or pulse in the seeable.

5. All references to the *Collected Papers of Charles Sanders Peirce* (1931–58) are identified by the volume and paragraph number.

6. See Deleuze's writings on the logic of sensation in *Francis Bacon: Logique de la Sensation* (1981) and 'Francis Bacon: The logic of sensation' (1989).

7. Jonathon Culler (1975) has renamed Peirce's symbol as the *sign proper*. In this redesignation, there is recognition that both the icon and the index have qualities that exceed the sign as commonly understood.

8. Francis Frascina (1975) provides a perspicacious semiotic reading of some of Picasso's collages, including a reading of *La Suze* (*Glass and Bottle of Suze*, 1912).

9. Voight (1996) discusses this impetus in relation to the work of contemporary Australian women artists.

10. For a discussion of this difference see Rosalind Krauss's (1988b) article 'Notes on the index: seventies art in America' and Georges Didi-Huberman's (1988) article 'The index of the absent wound (monograph on a stain)'.

11. Roland Barthes' notion of the *punctum* in photography finds its correspondence in painting, in Mieke Bal's (1991) elaboration of the navel.

12. In an article entitled 'Shedding light for the matter' (2000), I elaborate Carter's understanding of *methektic* performativity in relation to indigenous Australian cultural practices.

13. Through this discussion we may begin to understand why and how painting plays a critical role in the maintenance of country and Dreaming for indigenous Australians.

14. Advertising operates according to a logic that imaging produces reality.

15. The distinction between fact and fiction becomes problematic if one accepts imaging produces reality.

16. It could be argued that mimesis involves the ability to become other.

CHAPTER 3

WALKING WITH JUDY WATSON
Painting, politics and intercorporeality

Marsha Meskimmon

DIALOGUE: *LOW TIDE WALK*

In June of 1990, the artist Judy Watson, accompanied by her mother, grandmother and other family members, travelled to Riversleigh Station in northwest Queensland to learn more about her indigenous Australian heritage as a descendant of the Waanyi clan. Like many indigenous Australians of her day, Watson's grandmother, Grace Isaacson, was taken away from her family at Riversleigh Station in a brutal and misguided attempt to assimilate the indigenous population into the settler community. The 'Stolen Generation', as these forcibly removed children came to be known, left a potent legacy of displacement throughout Australia, and many of their children and grandchildren have sought to regain a sense of community and belonging by returning to the places from which their ancestors were taken and where their more distant kin still remain as caretakers of the land.

These journeys back should not be mistaken for naive attempts to restore the past intact or to find an essential identity or point of origin. Rather, those indigenous Australians who lost their connection with clan and country through the violence and misplaced paternalism of colonial settlement, travel back to their people and places in full awareness of change. Indeed, Judy Watson's journey is a case in point. As an urban Aboriginal artist, Watson's work is embedded in the contested sites, histories and knowledges of post-contact Australia and, prior to her 1990

travels in northwest Queensland, she had already explored the politics of Aboriginality in her art, focusing especially upon cross-cultural concepts of gender, identity and visuality. Tracing her matrilineal connections to Riversleigh Station and the important sites of Lawn Hill Gorge and Louie Creek was a personal journey and a political act, made in the recognition that there could and would be no prelapsarian 'home' awaiting her. As she wrote in 1993 of this extraordinary trip:

I listen and hear those words a hundred years away

This is my Grandmother's Mother's Country

it seeps down through blood and memory and soaks

into the ground

(Watson in Boomalli 1993: 30)

Watson made a series of paintings charting her experiences in Waanyi country entitled *under the bloodwood, looking*, of which *low tide walk* (1991) is one. (fig. 4) A large work on unstretched canvas (191 x 130cm), *low tide walk* was produced at the interface of land and body, both literally and figuratively. Laying the untreated canvas on the ground, Watson rubbed powdered pigment into the fabric, this very physical act recalling the ritual use of ochres by indigenous Australians to mark their bodies and delineate sacred ground. Layers of washes made stains across the pigmented surface and soaked into the canvas, creating evocative pools of 'blood and memory', the canvas itself bearing the indelible intertwining of body and place. The wet cloth traced the contours of the ground as it dried, picking up the impressions of grasses, leaves and seeds and turning the painting into a subtle, three-dimensional form with its own corporeal topography.

If *low tide walk* materialized the inevitable entanglement of body and land, it also invoked powerfully the physical passage of time and history. *low tide walk* is like the undulation of sand at low tide, described by the action of water through time. Concentrated and dissipated pools of pigment and charcoal suggest 'place' as mutable and evolving, the effect of continual, but by no means unidirectional, processes of change. The two sets of dotted lines (one in white, the other in black) overlaying this

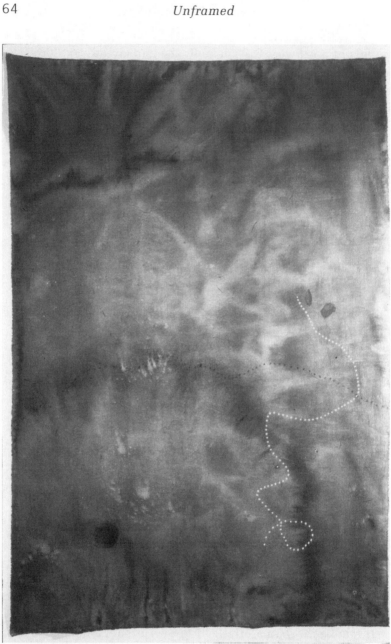

Figure 4: Judy Watson, low tide walk, *1991, mixed media. Courtesy of the artist.*

contingent history of site inscribe walkways, memories, bodily engaged. Again, the lines refuse a straightforward path and circle back upon themselves, crossing and weaving their tale. As Victoria Lynn observed, the abstract paths of these dotted lines potentially describe more than one memory from this old land:

The white dots may innocently invoke the image of the fishing net being cast into the water, a daily routine that is bound up with notions of survival. On the other hand, it can suggest a noose, and by implication, makes reference to Aboriginal deaths in custody.

(Lynn 1996: 8)

There is no answer, in the singular, to the narrative references in the work – they evoke both the empowering connection of indigenous Australians with their traditional lands and the devastating fact of the colonial past, marked by genocide and dereliction. As Hetti Perkins argued so effectively, Judy Watson's art holds these two forces in dynamic tension precisely by encoding histories and sites in the processes of a vital, painterly practice (Perkins 1998: 17) and it is this painting practice which compels me to further explore elements of her art-making here.

Watson's work is well known, both within Australia and internationally, and critical attention frequently focuses upon its relationship to questions of Aboriginality, authenticity and abstraction. Clearly, these categories are interrelated; discussions of Aboriginality and contemporary art practice often hinge upon issues of authenticity and appropriation, while explications of the role of indigenous mark-making techniques and patterning in twentieth-century Australian art usually contend with the significance and cross-cultural definitions of 'abstraction'. (Ryan 1997; Thomas 1999) *low tide walk* thus participates in a corporeal mapping process, through which multiple investments in body and place begin to find visual form in the contested histories of abstract painting itself.

In attempting to understand Watson's particular intervention into these debates, adherence to a limited oppositional paradigm is stultifying. That is, defining the work of urban Aboriginal artists as 'inauthentic', operating in opposition to the 'authenticity' of their rural counterparts, simply misconstrues the complexity and political engagement of their practices in

favour of a Eurocentric conception of the 'tribal' as an eternal, unchanging essence. Similarly, applying the binary logic of abstraction vs. realism to work made in the contexts of indigenous narrative, symbolism and visuality, artificially imposes a system through which the art is rendered insensible or even invisible.

Critics have been quick to demonstrate how effectively Watson's work confounds these simplistic categories and asks us to think differently about the interaction between Aboriginality, authenticity and abstraction. Vivien Johnson, for example, argued that it is not possible to define Watson's work as *either* a mode of postmodern appropriation *or* authentic Aboriginality, and it is time we moved beyond those limiting terms. (Johnson 1992: 239) In her article, Johnson also reiterated the significance of feminism to Watson's practice and reaffirmed the artist's woman-centred approach as crucial to her dynamic revision of static dualist conventions. As Lynn, too, contended:

Aboriginal women artists have only recently begun to receive their due attention. The Aboriginal Women's Exhibition at the Art Gallery of New South Wales in 1991 examined the strength and variety of work by women, and broke down the artificial divisions of tribal = authentic, urban = inauthentic.

(Lynn 1996: 12)[1]

The binary categories seen to be insufficient to think through Watson's (and other indigenous women's) compelling work, such as authentic/inauthentic, traditional/contemporary, modernist abstraction/postmodern appropriation, participate in a wider framework of exclusionary binary logic premised first on the mind/body, subject/object split. Given the privilege of masculine, Eurocentric cultural positions in this knowledge system, it is hardly surprising that the work of an indigenous woman artist, taking gender and Aboriginality as key themes, would come to counter its archetypal norms and forms.

Departing from the logic which delimits an empowered 'one' by negating its 'others', however, does not consist of reversing the terms of the opposition and unproblematically celebrating the excluded categories. That is, to collapse Watson's work into an essentialized, 'authentic', indigenous, female identity or to

assert the absolute equation of woman with nature, does not contend with the systemic limits of the oppositional paradigm itself. In fact, it runs the risk of reinforcing it, attempting to locate the 'authenticity' or finite meaning of Watson's practice in her biology, as if biology were an unmediated, pre-cultural reality, waiting to be revealed in paint. The nonsense of this goes beyond the fact that Watson is a descendant of both indigenous and settler Australians and that the histories of post-contact Australia are, by definition, about the mutability of power, nation and identity. The most damning element of this paradigm is the racist, sexist and intellectually untenable presumption that subjects are determined by a fixed relation to their biology, rather than brought forth in the complex interactions between biology, agency and society which constitute embodiment.

Acknowledging the embodiment of subjects and the situated-ness of knowledges is not new, but it is powerful. The concept of embodiment enables us to move beyond the mind/body, subject/object split and to mobilize difference productively. This has important political and conceptual ramifications for those subjects hitherto silenced and denigrated as 'other' and it reaffirms the potential of aesthetic interventions to make new knowledges. Therefore, the question raised so pointedly by works such as *low tide walk* is how to think of embodiment as it is materialized within a dynamic visual and material praxis and here, I would suggest, a useful strategy is to re-examine embodiment as *intercorporeality*.

Intercorporeality reiterates the processual nature of embodi-ment; embodiment emerges in processes of engagement with the world and is not, in itself, an object or 'thing'. This shift from object to process is subtle, yet important, in that it instantiates subjectivity as relational ('enworlded') and open-ended. As Gail Weiss put it, 'the experience of being embodied is never a private affair, but is always already mediated by our continual interactions with other human and non-human bodies. (Weiss 1999: 5) As I have argued elsewhere, embodiment, and indeed embodied subjectivity, cannot be represented as kinds of things, as bodily objects for instance, but rather are materialized in the visual by setting up the parameters for corporeal interplay.[2] In an important sense then, it does not simply picture Watson's 'Grandmother's Mother's Country', but emerges in and through

the processes of negotiation which took place between bodies, sites, histories, meanings and memories when Watson made this journey. The work is neither a representation of the land, nor of the embodied subject, if that implies that either the subject (Watson) or the locus (Waanyi country) was a complete and fixed entity *before* their encounter and remained so *after* it had taken place. Rather, the making of the work participated in the very practices through which Watson's embodiment and the site's manifold meanings were materialized in negotiation and engagement. Neither would ever be the 'same' again. These processes are the inverse of postmodern artistic appropriation[3] or assimilation, which assume that the 'other' is taken, consumed or ingested by the 'one', who maintains the privileged position of unity and transcendence throughout.

Working with the model of intercorporeal exchange instead, we can see Watson's work as a physical and intellectual dialogue with the site, an attempt to see what might otherwise remain invisible there and hear the long-silenced stories it has to tell. She does not 'conquer' the land as if it is empty or unused (a crucial component of settler logic as it contrived the myth of *terra nullius*), but uses art to engage with it. The works bear the hallmarks of their making processes, of their vital connection with the land, the bodily presence of the artist and the temporal span of the dialogue which opened between them. Watson's work is a convincing manifestation of the enworlding dialogues Donna Haraway argued were crucial to situated knowledge:

Accounts of a 'real' world do not, then, depend on a logic of 'discovery', but on a power-charged relation of 'conversation'. The world neither speaks itself nor disappears in favour of a master decoder. The codes of the world are not still, waiting only to be read... the world encountered in knowledge projects is an active entity.

(Haraway 1991: 198)

In Watson's hands, her 'Grandmother's Mother's Country' is just such an active entity, capable of participating in the power-charged relation this dialogue engenders around Aboriginality, history, memory, site and sexual difference.

But this dialogue goes further; *low tide walk* itself is one of the ('non-human') bodies which configure knowledges in

intercorporeal encounters. In the space of the gallery and within Watson's wider *oeuvre*, the painting makes connections with other 'bodies' and ideas in the world, with spectators, works of art, concepts of landscape, Aboriginality and the woman artist. *low tide walk* sets up conditions which bring us, as viewers, to our senses; visually, our mode of attention moves between surface and ground, vertical and horizontal, depth and breadth as we engage the work. Moreover, its three-dimensionality sets up a bodily and topographical tactility, a kind of haptic aesthetic, in which multi-sensory effects are produced through a non-objectifying, embodied mode of vision. (Fisher 1997; O'Connell 2001) While we do not actually touch *low tide walk*, we are made aware, through its unmistakable corporeality, of our sense of touch and its intimate connection to vision, a vision that does not introduce an objectifying distance.[4]

low tide walk counters the visual conventions deployed by those modes of landscape painting, cartography and urban planning focused upon the representation of territory as an object with defined boundaries. The mapping practices materialized by Watson's painting are, rather, deterritorializing strategies which emphasize agency, activity and temporality as the forces through which spaces are made meaningful. 'Seeing' such places does not simply entail recognizing their landmarks or reading the superimposed lines of geopolitical demarcation which cut them into manageable, nameable segments; *low tide walk* is characterized by its borderlessness, the absence of a singular narrative marking system and even of an objectifying name. The work is not called 'the' or 'a' or 'this' low tide walk, but instead invites us into the activity of walking, of mapping, of engaging in a corporeal dialogue with the extension and the depth of places, times and histories. In this way, the painting reiterates the specificity of embodiment as an intercorporeal exchange which is ongoing, relational and yet definitively located.

Taking the concept of embodiment seriously argues for just such processual, enworlding, non-representational accounts of the creative agency of art, its makers and its participant-viewers. In this specific sense, the compelling configuration of painting practice and embodiment in Watson's work can shed new light on questions of Aboriginality, sexual difference and the articulation of site, history and memory against the grain. It also

offers an opportunity to think more critically about cross-cultural exchange, politics and the potential for reconciliation in the future.

RECONCILIATION: *KOORI FLOOR*, CASULA POWERHOUSE

In 1994, Watson undertook the commission for the *Aboriginal* (or *Koori*) *Floor* at the new regional museum, the Casula Powerhouse in Liverpool, southwest Sydney. (fig. 5) The *Koori Floor* is, as the name suggests, a 'painted' floor piece; indeed, the work extends some 500 square metres to cover the whole floor of the main hall of the reclaimed power plant and to transform it, visually, into a community arts space.

Regional galleries in New South Wales play a key role in the life of their local communities and establishing a new art centre is an important economic, social and symbolic event. Thus, the Casula Powerhouse commission was a public acknowledgement of the significance of indigenous communities from the Georges River area to the history of the region and its continued cultural development in the future – it was, as Jo Holder recognized, part of the ongoing work of Reconciliation. (Holder 1995) Sometimes termed 'Aboriginal Reconciliation',[5] the process of bringing indigenous and settler Australians into full partnership as citizens of a shared land is an imperative, but complex, task.

I want to suggest that Watson's *Koori Floor* demonstrates both the complicated forms of negotiation which are necessary to projects moving toward Reconciliation and the potential of an aesthetic strategy premised upon intercorporeality to articulate these diverse, sometimes competing, interests successfully. The *Koori Floor* project not only brought conflicting sites, meanings, materials and visual languages into connection, it engaged the critical nexus between aesthetics and ethics such that the political implications of defining territory were refashioned productively.

Turning briefly to the work of Rosalyn Diprose will help to clarify the links I am making between ethics and aesthetics as they touch upon embodiment as process. Diprose's insights into the parameters of an ethics premised upon sexed specificity rather than universal first principles bear a striking resemblance to intercorporeal aesthetics. In her work, Diprose revisited the etymology of 'ethics' from *ethos* – 'dwelling', to emphasize the

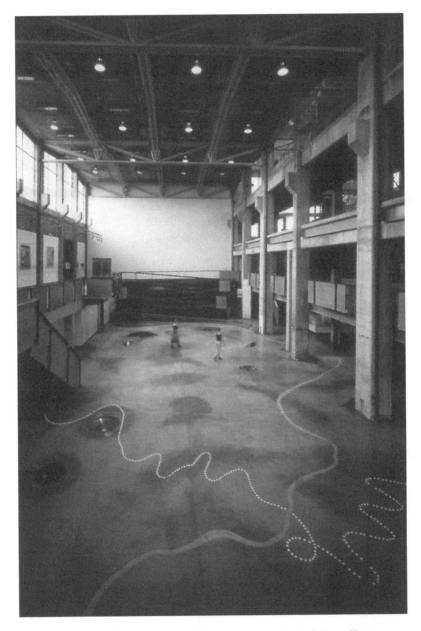

Figure 5: Judy Watson, Koori Floor, *1994, painted installation.*
Courtesy of the artist.

simultaneity of 'dwelling' as a noun (material locus), and as a verb (taking a position). This double play posits the ethical subject as always, already located but capable of intervening through that location: 'From this understanding of ethos, *ethics can be defined as the study and practice of that which constitutes one's habitat*, or as the problematic of the constitution of one's embodied place in the world.' (Diprose 1994: 19; italics in the original) Thinking in this way emphasizes relational agency in the world and the absolute significance of corporeal specificity and location – the map and the ethical activity of mapping.

Like *low tide walk*, the *Koori Floor* contends with Aboriginality, authenticity and abstraction differently, using the parameters of the site and the limits of a painterly practice to interrogate another form of map-making. The site of the Casula Powerhouse is a contested zone, part of the less wealthy (sub)urban sprawl of Sydney which, by the mid 1990s, had become a truly global city. The tensions which accompanied Sydney's world status emerged in the 1980s around corporate developments within the central district but, by the next decade, much energy and attention had turned to reinvigorating the decaying suburbs – either through problematic modes of 'gentrification' or by renewing community life.[6] In the midst of these changes, the question of Aboriginality loomed large. How could local indigenous groups play a part in marking important sites in and around Sydney when the region was already heavily inscribed by colonization, urbanization and the decimation of the Aboriginal population native to the area?

This question could be asked of much of southeastern Australia, where the violent eradication of indigenous people by colonial settlers was most marked and the changes to the contours of the land, through planning, construction, industrial development and even the importation of non-native plant species, were most thorough. However, the question being asked is actually a loaded one, premised upon that cliché which equates 'authenticity' with an essentialized, eternal, tribal identity. It presumes that urban (or, suburban) Aboriginal communities cannot but be debased, inauthentic and unable to provide a genuine voice in the polyphony that is Reconciliation. At its most reactionary, this position enables urban Aboriginal

contributions to the contemporary cultural life of communities to be ignored, while tokenizing 'authentic' indigenous perspectives (from regions far away from the urban centres of power) taken as representative of homogeneous Aboriginality.[7] Clearly, in the processes of Reconciliation, this opposition between Aboriginal authenticity and debasement, between tribal/rural and urban, is untenable and counterproductive.

The *Koori Floor* project provides a fascinating alternative to these debilitating arguments about Aboriginality and authenticity in the urban southeast. The floor painting does not simply return us, unproblematically, to a pre-contact past, nor does it connect Aboriginality to an essential identity. Instead, the *Koori Floor* negotiates the stratigraphy of the site as it makes meanings and histories in the present. The work acknowledges that this space is always already inscribed by competing discourses of community and knowledge and that Reconciliation is only possible when these are seen, heard and, I would argue, bodily understood.

Before embarking upon the work, Watson consulted with the three groups local to what is now Liverpool – the Gandangarra, Tharawal and Dharuk. This consultation process was crucial to the production of the work, demonstrating dialogue, partnership and a respect for the specific knowledges of the Georges River groups. Watson's people are not local to the region surrounding the Casula Powerhouse and the work is not intended as a sort of generalized 'Aboriginal' design. Watson's dialogues with local indigenous people were a public recognition of differences between Aboriginal groups, their specific relationships to places within Australia and their particular traditions, customs and understandings. The floor project, born of this dialogue in difference, acts as an articulation of the living knowledges of the local indigenous communities, sited within a contemporary cultural space.

This site is significant; Watson's massive artwork did not embed these living knowledges within an eternal past, but acknowledged their vital role within the shared space of contemporary art, culture and community. Neither the power station nor the floor painting are reified as relics of 'better' times now gone, of an edenic pre-contact Aboriginality or a Utopian progress narrative of industrial development. Their reconfiguration as the shared

past of this place, inscribed in the definitive materials and languages of the present, proposes Reconciliation as a form of assemblage in which the constituent parts are each prominent, but none primary.

For instance, the building itself bears the weight of its former use in the sheer physical presence of its great concrete pillars, huge, grated windows[8] and the extraordinary expanse of its main hall – a space which would have held the huge turbines of the power plant. However, the structure has been transformed into an art space through careful lighting, climate control devices and the stylish redeployment of its industrial features as hanging and viewing galleries. And, of course, the *Koori Floor* is an absolutely modern feature of the aesthetic regeneration of the power station, bringing traditional visual motifs and powdered pigments together with glass, bronze, aluminium, concrete and lighting to engender a mode of painterly abstraction as installation. Our ability to calculate the depth and breadth of the floor is complicated by the delicacy and detail of its painted surface. Depths are created by the ebbs and flows of muted, ochre-toned areas, the inset lighting features suggest islands in water or dunes emerging from sand, while the dotted line pathways come into view and fade away as rambling, linear effects. The physical presence of abstraction is emphasized by the *Koori Floor* and this again brings the modernity of installation, painting and this space into direct contact with the traditional visual languages of indigenous Australian art. By so doing, the *Koori Floor* mobilized multiple histories to configure the present, reconceiving the knowledges of indigenous Australians as utterly contemporary and of absolute relevance to the social and artistic life of Australia in the future.

This conjunction of materials and meanings *in situ* begins to define the work of the *Koori Floor* in thinking difference toward Reconciliation, but an even stronger case can be made in terms of the ways in which the floor project mobilizes aesthetics – sensory knowledges – in a non-assimilative ethical strategy premised upon embodiment as intercorporeality. I want to suggest that by walking *in*, rather than simply *on* the floor, spectators participate in a kind of borderless immersion which visually deconstructs the simplified boundaries between self and 'other' in the space. Moreover, the *Koori Floor* materializes a

shift from object to process, or from *the map* to *mapping*, such that the critical links between an aesthetics of radical difference and an ethics premised upon embodied subjectivity might be developed. Arguably, such a link must be formed if art is to have any part to play in the politics of Reconciliation.

Like *low tide walk*, the *Koori Floor* is a visual plane, which seems to exceed definitive boundaries or limiting framing devices. Indeed, this effect is exacerbated by the floor project – its sheer scale and tendency to meander across and around the vertical features of the main hall make it very difficult to obtain a single viewpoint on the work as a whole, bordered, entity. Moreover, as a visitor to the Casula Powerhouse, you are not offered this distanced, objectifying perspective on the piece, but rather the opportunity to move within its mutable contours and examine its undulating surfaces and depths with, in and through your own embodied encounter. There is no simple inside or outside to the work and no unidirectional guiding pathway; to 'see' the work, you must mobilize a range of sensory skills and participate within the very structure of the piece, entering into complicity with its potential meanings. These features of Watson's work are critical to the ideas it can engender and its aesthetic contribution to the development of participatory dialogues through intercorporeal exchange.

At the end of her essay on embodied subjectivity and situated knowledge, Haraway turned to the question of boundaries, vision and cartography thus:

Boundaries are drawn by mapping practices; 'objects' do not pre-exist as such. Objects are boundary projects. But boundaries shift from within; boundaries are very tricky... Siting (sighting) boundaries is a risky practice.

(Haraway 1991: 201)

Earlier in this text, Haraway also argued that, 'an optics is a politics of positioning' (Haraway 1991: 193) and asserted that practices which re-embody vision can help to construct knowledges based upon creative agency, rigour and re-sponsibility. The aesthetic strategies deployed in the *Koori Floor* go some way toward re-embodying vision and engaging in the practices through which boundaries are materialized. Even more

pointedly, I want to suggest that Reconciliation is also a kind of 'risky practice', determined to interrogate those processes through which debilitating boundaries have been drawn and to shift those from within. Reconciliation is by definition a 'politics of positioning', a self-reflexive politics, premised upon an awareness of the multiple interests and viewpoints of the varied constituencies within post-contact Australia who must be seen, heard and acknowledged as partners for the future.

The connections between Watson's borderless, visually immersive floor painting and the interrogation of boundary practices constitutive of Reconciliation's political strategies are not merely metaphorical. The aesthetic tactics deployed in the floor piece operate to bring diverse spectators into this contemporary community arts space as participants, embodied agents engaged in a form of dialogue with the site, its histories and its emergent future. The conjunction between bodies, knowledges and difference in and through situation as an intercorporeal process in this way describes both the physical experience of this 'painting' and the participatory ethics of Reconciliation.

An ethics that takes difference seriously cannot but contend with embodiment, situation and practice, those very features which conjoin the aesthetic strategies of the *Koori Floor* with the dialogic politics of Reconciliation. The ethical implications of Reconciliation's political agenda are precisely centred upon the practices, which constitute one's habitat, the projects through which boundaries are sited anew such that partnerships in and through difference might be forged. One critical forum for the articulation of such partnerships between differences is art. In its embodied engagement with the world and in its potential to create new and changing cartographies, it can effectively initiate connections between diverse subjects without obliterating their specificity. Watson's immersive abstraction, installed as the primary map(ping) of a contentious site intersected by competing interests, histories and knowledges, engenders the embodied participation crucial to Reconciliation. Its aesthetic and intercorporeal agency lends itself to productive encounters with diverse others, similarly seeking to walk *in* this space, *with* Watson, to constitute their embodied place in the world.

ACKNOWLEDGEMENTS

This essay was formulated and begun while I was Visiting Senior Research Fellow at the Humanities Research Centre at the Australian National University, Canberra and I would like to thank the staff and colleagues at the HRC for their generous support of my work and their great hospitality during my stay.

NOTES

1. I would also suggest that readers interested in the significance of women artists, both indigenous and non-indigenous, to art in Australia, seek out the work of Hetti Perkins, Catriona Moore, Joan Kerr and Dinah Dysart (among others), who have consistently documented and argued for women artists' key place in the histories.

2. Marsha Meskimmon (2003) *Women Making Art: History, Subjectivity, Aesthetics*, London and New York: Routledge – see Chapter 4.

3. I am very aware, as I write this, of a positive sense of the word appropriation, in which it is the term used to describe those key moments in the acquisition of subjectivity when human agency 'appropriates' or uses productively, the structures and materials of the given, prior, world. This use, however, is rare and is not the way the term is construed in the sources on appropriation and fine art practice. For this other, more productive, sense, see Buchanan (1999).

4. Rosemary Betterton described this kind of embodied look best with her phrase 'intimate distance'; see Betterton (1996).

5. The term 'Aboriginal Reconciliation' is now argued to be slightly misleading, since it seems to suggest that indigenous people need to reconcile themselves with the settler community, when the whole point of Reconciliation is dialogue and partnership. I am thus using the term Reconciliation on its own in this text.

6. Meaghan Morris has detailed some of the city centre concerns in 'Great Moments in Social Climbing: King Kong and the Human Fly' in Colomina (1992) pp.1–51. On the suburban community work, I am thinking, for example, of the debates around the redevelopment of Woolloomooloo Bay.

7. Melinda Hinckson, working in collaboration with the photographer Alana Harris and local Aboriginal community groups, has begun an important project documenting indigenous sites

throughout Sydney. This work contests the false dichotomy which associated urban living with 'inauthenticity'. I came to know of this work through Hinckson's seminar at the Centre for Cross Cultural Research, Australian National University, Canberra, 13 March 2002.

8. The windows were the keynote of another permanent site-specific project, *Christ Knows*, by the artist Robyn Backen. For further details of the origins of this project, see Backen (1999).

CHAPTER 4

SUSAN HILLER'S PAINTED WORK
Bodies, aesthetics and feminism

Rosemary Betterton

COMING OUT OF THE FRAME

I will paint *against* every rule I or others have invisibly placed. Oh, how they penetrate throughout and all over.

(Hesse, 28 October 1960)[1]

The American critic Rosalind Krauss has described Eva Hesse's wall piece, *Hang Up* (1966) as 'an enormous, empty picture frame, the site of a painting declared and defied at the same time'. (Krauss 1994: 313) Krauss takes this work to be evidence of a refusal, or an inability by Hesse entirely to abandon painting for sculpture. She suggests further that Hesse's work represents the 'optical unconscious' of painting, that which had been repressed within modernism, but continued to trouble, disturb and foul up its logic. (Krauss 1994: 24) Unlike the 'topology of self-containment' offered by a modernist painting, it describes an 'unformed body without organs', (Krauss 1994: 19) dispersed, provoking anxiety, potentially chaotic and threatening to the rational, unified self.[2] Krauss takes Hesse's piece to be representative of a significant moment, not only for Hesse herself, but for modernism, a point at which its rules were literally turned inside out, and one which marked the beginning of the end for painting. The feminist critic Lucy Lippard also identified *Hang Up* as a turning point, but she saw it as the beginning of something else

Unframed

– the prefiguring of the aesthetic concerns of feminist art practices in the 1970s.[3] What is at stake in these different accounts of endings and beginnings that *Hang Up* represents?

What Eva Hesse said about this work was this:

> It is a frame ostensibly and it sits on the wall with a very thin, strong, but easily bent rod that comes out of it. The frame is all cord and rope. It's all tied up like a hospital bandage – as if someone broke an arm… It is coming out of this frame – something and yet nothing and – oh! more absurdity – it's very, very finely done. The colours on the frame were carefully gradated from light to dark – the whole thing is ludicrous. It is the most ridiculous structure that I ever made and that is why it is really good.
>
> (Quoted in Lippard 1976a: 56)

So, for Hesse herself, *Hang Up* was absurd, it corresponded to her desire to make work that was 'something and yet nothing', and yet it was meticulously made, framing and unframing space with the utmost precision of coloured line.[4] Her ambivalence about the piece is suggested in its punning title: it is both literally hung up on the wall and witness to her own continuing 'hang-up' about painting. My own response to *Hang Up* is that, rather than provoking anxiety, it makes me want to step into the empty space – the eight to ten feet – released by the frame, as if I have been given permission to do so for the first time. These two elements, the use of a precise absurdity, which mimics yet subverts the rules of painting and the (unspoken) invitation to enter into the space of the work, suggest nothing less than a seismic shift in the aesthetic grounds of abstract art. If, in Jacques Derrida's terms, the function of the picture frame is to maintain the 'conceptual schema' (Derrida 1987: 65) that distinguish form from matter, art from non-art, then here the logic of the frame is disrupted: it is a frame that defines bounded space and yet has itself become the 'body' of the work.

In this context, the critic Michael Fried's account of the painter Frank Stella, describing his favourite baseball player in action in the 1960s, is peculiarly interesting in its gendered anachronism. As retold by Krauss, this description becomes a metaphor for the aesthetics of modernist abstraction: the disembodied eye (I) in the autonomous field of the visual:

In that speed was gathered the idea of an abstracted and heightened visuality, one in which the eye and its object made contact with such amazing rapidity that neither one seemed to be attached any longer to its carnal support – neither to the body of the hitter nor to the spherical substrate of the ball. Vision had, as it were, been pared away into a dazzle of pure instantaneity, into an abstract condition with no before and no after. But in that very motionless explosion of pure presentness was contained as well as vision's connection to its objects, also represented here in its abstract form – a moment of pure release, of pure transparency, of pure self-knowledge.

(Krauss 1994: 7)

Late modernist abstraction came to stand precisely for this 'motionless explosion of pure presentness', through which the disembodiment of painting occured.[5] In Stella's vision of the baseball player, painting is reduced to a single transcendent moment of meaning and, in the words of the influential advocate of modernism, Clement Greenberg, this 'in turn, compels us to feel and judge the picture more immediately in terms of its overall unity'. (Greenberg 1961: 138) Although Krauss does not remark on it directly, Stella's metaphor is doubly gendered, not only in its evocation of the very masculine playing of a baseball game, but in the concept of self-knowledge that is only achievable when, in an abstract state of transcendence, vision is removed from its 'carnal support'. The term 'carnal' here precisely evokes the multiple associations of fleshly embodiment that haunted abstract painting until the work of Eva Hesse literally opened it up to admit the female body with all its connotations of temporality, materiality and excess: 'In a period when cleanliness and straight edges were close to the godliness of success, Hesse... associated concreteness with touch.' (Lippard 1976a: 192)[6]

In an investigation of what 'comes out of' Hesse's unframing of painting, I want to explore the embodied subject of aesthetics in relation to the painted works of Susan Hiller. These two artists are connected at the historical moment in which a critique of modernist painting developed alongside an emergent feminist art practice in the late 1960s and early 1970s, although I shall argue that this also marks a key difference between Hesse's and Hiller's positioning as women artists.[7] It may seem perverse to

base my claims on Hiller's painting, since she is best known for her extensive work in new media, video and installation, but it is to her transformation of practices of painting that I want to attend here. It was the encounter with minimalist and conceptual art in the 1960s, and with the women's movement, which gave Hiller a new language through which to speak. Between 1969 and 1974 she engaged in a variety of artistic activities including performance, group events and recycled works that became the basis of her subsequent practice.[8]

FROM TOMB TO ARCHIVE

Figure 6: Susan Hiller, detail of Painting Blocks, *1973–84, oil on canvas, dimensions as printed on the block. Courtesy of the artist.*

In a series of works called *Painting Blocks* begun in 1970/71 and completed in 1984, Susan Hiller cut up her own earlier

paintings and remade them as ten sewn blocks. While Hiller's work is conceptual in its use of series and a minimalist aesthetic, it has a strong material presence. It returns painting to one of its basic premises as a 'nomad art' made of portable sewn cloth or paper.[9] Neither painting nor sculpture in any conventional sense, the rough and frayed bundles retain certain characteristics of paint on canvas, but appear to be more like three dimensional stitched 'books', with the dimensions of the original painting and dates printed on their covers. While the transformation from painting to block implies a diminution of scale, in this process, the surface becomes a mass, which retains the dimensions of the original. (fig. 6) Hiller has commented of these works:

> By moving my own works into another state of being, I allow them to participate in life, instead of curating the work as though it were entombed in a museum. There is also a hidden psycho-political agenda: these works express my interest, at a very deep level, in the tactile quality of vision, in 'touching with the eyes'.
>
> (Hiller quoted in Brett 1996: 16)

So, what is invested in this transformation from painting to block, from looking to touching, and from tomb to archive? What relationships of paint and touch, space and spectatorship, memory and loss, are mobilized to engage the viewer by non-figurative means?[10]

My desire to 'see' *Painting Blocks* as paintings is frustrated, because the painted surface of the canvas remains hidden. However much I try and catch a glimpse of their coloured interiors, I can only recover their meaning *as* paintings through the tactile qualities of the rough fraying canvas and the date and dimensions given in stark print on the surface of each block. As a viewer, I am engaged in deciphering the relations between the visual and the tactile in which ideas of duration and 'touching with the eyes' are made explicit. This kind of viewing is neither disinterested nor instantaneous, as Greenberg suggested, but is directly dependent upon the embodiment of the viewer. *Painting Blocks* evokes an affective response that is situated in the reciprocal relations between vision and touch. And, if the work is seen not only as an *object*, but also as part of an intersubjective 'event' that needs a viewer who can move in

space rather than a disembodied eye to complete it, then it signifies a more complex relationship involving two beings. The art theorist W.J.T. Mitchell has suggested that pictures face us as subjects that confirm our presence:

Pictures are things that have been marked with all the stigmata of personhood: they exhibit both physical and virtual bodies; they speak to us, sometimes literally, sometimes figuratively. They present, not just a surface, but a *face* that faces the beholder.'

(Mitchell 1996: 72)

But such 'faciality' is in danger of remaking works of art in human form and ignores precisely how, as material *objects*, they interact with the viewer.[11] More helpfully, Jean Fisher comments that *Painting Blocks* involves:

an experience of *making* or *duration*, encompassing the act of viewing that reinstates a more interactive relation between art and the body... Its process is transformative; not loss of matter, but a change from one state of existence to another.

(Fisher 1994: 62)

The subject-object relation established between the embodied spectator and *Painting Blocks* involves an active process of decoding that not only requires the viewer to mobilize the senses of sight and touch, but to engage with how the work re-configures these senses in a new set of relationships. In ceasing to be paintings, the 'blocks' perform as objects – and such material-izations take time. The change from painting into block, from surface to thickness, and from vision to touch, requires the viewer to engage with the process of *remembering* what looking at a painting is like. It actively reinstates the experience of seeing over time that was disavowed within late modernist abstraction. Rather than only 'touching with the eyes', I arrive at seeing through a sense of touch, in what has become a complex set of relations between time, space, embodiment and memory.

In so doing, Hiller returns painting to something nearer its performative functions in pre-Renaissance and indigenous cultures, where it acts as a part of ritual, as a talisman or as a manual, conceived as being impermanent yet as having a

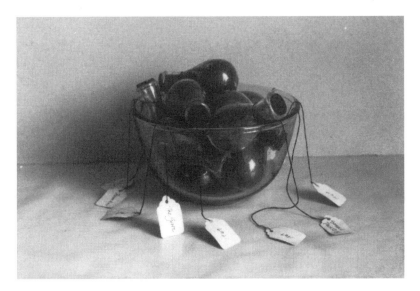

Figure 7: Susan Hiller, Hand Grenades, *1969–72, 12 glass jars, ashes of paintings, labels, bowl. Courtesy of the artist.*

presence and material effects in the world.[12] This ritualistic element in Hiller's work is evident in another recycled series, *Hand Grenades*, remade between 1969 and 1972, in which she set fire to previous paintings and kept their ashes in glass chemical containers as 'burnt relics'. (Hiller quoted in Morgan 1996: 35) (fig. 7) The transparent glass receptacles imply fragility and the handwritten labels, bearing the title and date of the former paintings, suggest impermanence and non-fixity: 'Like traces and remnants, they point forwards and backwards at the same time'. (Hiller quoted in Morgan 1996: 35) For if the ashes suggest mortality, the title of the work, *Hand Grenades*, also implies a violent rebirth: these glass memorials have explosive potential. Like the act of cutting up her canvases, Hiller enacts a violent material transformation on her paintings that also enacts a new moment of becoming. The critic, Yves-Alain Bois, has associated modern painting with the task of mourning, but suggests that this mourning need not be morbid once we believe in our ability to act in history: 'the desire for painting remains... this desire is the sole factor of a future possibility of painting, that is, of a non-pathological mourning.' (Bois 1986: 326) But, if painting is a form of mourning, what is 'it' that is being

mourned? Making painting, like writing, is a form of making that is also a transformative process. The crossed out word, the layering and repetition of brushstrokes always bears within it a material trace of the past. By recycling her paintings, Hiller allows her work to make a transition from entombment to 'another state of being'. She refuses to mourn their passing and, instead, implies that such 'remaindered' work can act as part of a new history. (Hiller 8.4.2000a) In her artwork, the subject is represented as being capable of change and renewal rather than mere repetition or mirroring.[13] Hiller's transformative practice does not offer consolation for loss, but enacts renewal through a practice of making and unmaking, remaking and reparation.

TRANSFORMATION AND TRANSACTION

Hiller has referred to retrospective memory as a 'transaction', not a simulation. (Hiller 8.4.2000a) By this I understand her to mean that her work of investigating and archiving cultural memory involves an active process of exchange with the past rather than a representation of it. Her 'archive' is an index of 'misunderstandings and ambivalences' that have emotional resonance in the present. (Hiller 8.4.2000a)[14] In works like *Dedicated to Unknown Artists* (1972–6), a collection of seaside postcards of 'Rough Sea', and *Fragments* (1978), based on shards of Pueblo pottery, she invents taxonomies for found objects, which combine rigorous formal ordering with a sense of openness and flux. These works anticipate the much larger ongoing project *At The Freud Museum*, begun in 1992, in which she uses archaeological collecting boxes as 'frames' for various found objects and representations such as divining rods, talismans, photographs or occult texts. These invite viewers to be active participants; like analysts or detectives we search for clues to decipher meanings and events. The connection Hiller makes between psychoanalysis as the investigation of the unconscious and archaeology as an investigation of the past is not fortuitous. Both offer a rigorous 'scientific' method for analysing the unconscious or the hidden.

These concerns are made explicit in the wide range of Hiller's work that combine painting or drawing with automatic writing in order to explore the marginalized speech of women. In *The*

Sisters of Menon, Hiller drew on an earlier project using automatic experiments, somewhere between writing and drawing that she had undertaken in France in 1972.[15] She subsequently lost the manuscripts until 1979, when she made a new work by putting them together in a cruciform layout of four L-shaped panels with additional 'translated' typewritten texts. The modular form of the work relates to the open-ended nature of the conversation between the barely articulated utterances of 'women' who are heard through the text:

who is this one/ I am this one/ Menon is (1)

Menon is this one/ you are this one (2)

I am the sister of Menon/ I am your sister/ the sister of everyone's sister/ I am Menon's sister (3)

I live in water/ I live on the air (4)

Menon can be transcribed as 'no men', but also as *nomen*, or name. (Lippard 1986: unpaginated) Hiller seeks a language to describe the self, or these multiply imagined selves, without resorting to the individual voice or celebrating an imagined feminine 'other'. The voices encompass a range of speakers that cannot be resolved into a singular identity. In the multiple voices of the *Sisters of Menon* – 'I', 'you' 'sister', 'everyone's sister' – there is no separation between the subject or object of speech, but rather a refusal of the fixity of self embedded in western ontologies. And, unlike paint on canvas, which acts as a skin that binds the surface, the handwritten and typed texts are more open and porous, without closure or resolution.[16] They enable a viewer to move in and out of the work and to take up other positions, even perhaps to lose her own sense of boundaries:

My 'self' is a site for thoughts, feelings, sensations, not any corporeal boundary. I AM NOT A CONTAINER... Identity is a collaboration. The self is multiple.

(Hiller 1983: unpaginated)

Hiller's statement resonates with strikingly similar comments on female subjectivity and embodiment in contemporary feminist philosophy.[17] For example, Christine Battersby proposes

Unframed

a model of '"Self"... capable of interpenetration by "otherness"'.
(Battersby 1998: 38) She suggests that we need to imagine
different metaphors for identity that would describe the
specificity of women in new terms:

> We need to think individuality differently, allowing for the potentiality
> for otherness to exist within it as well as alongside it. We need to
> theorize agency in terms of potentiality and flow. Our body-boundaries
> do not contain the self; they are the embodied self.
>
> (Battersby 1998: 57–8)

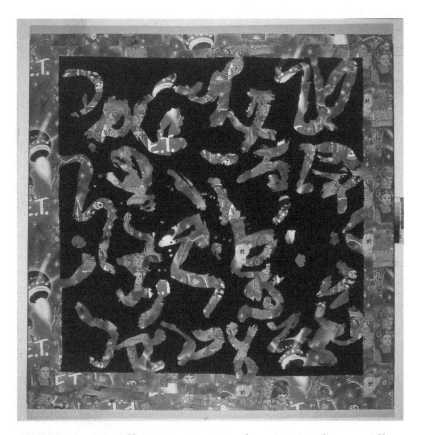

Figure 8: Susan Hiller, Extra Terrestrial, *1986, Ripolin on wall-
paper mounted on canvas; 56 x 56 ins. Courtesy of the artist.*

Just as Eve Hesse broke down the boundaries between self and object in her work, Hiller and Battersby describe an ontology in which selfhood is not singular, but co-constructed with otherness. One of the means by which Hiller redefines the limits of selfhood in her work is through an exploration of ways in which unknown or occult phenomena erupt into everyday life.[18]

In a series of paintings from the mid 1980s, *Home Truths*, Hiller combined figuration and abstraction to disrupt the 'topology of self-containment' offered by conventional pictorial space. (Krauss 1994: 19) Instead, the paintings suggest a shifting, liminal arena whose edges and limits are uncertain. In *Extra Terrestrial* (1986), a commercial wallpaper designed for a boy's bedroom is partly painted over with black Ripolin paint. (fig. 8) Inverting the usual spatial metaphor in which the unconscious lies 'beneath' the rational, Hiller invokes a female presence that covers and partially effaces the masculine stereotypical fantasy of Space Invaders. This shifting of the figure/ground relationship enables blankness to 'speak'. The negative spaces left unpainted appear like a script in an unknown language from the '"outer limits", the unspoken and out of control'. (Hiller 1996: xii) As in Freud's concept of *unheimlich* (the uncanny), it is the juxtaposition of the homely and familiar with the unknown and disturbing that disrupts our sense of security. Mieke Bal draws on Freud's work to argue for a practice of reading as an 'hysterical poetics... a search for the displaced, the unsaid, but often visible, sign of the unspeakable experience' in which 'the categories of the literal and the figural change places.' (Bal 1991: 63–4) Hiller's paintings enact just such a transposition between surface and ground, positive and negative, literal and figural, which point to the pressure of the unsayable from the dark side of the wallpaper.[19]

A similar set of interests is evident in Hiller's recent large video installation *Psi Girls* (1999), which expands beyond the confines of the static image into sound and movement. Hiller uses clips from American and European cinema, including Mark Lester's *Firestarter* (1983), Tarkovsky's *Stalker* (1979) and Danny DeVito's *Matilda* (1996), each of which depicts an adolescent girl who has the power to move objects by telekinesis. The scale of the five screens at full room height surround the viewer and their changing images, fluorescent colours and the physical

sounds, envelop all the senses. The scale of the installation 'places the viewer in the situation of [the] omniscient omnipotence of childhood'. (Hiller 8.4.2000b) As each girl begins to move objects, the tension builds and, at the same time, the soundtrack rises to a crescendo with the rhythmic handclapping and drumming of a gospel choir and then breaks, followed by the loud electrical buzz of an untuned receiver, and silence, before the cycle begins over again. As Hiller says:

the drumming and clapping of the church choir has a compelling rhythm... It has that kind of psychological effect: you almost feel it working on your blood pressure and your heart.

(Betterton 1999: unpaginated)

This synaesthetic use of colour, sound and movement engulfs the viewer in semiotic excess *within* the space of the work. Hiller does not use video as transparent medium, but in a way that evokes a physical and emotional response more akin to haptic art forms such as painting and sculpture. In her analysis of the visual erotics of video, Laura Marks has defined haptic perception as 'the combination of tactile, synaesthetic and proprioceptive functions, the way we experience touch both on the surface of and inside our bodies'. (Marks 1998: 332) The experience of *Psi Girls* is precisely that of being 'touched' simultaneously by the moving images and rhythmic sound that enter into the heart and blood. As in all of Hiller's work, we are invited to engage with the psychic and the embodied, the intell-ectual and the irrational, the internal and the external in ways that confound any neat distinctions between such categories.

I imagine an encounter between Eva Hesse and Susan Hiller, perhaps at La Guardia Airport in September 1965, Eva returning from Germany to New York via London, Susan leaving for Europe and further East. I think of the conversation that they might have had about beginnings and endings, memory and the future, the death of their mothers, loss and hope, paint and latex, string and thread, performance, art and women's coming liberation...

One of the recurrent themes in the work that I have described here is that of the temporal process of making, unmaking and remaking that remains deictically in the object itself: Eva Hesse

compulsively binding her frame like a broken limb; Susan Hiller destroying and remaking her paintings over again.[20] But if we see this 'remaindering' as a refusal to mourn the past so as to give it renewed agency in the present, then a key difference between Hesse's and Hiller's historical positioning as women artists becomes apparent. They are of the same generation, born in 1936 and 1940 respectively, but whereas Hesse, isolated within the male-dominated and conventionally gendered avant-garde circles of New York in the 1960s, could only enact a refusal of painting and make it 'something and yet nothing', Hiller, working as an artist within an emergent women's movement, was able to recast her painting in new terms, to make 'blankness' speak. Hesse was well aware of the multiple ways in which femininity inscribed her role: 'Woman, beautiful, artist, wife, housekeeper, cook, saleslady all these things. I cannot even be myself, nor know what I am.' (Hesse's diary entry, 4 January 1964, quoted in Lippard 1976a: 24–5) But she had no political language through which to articulate her position. Had she lived, she might, like Hiller, have made the engagement between her practice of art and women's politics.[21] In both cases, their work has played a formative role within the feminist critique of modernist painting. The work of Hesse and Hiller shows the complex relations between the material and the semiotic, time and the object and the psychic and the somatic that were beginning to be articulated within art at the turn of the 1970s. There is a need to remember the complexities of that historical moment in proto-feminist art before it is either forgotten or mythologized as a state of prelapsarian theoretical innocence.[22]

In this chapter I have described a practice and aesthetic of art-making that differs from the late modernist claim of 'no before and no after'. The procedures involved in making these works anchor them as physical matter that occupies space and with which we become acquainted through the senses of sight and touch. They are produced both as abstract and material practices that are dependent on a psychic and physical embodiment shared by the artist and her viewers. They can be perceived as enacted through time and as always necessarily incomplete, in the sense that the works continue to alter physically, and as their meanings change. Hesse recognized the fragility and physical degradation of her latex works over time: 'Life doesn't last; art doesn't last,

it doesn't matter.' (Hesse 1970, quoted in Lippard 1976a: 210)
This resonates with Hiller's later comment:

> In remaking my old paintings I wanted change, but everything changes
> inevitably... in other societies... sculpture is left to rot... We're differ-
> ent; we think if we can't keep a painting perfect, we'll have no more
> painting in future.
>
> (Hiller 1996: 34)

The life (and death) of painting is recognized and accepted in
both these statements as part of the very process of making new
art. Both artists have consciously used ritual and repetition,
wrapping, binding, layering, folding, in ways that recall the
domestic and feminine rituals, as well as some of the fears and
doubts that these may hold at bay. And, while such practices
have no intrinsic relationship to re-imagining the female subject,
by re-embodying vision in a set of intersubjective relationships,
they can lend themselves to the representation of different
topologies of self. These topologies do not image the female body
directly, but evoke it through material traces, voices, and actions,
which re-inscribe the body – with difference.

ACKNOWLEDGEMENTS

Earlier versions of this paper were given at the symposium,
'Uncommon Senses' at Concordia University, Montreal, in April
2000, and appeared in P. Florence & N. Foster (eds) (2000)
*Differential Aesthetics: Art Practices, Philosophy and Feminist
Understandings*, Aldershot: Ashgate. I am grateful to Deborah
Cherry and to Penny Florence for their constructive criticisms,
and to Susan Hiller for her generous permission to reproduce
her work.

NOTES

1. Eva Hesse's diary entry, quoted in Yale University Art Gallery
 (1992) *Eva Hesse*, New Haven: Yale University Press
2. Krauss draws on the work of Gilles Deleuze and Felix Guattari
 (1983) *Anti-Oedipus*, Minneapolis: University of Minnesota

Press, to sustain her argument about the 'body without organs'; see Krauss (1994: 315).

3. Hesse's work has long been regarded as a precursor of the concerns of feminist artists in the 1970s, particularly for her feminine practice based on the experience of a sexed body. (Lippard 1976a & b) She was profiled, along with other contemporary American women artists, in *The Feminist Art Journal*, co-edited by Cindy Nemser in the early 1970s. (Robins 2001: 203) Lippard included Hesse in her curated exhibition, *Eccentric Abstraction*, in New York in 1966. Lippard also wrote the catalogue essay for Hiller's 1985 exhibition at the Institute of Contemporary Arts, London, which was later reprinted as a preface to Barbara Einzig (ed.) (1996) *Thinking About Art: Conversations with Susan Hiller*, Manchester: Manchester University Press.

4. Briony Fer explores the idea of blankness in Hesse's work in Fer (1994). As Norman Bryson put it in a different context, something is 'missing, but what it is can never be named because it is precisely, absence.' See Bryson (1983: 71).

5. Krauss connects this statement with the final sentence in Fried's own essay on painting, 'Presentness is grace'; see Fried (1968: 147).

6. This is analogous to the claim made by W.J.T. Mitchell that the silencing or repression of language in modernist abstraction was shattered in the mid 1950s by Jasper Johns' *Flags* and *Targets* which marked 'the resurgence of artistic impurity, hybridity and heterogeneity summarized as the "eruption of language into the aesthetic field"'; see Mitchell (1994: 239).

7. Hiller trained as an anthropologist before she left the USA in the late 1960s and has continued to publish in this field, for example, her edited collection, *The Myth of Primitivism: Perspectives on Art* (1986). She settled in London and began her professional life as an artist in the early 1970s.

8. See Tate Gallery Liverpool (1996) *Susan Hiller* for an overview of her work.

9. Many of Hiller's earliest works are of this type, including 'Cloth books' (1971), '*Sisters of Menon* sewn canvases' (1972) and 'canvas and paper formats' (1974); see Kettle's Yard and Museum of Modern Art (1978: 34).

10. I am using the term 'viewer' rather than 'spectator' to avoid this more distanced form of the gaze: 'looker' would be more accurate, but less grammatical. Norman Bryson argues 'glance' rather than 'gaze' implies a less authoritarian viewing position,

but this does not suggest the act of looking over time that I describe; see Bryson (1983).

11. Patricia McCormack also warns that the concept of 'faciality' can obscure the power relations involved in the choice of *which* faces are represented and *how* they face the viewer; conference paper given in Bologna, 29 September 2000.

12. Hiller developed an enduring interest in indigenous cultures from her early field research as an anthropologist in Central America in the 1960s. See also the chapters by Barbara Bolt and Marsha Meskimmon in this book for interesting discussions of performativity in the context of indigenous Australian art practices.

13. Hiller's re-use of her own earlier paintings can be contrasted with that of the younger British artist, Tracey Emin. In a work entitled *My Major Retrospective (1982–92)*, Emin reproduced her own early paintings as miniature photographs, which she exhibited on shelves as a new artwork shown at the White Cube Gallery in 1992. Whereas Hiller destroyed and re-made her paintings, allowing them to 'participate in life', Emin recorded hers as a kind of ironic *memento mori* enshrined on the gallery wall.

14. Lauren Berlant comments on the significance of her own archive on contemporary American life as follows: 'These materials frequently use the silliest, most banal and erratic logic imaginable to describe important things, like what constitutes intimate relations, political personhood and national life.' (Berlant 1997: 12).

15. See Tate Gallery Liverpool (1996) for a fuller account of Hiller's experiments with automatic writing and drawing.

16. These observations are similar to those made by Deborah Cherry in a paper on Zarina Bhimji's installation, *She Loved to Breathe – Pure Silence,* 1987, at the Association of Art Historian's Conference, Liverpool, April 2002.

17. These concerns are evident in the writing on feminist philosophy by Elizabeth Grosz (1994) and Moira Gatens (1996) in Australia, and Iris Marion-Young (1990) and Judith Butler (1993) in the USA.

18. For example, *Belshazzar's Feast/The Writing on the Wall* (1983–4), and *Magic Lantern* (1987).

19. This reminds me very much of Charlotte Perkins Gilman's short story *The Yellow Wallpaper* (1892/1981), in which the woman narrator who is being forcibly treated for depression 'sees' the figure of a woman trapped within the pattern of the bedroom wallpaper.

20. Examples of similar practices include the painter, Lee Krasner, who cut up her old drawings and re-made them as collages in the 1950s, and Helen Frankenthaler who let paint flow and stain unprimed canvas on the floor emphasizing the tactility of the medium. The contemporary painter, Avis Newman, also uses methods that suggest an open-ended process of making and unmaking over time, of touching and re-touching. Newman's *Webs (Backlight)* (1993) uses a process of layering and repetition of marks each of which, while partially obliterated by another layer of paint, remains visible underneath like a material trace of the past; see Newman (1997).

21. Hesse recorded the strong impression made by her reading of Simone de Beauvoir's *The Second Sex* (1949/1983) in her diary. She was aware of the gendered prejudices of her own time against women artists, but did not take any part in the emerging women's art movement in New York. (Lippard 1976a) Like Sylvia Plath, Hesse's early death has bestowed on her the aura of tragic, misunderstood genius, rather than as taking part in a sustained tradition of female authorship.

22. Several recent studies have begun to recover the complexities of art by women in this period, which because of its timing was not previously 'read' as feminist. See L.C. Jones (1993) 'Transgressive Femininity: Art and Gender in the Sixties and Seventies', in J. Ben Levi, C. Houser, L.C. Jones and S. Taylor (eds), *Abject Art: Repulsion and Desire in American Art*, New York: Whitney Museum of American Art; and S. Watling (1998) 'Pauline Boty: Pop Painter', in S. Watling and D.A. Mellor (eds) *Pauline Boty: The Only Blonde in the World*, London: Whitford Fine Art & The Mayor Gallery Ltd.

CHAPTER 5

THE SELF-PORTRAIT AND THE I/EYE

Partou

There is a solitude of space

A solitude of sea

A solitude of death, but these

Society shall be

Compared with that profounder site

That polar privacy

A soul admitted to itself –

Finite infinity.

<div align="right">(Emily Dickinson, poem 1895)[1]</div>

The self-portrait of a female painter is an attempt at re-addressing the imaginary of the feminine, a visual retort to the question posed by Frances Borzello: 'What is an artist?' (Borzello 1998: 27) Who is this *She/Painter/Artist* amidst the already histor-icized map of the male-dominated art world? In practice, she may be regarded as 'good enough', however, set against social mores and economic structures, the female artist is regarded as an anomaly to the norm. At best, the female artist was seen as a 'prodigy', and at worst 'a grotesque transgressor of womanliness', never living up to her male counterpart 'as the mad genius, the outlaw or the mystic'. (Borzello 1998: 30) I, like so many women artists, need to rewrite that image. The text of the active female

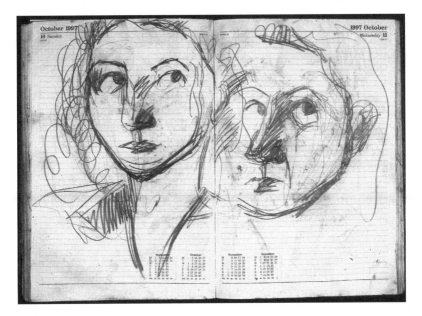

Figure 9: Partou, Self-Portrait Drawings (two heads), *1998,
pencil on paper, old diary, 30 x 43 cm. Courtesy of the artist.*

critically situating and imaging her own imaginary and true
potential is the task of this reconfiguration of discovering who/
what the artist is. The person working in the studio, producing
images that are fed into the cultural mainstream of our ideas
and concepts is given to us as male: man the maker. Rewriting
the visual text of the I/eye that looks at the female body is central
to my own methodology within the medium of paint, via the
genre of the self-portrait.[2] Two eyes stare back at a familiar
reflection in the mirror, encountering another pair of eyes.

With whose/which Eye do I see me/myself?

The: Sexual Eye

 Political "

 Corporeal "

 Social "

 Historical "

 Religious "

The self-portrait genre as an embodiment of a (gendered) body, as the image of an artist *without* the appendage of clothes, is the site in which I find appropriate expression: a body in action, a being preoccupied with its own recognition, not merely accepting of a 'likeness', even though the traditional mirror reflection is the process used.[3]

These paintings are the autobiography of a naked body; making a statement of Self, as woman and artist, via the awkwardness of holding the ancient tools of painting in hand: a naked female body stating *herself* in paint. This is a specific female body. She is not merely an element in a painterly gesture; repeated yet again as the predicate of a pictorial subject that has for so long been associated with the expressive repertoire of the male artist. From as far back as the pharaohs of Egypt, there are examples of artists whose self-portraits make a visual gesture towards establishing their identity. The body as a place, via the depiction and use of which the female artist can begin to situate herself as an authoritative subject is part of the import-ant and radical theories current in recent feminist thinking:

Seeing that the subject's consciousness or interiority, its essential humanity or unique individuality, can no longer provide a foundation or basis for accounts of identity, it is appropriate to ask whether subject-ivity, the subject's relations with others (the domain of ethics), and its place in a socio-natural world (the domain of politics), may be better understood in corporeal rather than conscious terms.

(Grosz 1995: 83–4)

Irigaray's delineation of woman's pleasure as non-scopic is in a way extended by these paintings. Not only do I look with self-pleasure and curiosity at my body, face, hair, but also I touch this body seen in the mirror by painting it on the surface of the canvas/panel; using brushes and my hand to shape this image in paint is itself a double pleasure. I observe a woman in the mirror, actively taking her 'pleasure more from touching than looking, and her entry into a dominant scopic economy' which would signify 'again, her consignment to passivity'. (Irigaray 1985: 26) This is shifted, and intersected by my eye, a woman's eye, actively seeking 'her' in the mirror. Here, in the sensuality of pigment and colours, she is not consigned to mere passivity,

her beauty becoming, in my hands, as woman, an altered 'object of contemplation', (Irigaray 1985: 26) making of 'her' a subject of one/she-who-is-*whole*-in-and-with-herself. The image of the woman in the mirror represented in paint on a piece of canvas or board, makes mimesis a tangible negation of the ludicrous notion that asserts woman's sexuality as being constructed on the premise of a 'lack':

> To play with mimesis is thus for a woman, to try and locate the place of her exploitation by discourse, without allowing herself to be simply reduced to it. It means to resubmit herself – inasmuch as she is on the side of the 'perceptible' of 'matter' – to 'ideas' in particular to ideas about herself, that are elaborated in/by a masculine logic, but so as to make 'visible' by an effect of playful repetition, what was supposed to remain invisible: the cover-up of a possible operation of the feminine language.
>
> (Irigaray 1985: 76)

The image of me naked is not some idea of 'femininity', but the experience of a 'real' female body seen in the active process of observing, drawing and painting a conscious image of *her*-spiritual-*self*-through-*her*-corporeal-*self*. This is *She*-the-artist as woman, not trying to be polite or genteel, but un-self-conscious, anxious, deft, unsure, playful and completely engaged presence. I stand in the nude, and not denying the sexualised view from which these paintings can be read, I challenge the feminine role by exploring the very thing that has been subject of exploitation: passive wordless misrepresentation in the hand of the male artist looking at his female model. I am active. I make my own image. I move. I create, perform and paint with sweeping gestures. Self-engrossed, I celebrate and analyse and stare, making myself the central subject of a universal biography of woman's body within the masculine tradition of the active eye, and decisive hand.

I am not only dealing with my sexuality painted *as* a woman, but I am trying to reassert the social-gendered I/eye, that has always been focused from the male towards the female. Woman has come to be visually representative not only as the agent of masculine-erotic imagination, but also the symbolised notions of nature, home, revolution, justice, war, peace, through a catalogue of socialised symbols. I want to forego such pre-

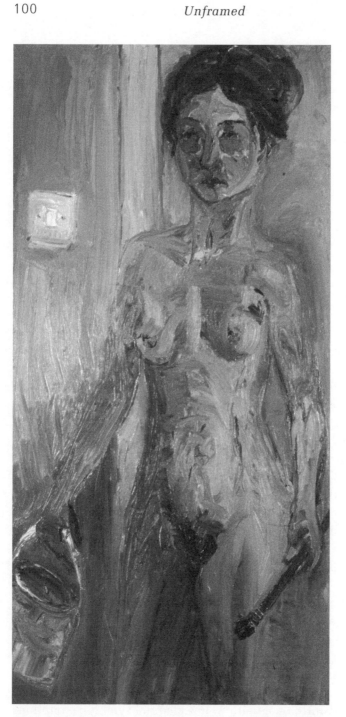

Figure 10: Partou, Standing by Wall – Self-Portrait With My Hair
Up, *1999, oil on canvas, 176 x 72 cm. Courtesy of the artist.*

determinates, and paint myself as a woman situated within the gendered-ego of the female I/eye, scrutinising the female form and position. I read 'her' as I am read myself: both as a woman and as an artist. It is a political and an intimate project, being active in the process of painting 'her'. The clothes that hide and distort, placing one/her into a framework of reference are stripped off. Despite her vulnerable flesh she moves and gesticulates, refusing to stand inactive.

Indifferent one, keep still. When you stir, you disturb their order. You upset everything. You break the circle of their habits, the circularity of their exchanges, their knowledge, their desire. Their world. Indifferent one, you mustn't move, or be moved, unless they call you. If they say 'come', then you may go ahead. Barely. Adapting yourself to whatever need they have, or don't have, for the presence of their own image. One step, or two. No more. No exuberance. No turbulence. Otherwise you'll smash everything. The ice, the mirror. Their earth, their mother.

(Irigaray 1985: 207–8)

She watches herself watching herself: taking note, and making a catalogue of psychological moments; emotion going beyond the recognisable being centred more on the day's weather in one's heart and mind. These are geographical notations of an interior world: here is doubt, there bravado, over the way lies a stretch of fear, coloured by a horizon of hope. The psychological self showing in the posture and position of the figure depicted in the composition gives a resemblance of a body recognised as gendered and maybe, in some specific feature, as having a personality. These portraits are (about) the *colour* of self seen in private, and bravely presented to the other of the viewer, in public.[4]

My project is to establish the painter *as* female, *as* active, *as* sexualised and *as* gendered in her difference.[5] She is powerful in her studio: in her own representation as self-reflective of the wit and depth of her psychological position. She does not accept the Freudian/Lacanian concept of woman = lack. On the contrary, it is a concept of woman = creative independence. The paintings are abundant: the edge of canvas or panel filled with the flesh and energetic movement of my body in a decisive moment of action. The objects all relate to my needs and my textual commentary: the postcard, light switch, light bulb,

doorway, chair and other artefacts observed within the studio space. They are an aspect of my archaeology as an artist working in a studio where the history of art, and minimal reference to some kind of contemporary technology is recorded and used as my prop or point of reference. A woman in the twenty-first century, active in the ancient practice of painting, self conscious-ly aware of her philosophic stance and politicised responsibility.

These self-portraits aim *visually* to act as vehicles of re-commendation for women to speak as women, '*Parler leur sexe*'. (Irigaray in Whitford 1991: 173) These are not just paintings that enjoy their skill and sensuality of pigment and colour. They are deliberate statements structured out of the deep-seated need to speak from the female body, and with a female voice using drawing and painting as the essential ingredients and tools. My focus or true genre is to seek the wholeness of body and psyche, as potential in the '*I*' who is both woman and painter.

The poetry of the autobiographical experience is a mixture of the social, religious, geographical, racial, lingual and historical time. That is the domain of the dream, and the ancient intuitive self that shapes one's ontological map – an uncharted territory of the abstract self deciphered in a language at once both palpable and invisible – thus making a strange though cohesive text, that employs the noun of one's 'real' history and the consonants of a personal 'psychic' archaeology. I go beyond myself as woman, Persian, born from a Moslem-Jewish heritage, which at the same time denied me a religious upbringing, insisting on a Communist standard of world imaginary in politics as well as gender. I go also into the deeply intimate notions of a self who is those things cited above, and yet none of those things simultaneously. The meaning in my essential journey of becoming lies beyond the history of western art, the theology of the Bible, the Torah, the Koran, or *Das Kapital* for that matter:

Thus identities are not just plural (an ideal typical of post-modern indifference). They are historical complexes of textured difference... These are registers of historical and political affiliations and experi-ences which speak of the necessity to grasp persons as living, specific configurations of historical placement around deeply and mutually interactive categorizations – race, class, gender – which are never discrete totalities, but complex formations operative as much as the

level of psychic as of socio-economic constructions.

(Pollock 2001: 94–9)

I shadow my own gaze. Like a suspect, at once both suspicious and afraid of being discovered, I shadow myself in the mirror. Not only when I am still and staring, but also when I shift about the studio, catching myself in part reflected in the reciprocating gaze of the mirror. In the bathroom, broken at each corner by a mirror, not large enough to show me the whole body, I see my face, a shoulder, my belly and hair. Amidst this alliteration of fugitive shadows I wait and watch for a sign. Looking into the eyes staring back at me, I recall the childish excitement of an eleven year old, reflected in the walls of glass pushing a bulky trolley of suitcases, through the as yet partially constructed airport lounge of Terminal 4. I enter England, an unwilling émigré, brought here under the cunning pretext of an extended vacation. Where does that little girl connect to this adult woman of forty-something? My eyes caress my flesh-round belly, and memories of the foetus aborted fill the canvas with regret. I am always in the here, squeezed between the edge of canvas or panel and the wall opposite where a lightswitch winks, on and off. How does one hold a dialogue with a mute gaze in the mirror, with her who is naked, standing with paint-splattered knees, holding brushes greasy with congealed pigment? The picture postcard on the wall distracts my attention from the shadowy woman in the mirror. I am performing the act of painting a 'self-portrait'. I ask myself what this term – a portrait of the self – actually means. Is it a likeness or an imaginary idea of [a] *Me*?

The present speaks of my past and through that impossible and impassable avenue, where neither translation nor transcription are any longer viable forms of understanding a text, a different kind of My[his]tory occurs. An autobiography always creates a strange aura of impersonality, an open edged voyeurism into *every* biography wherein *You* and *I* are no longer margined out by our specific histories. The representation of the naked woman caught in the act of painting herself, in rich, fast gestural movements of colour and line, could be anyone at all; *any* woman. It is because painting and drawing function within their own alphabet and phonetics, that the process of making a painted image manoeuvres beyond and despite the Word. Through the

calligraphy of mark making (drawing), and the gesture of placing coloured pigment on a surface (painting), the Word is reinvented.

Autobiography through self-portraiture is a rewriting of histories. The self-portrait is a narrative of a reality already lived, but in part fused within the act of forgetting, which becomes reinvented into another layer of reality. In the antechamber of Memory resides Autobiography. Similarly, in the dark passages of seeing the reflected self, lurks the ghost of a self whose bold gaze coyly returns its rhetorical muteness: a mixture of the bold and the sly. This figure inhabits the non-space of the mirror. Here is the shadow of my own shadow, staring back in the confident knowledge that by stopping to notice 'her' in the mirror, I am obliged to confront *her* reality, as apart and perhaps independent from my own, who stands outside the mirror. She is the surprise hidden in the husk of the look. Every fleeting gesture a moment caught in the epic of seeing. If anyone were to enter on this meeting of 'her' and 'I', she would disappear. Our dialogue takes place away from a third person: It is the *you* and the *I*, whose disinterested and disengaged confrontation is an ambitious hope for a potential meeting between the *I* and the *thou*. Here, in the unfixed place between where I end and the mirror (*thing*) begins and she is reflected back (to me), rests the location of an extraordinary rendezvous. She is only alert when I look at myself: me looking at me. Then she stirs herself and without notice, as I turn to check the alignment of crown to navel, or distance between shoulder and right elbow, she's there gazing back, silent and patient. *Me* looking at *me*, looking at *me*, looking at *me*: I become a triumvir embodiment of three.

Corporeal Eye	=	My Body
Archaeological Eye	=	My Memory
Journal's Eye	=	My Reflection

The archaeological eye: h[I]story, is the seer who envisions me as both vividly alive and moribund, in my future potential as a corpse. The 'I' becomes truly palpable in the here and now, arrested in the lumps of paint, held in a frame, as when you look up and glance someone sitting in a window, nonchalantly gazing out beyond you into the street below.

Perhaps the self-portrait is always an effigy, a practice towards the realisation of the perfect representation bequeathed after one's death. As in the Egyptian-Roman Mummy portraits, which were portraits of the deceased painted on the wooden or parchment coverings to the mummified corpse, as representative of the spirit (*ka*),[6] in readiness to confront the other life. In this mute reflection, the message or dialogue which the look poses can only be guessed at, giving the onlooker a reading of itself as a psychic text, which permits for an open-ended possibility of transference projections to take place.

In the paintings of myself as an unclothed female seen in the act of painting, the issues of nudity, gender and the historically expected (gendered) role of the artist are made visually immediate. The self-portrait delivers the ultimate autobiography, occupied not with the minutiae of a life's events that outlines birth, wonder, loss, joy, success, and death – all wrapped in the cloak of the mundane – but rather the intensity of a life captured within a rhetorical moment of wordless gaze. With her lips resolutely shut, the apparent peace of an orchestrated silence hints at a never-ending performance of a life, making a visual alliteration of a chosen moment or state of mind that becomes within the finite frame of each painting, the complete story of a life(span).

I paint from the first person speaking in the hieroglyphics of pigment and gestural mark. My colours are the vernacular accent of someone whose origins lie in the near East. My narrative is the speech of the first person pronoun, looking for a place in which the metaphysical vocabulary can write its ontological story. These paintings offer only one cultural location to the viewer who is unfamiliar with my biography: that of a woman naked painting the image of herself as she sees or remembers seeing it in the mirror. I am not *saying* anything. I am just looking. What is there to say? What is there to recount? I am here. There is a mirror in front of me: just to the right, or just to the left of me. I half look at the mirror in which a familiar 'I', an *other-that-is-the-same-as-me*, floats in and out of view. The mirror is fixed. I move. The canvas or panel is propped up and passive. I am active. Everything else is passive. I as the active agent become at once both the dynamic subject and the receptive object. I try to conjure a stillness and so give form to this moving, breathing, thinking presence of an I/eye: seen from the reverse

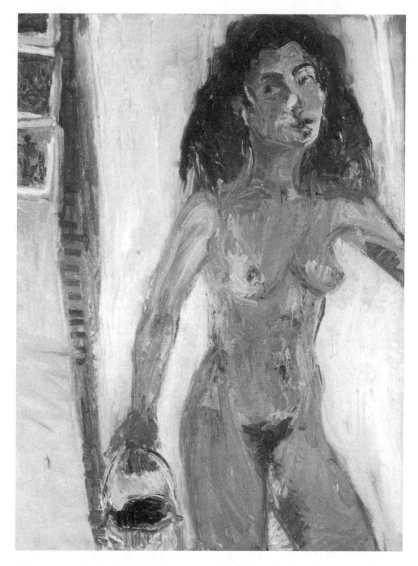

Figure 11: Partou, Self-Portrait – Black Paint Pot, *1999, oil on canvas, 122 x 92 cm. Courtesy of the artist.*

of the passive flicker in the opalescent shadow-idea of that who is *Me* in the mirror. The corporeal eye perceives the connection of my body as extension reaching towards the archaeological I (eye) in the mirror. The 'I' discovered in the mirror unravels a story with a past that connects to a future: a kind of extension across the formulae of temporality. She is not the same as

Blanchot's 'third person' of 'myself become no one, my interlocutor turned alien'. (Blanchot 1955: 28)[7] The shadowy figure in the mirror, both corporeal and non-material confused by the refracted light of the mirror, becomes the potential of that *other* for whose imminent appearance 'I' am mingled with this strange space of silence, and solitude. She is a familiar, and a confidant whom I am glad to have the courage to let myself encounter the *other*, and watch as I fall into *her-as-the-Beloved*.

Out of this strange meeting, in the regions that function beyond what we assume as *reason* and *reality* emerges a painted image of a 'self'. The journalistic eye stares back. As in an intimate journal recording a momentary scission of a personal experience, the journalistic eye is transfixed, taking a kind of erotic pleasure in performing an auto-voyeurism on her own presence, touch, stance, shadow, and story. The painterly language of this 'journal' is no different from the textual range of the written word on page: Jour = Day; Journal = Daily; Journey = travel = pass through, as in light that traverses the barriers of the camera lens and via the inversed image, recreates in replica what is *out there*. The ego involved with its own enjoyment of self given to self, is the active libido that generates itself because of itself. This emptiness of intention, that can be perceived as almost auto-erotic, is translated into a repetitively poetic play of self-reflexive curiosity.

As a genre, the self-portrait is a mischievous and risky foray into the unconscious stillness of the stubborn gaze in the mirror. It is the gaze that traverses from (and through) the intimate out into a public arena. The one who is being investigated becomes transcribed in the act of self-portraiture, as the one who investigates. The scrutiny of self turns upon its heels and scrutinises the universal *other-self-that-is-not-I*.

By discovering the corporeal self and making a candid representation, the 'sexualised female' is wrested away and out of the imaginary language of the male repertoire, as the subject of an age-old visual economy of appropriation and exploitation. Within the structures of this economy my body is merchandise for the self-intentioned use or misuse of *his* fantasy. I play no role in that economy other than a mute subject. My pleasure is neither negotiated nor sought, except when directed within the male production of a script rehearsed by men among themselves.[8]

Why my pleasure of self and the other should be taboo and a threat, must surely tie in with the dark secret of empowerment which such self-knowledge and representation would bring. She must be kept away from her own kind and most importantly from her own self. She must not look at her body, to know and enjoy it, because that is a flesh-language, and a corporeal-knowing that will arm her to defend her own *needs* and her own *desires*. And once she is familiar with her own map, then surely will she not begin to look for a route to the *divine-other-that-is-also-her* – awakening to her own meaning(s). By discovering '*her*' pleasure in the realms of the sexual, she must then undertake a further journey, travelling through and beyond 'the dimension of desire' to a place where the 'untranslatable' *Self-as-the-other-who-is-her-as-the-Beloved*, may be met with:

> Not to forget that the dimension of desire, of pleasure, is untranslatable, unrepresentable, irrecuperable, in the 'seriousness' – the adequacy, the univocity, the truth... – of a discourse that claims to state its meaning... it is right here that the most virulent issue at stake in the oppression of women is located today: men want to hold onto the initiative of discourse about sexual pleasure, and thus also about *her* pleasure.
>
> (Irigaray 1985: 163)

The process of painting or drawing my own image is akin to that soundless instant when diving into deep water, swimming under water, where the image of my embodiment is shattered, and sound mutates into another audio-lingual layer. Each time that I emerge from this process of representing myself, as when released from the liquid grip of the deep, I come up for air, only to find that my image, the mirror, the studio and the very texture of my breath have all moved one more notch outside of the boundaries of the understandable. The self-portrait acts like a vortex of energy. The liquidity of the visual text of *a self* cannot be linear, accountable to time, or any notion of completion. It is always experienced as a shattered remains of something that is potentially whole, but rarely contained as such. Each self-portrait painting, drawing, or print, is like a broken shard from an ancient plate once held as a whole vessel. A roomful of self-portraits seen in retrospect of a life already lived, may at first appear to be making an accumulative statement, and a complex

of parts presented as a whole. But in truth each portrait, one hung next to the other, annuls the one before or after. Each painting contradicts the narrative of the next. As in all biographical texts, we are invited to make a definitive conclusion, but the self-portrait denies one the privilege of a final narration, taking as its very process a position of anti-definition.

The desire of our own is a desire that transcends the sexualised issues of the imaginary of gender, as one who speaks *from* herself *as* herself, demanding to be given the regard of one who is part of the greater scheme of *Becoming*. Her presence in the world is not only to regurgitate a *script* handed to her at birth, but to have the satisfaction of writing her own *scenario*, represented by a protagonist who acts *as* her[self] and not merely some caricature who is led to masquerade *like* her. This is the drive or desire that can be reinterpreted as making our own representation and our own true likeness; given as an honest, first-hand experience of speaking, painting, and being active *from* the locus of a woman's corp(o)real centre:

What [women] do need is to stand centred about their own axis, an axis which passes microcosmically from their feet to the top of their head, macrocosmically from the centre of the earth to the centre of the sky. This axis is present in the iconographic traces left by traditions in which women are visible. It is on this axis that women find the condition of their territory, of the autonomy of their body and their flesh, and the possibility of an expanding jouissance.

(Irigaray [1989] *Gesture in Psychoanalysis*: 134; [1974]
Sexes et Parentés: 114, in Whitford [1991]: 164)

The central 'axis' of self and 'becoming', is situated amidst the very ground and air where I stand, as body, and speak, as a psyche. This body (margined) space is the primary place in and from which I may perhaps begin to 'find the condition' of my own 'territory', initiating the process that would come to delineate the complexity of my own specific autonomy of 'body' and 'flesh'. Making of this 'axis' that 'is present in the iconographic traces left by traditions in which women are visible', the dynamic locus in which I can hope to situate the autonomy of my own body and flesh and from where I may re-write 'the possibility of an expanding jouissance'.

Irigaray returns again and again to the fundamental crisis in law and discourse of the shackles placed of the female who remains unknown to herself, and yet a *gratis* commodity in the masculine initiative on sexuality and self-articulation. The 'hierarchical structure' has not only created 'a position of inferiority' for the feminine, but also set up various systems whereby the feminine is excluded from language. What is named as 'true' and 'proper' has invested culture and the universal psyche with the power to prohibit the feminine from learning to generate 'self-affection' and 'self-representation'. (Irigaray 1985: 161) This is a feminine-subjective territory of space and time that is as yet to be drawn and established, in which the female can also be situated as a knowing and therefore an actively self-represented subject.

One thing remains clear: in order to re-conceive bodies, and to understand the kinds of active interrelations possible between (lived) representations of the body and (theoretical) representations of space and time, the bodies of each sex need to be accorded the possibility of a different space-time framework. (Grosz 1995: 100)

NOTES

1 Johnson, Thomas H. (1960) (ed.), *The Complete Poems of Emily Dickinson*, Boston.

2 Using the material body to express a personal agenda, whether it be political, religious or poetic, is explored by Helen Vendler, in her brilliant analysis of the essence and shape of (poetic) 'style' as bearing a lyrical parity with the 'material body'. Thus she describes how the choice or change of style in a writer's process can come to be representative of 'an act of violence', and as the intentions – knowing or otherwise – of (the) writing 'style'. 'It is still not understood that in lyric writing, style in its largest sense is best understood as a material body. When a poet puts off an old style... he or she perpetrates an act of violence, so to speak, on the self. It is not too much to say that the old body must be dematerialised if the poet is to assume a new one.' (Vendler 1995: 1) There is a parallel here to the way mystic and visionary women used their bodies to access a higher spiritual experience or perception. The violence which Vendler uses as a metaphor for the poet's change of style – voluntary or otherwise – may be read as reflected in the self-flagellating

attitude of these medieval, mystic women. The body of the feminine having been placed in the economies of every 'filth' that can be associated with hatred and the abysmal depths of sinfulness, promoted in these women a strange fetish to self-hurt and a dislocated attitude towards the sanctity and wholesomeness of their own flesh. Although it is difficult for us to fully perceive the reasoning behind this kind of violation and self-abuse, the wounds and hardship inflicted on their own bodies were used by the female mystics as a means of gaining power and authority within their religious arena – 'The loathing of the female flesh, expressed in countless official church documents, created enclosed and restricted geographies for women who in turn spent much of their spiritual search in self-flagellation and loathing of their own body... the Classical body denotes the *form* of official high culture. Medieval "high" culture was Latin, male and extremely homogenous, including such discourses as philosophy, theology, canon law and liturgy. In the medieval church, the Classical body was harmonious, proportionate and monumental; it attempted to represent a sort of disembodied spirituality and, as such, it never existed except as cultural representation. The grosser, more material aspects of "the body" were displaced onto the "grotesque body". Woman (along with other marginal social groups, the lower classes, for example) is constructed by this dominant culture as the grotesque body, the other, whose discursive norms include heterogeneity, disproportion, a focus on gaps, orifices, and symbolic filth... The mystic's pain – her inflicting of wounds upon herself – grants her the authority to speak and be heard, to have followers, to act as a spiritual advisor, to heal the sick, and to found convents and hospitals. Her body bears the marks, the "signs", of her own spiritual power. The mystic's progress, then, is discursively organised by the disciplines authorized by religious tradition and performed on her body. She changes, however, the meaning of the physical forces that oppress her. She assumes for herself the power to define what they mean.' (Laurie A. Firke, 'Mystical Bodies and the Dialgues of Vision', in Wiethaus [1993] 36–42) The deeply personal, and at times harrowing images of Frieda Kahlo's self-portraits, are candid twentieth-century equivalent examples: a woman painting her body with all its pain, suffering, humiliation, and tragedy. Kahlo's portraits are painted by her intimate woman's eye. These are the eyes of one who knows her body shamelessly, and without judgement.

3 The notion of the other [facial/bodily presence], as the *loci* of
 'regard' or the place of moral responsibility which rests on the
 quality and intention of my 'gaze' is the stand which Levinas
 takes in considering the other; but more precisely the self's own
 impenetrable capacity for truly seeing the other: 'The way in
 which the other presents himself, exceeding the idea of the other
 in me, we here name face. This mode does not consist in figuring
 as a theme under my gaze, in spreading itself forth as a set of
 qualities forming an image. The face the Other at each moment
 destroys and overflows the plastic image it leaves me, the idea
 existing to my own measure and to the measure of its ideatum –
 the adequate idea. It does not manifest itself by these qualities…
 It expresses itself.' (Levinas 1979: 50–1, quoted in Vasseleu
 1998: 88) Or, as Cathryn Vasseleu goes on to expand, 'The
 anarchy of the face is an infinite difference, theorized by Levinas
 as a never presentable deferred identity, or difference as a non-
 recurrence, as always already past.' (Vasseleu 1998: 89)

4 As Levinas writes: 'The I always has one foot caught in its own
 existence. Outside in face of everything, it is inside of itself,
 tied to itself. It is forever bound to the existence which it has
 taken up. This impossibility for the ego to not be a self
 constitutes the underlying tragic element in the ego, the fact
 that it is riveted to its own being.' (Levinas 1978: 84)

5 Betterton's writings on the depiction of the female body in art
 confirm Irigaray's project in exposing the long-established
 domain of the 'morphology of the male body' as the active maker
 of 'the phallocentric logic and language of the symbolic order',
 which has hitherto dictated how the female body may be situated
 in the scopic tradition of art. Having been perceived or
 'imagined within a phallic system of representation', this genre
 becomes, in the hands of the female artist, a viable space from
 which a new 'critique of the system itself' may be initiated.
 (Betterton 1996: 105) 'The question of how to represent the body
 has become an interrogation of identity, marginality, power and
 difference: the body in history. Themes of identity have been
 explored in such practices through the relation of personal to
 historical memory, through journeys, both real and metaphor-
 ical, and through the representation of self from the point of
 view from those displaced from the "centre" by gender and race.
 This kind of work engages with… an inter-subjectivity which
 enables identifications and differences between women and men
 and between races and cultures to be recognised. It also asks
 how we – as women, as feminists, as post-colonial subjects –

might journey towards the articulation of our own desires.' (Betterton 1996: 193)

6 From Egyptian, a word/name denoting the ancient belief in the dynamic spirits that would attend human or statue representations.

7 The writer must, according to Blanchot, lose himself in the process and along the breadth of the journey into the land of writing; as a refugee who forsakes the native land for the adventure of experiencing both a new territory, as well as seeing her/him-self as an unknown other. 'When to write is to discover the interminable, the writer who enters this region does not leave himself behind in order to approach the universal. He does not move towards a surer world, a finer or better justified world where everything would be ordered according to the clarity of the impartial light of day... What speaks in him is the fact that, in one way or another, he is no longer himself; he isn't anyone any more. The third person substituting for the "I": such is the solitude that comes to the writer on account of the work. It does not glorify consciousness in someone other than myself or the evolution of a human vitality which, in the imaginary space of the work of art, would retain the freedom to say "I". The third person is myself become no one, my interlocutor turned alien; it is my no longer being able, where I am, to address myself and the inability of whoever addresses me to say "I"; it is his not being himself.' (Blanchot 1955: 28)

8 My nakedness is not merely being undressed, but a nudity that revels in its candid state of detachment. Clothes can indicate an associative erotic genre/scene, and the hint of nakedness is in itself a green light for erotic imagining. Nudity, however, is almost innocent, protected, within it(her)-self. These portraits are not the product of masculine erotica, which ultimately sees the phallic as the central aspect of the partly dressed or naked female figure: 'In all probability no one has to this point seriously enough considered to what extent the image of a de-sirable woman is dependent on the image of the man who desires her, so that in the end it amounts to a series of phallic projections which progress from one segment of a woman to configure her entire image, whereby the finger, the arm, the leg of the woman, could actually be the man's genitals – that it's the male sex organ in the woman's firm, stockinged leg, the thigh swelling over – or in the pair of rounded buttocks out of which, arching backwards in tension, the column of the vertebrae extends – or in the double breasts, that hang down from the

extended neck or freely from the body – so that the phallus is finally the entire woman, sitting with hollow spine, with or without hat, standing erect'. (Hans Bellmer quoted in Neret 1993: 21)

CHAPTER 6

THREADS
Dialogues with Jo Bruton, Beth Harland, Nicky May and Katie Pratt

Rosa Lee

Try this simple experiment: close your eyes tightly, stand up and walk to the other side of the room and back. You have just simulated for yourself what it is like to be blind. Well, not quite: there are several important factors missing. Firstly you knew all along that you could open your eyes at any minute if you ran into trouble (e.g. a large, hard obstacle). A blind person does not have that option for recovering from a mistake. Secondly, you almost certainly used your visually derived mental 'map' of the room's layout to guide you. Thirdly, you drew on a set of spatial concepts and orientation skills developed across your life-span that involved vision as a major unifying sense: the very first time you, as an infant, watched your hand as you reached out for an object, you were already learning about space through vision... The congenitally blind rely on *hearing, touch and movement*.

(Ungar 2001: 1, my emphasis)

In a world increasingly obsessed with the primacy of the visible, the following chapter will attempt to track the limits of vision in painting, and trace the labyrinths explored by some contemporary painters whose work engages directly with such limitations. It could be said that it has always been the job of the artist to question artificial divisions, deliberately to blur superficial boundaries and confound any neat conclusions about their work. In this respect, the paintings of Jo Bruton, Beth Harland, Nicky May and Katie Pratt will provide the main focus here, their voices and work providing grist to my theoretical mill.[1]

REPRESENTATION

The more our world is rendered forth in visual imagery, the more things are left unexpressed.

(Marks 1998: 334)

In her book *The Skin of the Film* (2000), the critic Laura U. Marks addresses the difficulties inherent in questions of representation and language. Although she is writing in relation to her investigations of inter-cultural film and video work, the painters discussed here are equally at pains to leave conventional imagery and codes of representation, especially of 'abstraction', behind. There is a palpable desire to express through investigation, sheer invention and often cryptic clues, what is ordinarily not directly visible, paradoxically, to explore what Marks refers to as the unexpressed. At the same time, it is clear that the 'language' of painting does not readily lend itself to the making of direct statements. It is arguably an art of pure interpretation. For the painter, the codes and languages of painting, like the paint itself, are, by their very nature, slippery and amorphous. As a form of communication, it is invariably a very imprecise tool, prone to ambiguity and subsequent misreadings, if not downright incomprehension, from viewers. Unsurprisingly, for the painter, this leads to a mistrust of definitions, even a suspicion of language itself, and underlines a desire not to fix ideas through words or vision alone. We have to question constantly the role of vision in this context. The problem, it seems, lies in the interpretative nature of 'meaning' in painting.

Over the past 20 years or so there has been constant debate about the 'language' of painting, to the extent that we now might refer pompously to *reading* a work of art. While I would readily agree that reading *about* a particular work or artist can yield insights, the security blanket of the written word inevitably overrides somatic and authentic responses to the experience of viewing, or indeed, of making. This over-reliance on the visual or visuality when referring to painting is alluded to by Marks in her discussion of *tactile* epistemologies, where knowledge is gained not through a model of vision, but through, as she puts it, a relationship to the world of *mimesis*. (Marks 2000: 138)

Acts of mimesis, perceived as mediated by the body, directly challenge the assumption that symbolic representation be accepted as the sole source of meaning. Symbolic representation is best defined in its negative sense, as privileging the 'visual' over multi-sensory perceptions (for 'visual', we could perhaps equally read 'logical'). Marks describes this relationship between mimetic and symbolic representation as being 'related in the way that the inside of a glove is related to the outside'. (Marks 2000: 335) Identifying the embodied and entirely mutable nature of language, she expands on Walter Benjamin's view:

Benjamin argued that language is the highest form of the mimetic faculty. This does not describe language as the system of signs we have come to understand it to be. Rather it describes a language that draws close enough to its object to make the sign ignite.

'The coherence of words or sentences is the bearer through which, like a flash, similarity appears. For its production by man [sic] – like its perception by him – is in many cases... limited to flashes. It flits past.' (Benjamin 1978: 335)

Language is rooted in the body, its meanings inseparable from the sound and gestures that bore it forth.

(Marks 2000: 138, my emphasis)

For our purposes, considering the paradoxes encountered in the process of making, Marks also offers some reassuring insights. She concludes:

Mimesis shifts the hierarchical relationship between subject and object, indeed dissolves the dichotomy between the two, such that erstwhile subjects take on the physical, material qualities of objects, while objects take on the perceptive and knowledgeable qualities of subjects. Mimesis is an immanent way of being in the world, whereby the subject comes into being not through abstraction from the world but compassionate *involvement* in it. As Roger Caillos (1984) wrote, mimicry (he did not use the term mimesis) 'is an incantation fixed at its culminating point', because things which have been in contact *leave their traces irrevocably on each other*.

(Marks 2000: 141, my emphasis)

Life in the bubble of the studio is characterized by self-imposed rules and regulations that enable and accompany the conception of 'ideas' for the work. These ideas may well take the form of apprehensions (though what is called inspiration may well play a role), which incorporate the acute awareness that intention, as with theory, might be thwarted subsequently through technical and other events beyond one's immediate control. As Marks points out, it is about a 'compassionate involvement' (2000: 141) and I would add, about *being in the work*. There is a symbiotic, rather than a causal, relationship at play, where desires, materials, process and details coalesce, with the hope that the final outcome will be a happily negotiated settlement between the known and the unpredictable.

I have always wanted to stimulate the audience's (and my own) perception of the object through a direct experience of the phenomenology of the material. I don't feel the material is the subject, it is not purely about process. Direct response, immediate response if you like – that almost physical/emotional jolt felt in the back of the neck, pit of the stomach, or racing up the spine... beyond intellect, that place where modern/postmodernism's obsession with the dialectic between subject and object is no longer relevant.

(Nicky May 2001)

The language – although this word may be totally inappropriate here – of painting, as Nicky May states, attempts to reach 'beyond intellect' in as far as it aspires to re-conjure, through the canvas, diffuse experiences and perceptions. In the making of work, these responses appear to be non-verbal, although the methods and conditions conducive to this may be critically considered or engineered. Such definitions, however, do not speak of the constant intertwining of both spheres, nor do they encompass the infinite degrees of experiences and apprehensions that inform us at every stage between these apparent poles of our sensibilities. Conscious decisions appear to be vital to the possibility of tapping into other, more somatic layers of consciousness, crucial to the conception and subsequent making of the work. In this respect, Trinh T. Minha's view of *'speaking not about, but nearby'* (quoted in Marks 1998: 332, emphasis in original) seems a particularly useful concept here.

LABYRINTHS

Almost everything people try to say about painting turns out to be
unsatisfactory. Qualities of excellence in painting are pictorial qualities,
which are not illustrational qualities, and which are very much tied up
with the creation of space and colour.

(Heron 1987: 45)

In an article written some 15 years ago, entitled 'Painting is
Silent', Patrick Heron controversially argued the case for
painting's enduring obduracy, its right to 'silence'. While it might
be easy to agree with Heron's first comment above, his
subsequent assumptions are still very much open to debate.
References to space and colour naturally conjure relationships
outside of the painting itself and are conditional on the effects
of the materials used. For example, the way in which paint
coalesces or the ways in which varying degrees of colour are
juxtaposed may determine overwhelmingly the resulting 'space'
of the painting and therefore inadvertently affect the very
meaning of the work. Questions of 'excellence' in painting are
so vexed and fraught with subjective interpretation as to render
the desirability or value of such a quality virtually redundant.

Painting's 'silence', however, enables significant resonances,
and should not in any sense be mistaken for absence. The space
it conjures allows for speculation, reflection, enjoyment, debate,
and disagreement. It is polyvocal, in as far as it attempts to be
inclusive, alluding to senses other than the visual or the purely
cerebral. Attention to detail is manifest not just in the final
'body' of work, but is apparent throughout the myriad dances
and shufflings inherent in a working day, all the plans, structures
and quirky tricks we employ in order to 'get going'. Often the
means for arriving at the destination are made deliberately
convoluted and unclear, but the vehicle and the preparations
for doing so are immaculately honed and polished, though
hopefully not obviously so. (fig. 12)

Where my own work and practice is concerned, I have always
experienced the interface between 'language' and the 'visual' as
being intensely problematic, hence the concerns expressed in
this chapter. My hope is that the dialogues and investigations I
outline here will untangle these knots to a certain degree and

Figure 12: Rosa Lee, Ariadne, 2002, oil on canvas, 173 x 147 cm.
Courtesy of the artist.

open up a debate. What I am examining in my painting is the
notion of the detail.[2] Given that it has very many attributes and
associations, detail is a conjurer, both in terms of painting and
in the minutiae we see and experience all around us: the things
that perhaps are overlooked; the clutter and baggage of a lifetime
which becomes overbearing and is thrown out. In work, as in
life, there is a tendency to hang on to particular details or
fragments: one might say *paraphernalia*. In my case, this has
led at the same time to a search for structure – a kind of attempt
at order and the often-paradoxical search for a language to

articulate the possibility of fluidity and the shifting nature of meanings. In this respect, painting, in its silence, is arguably well suited to the exploration of such paradoxes and dilemmas, where conventional boundaries become blurred.

My interest in mythology indirectly informs part of this search, and stems from looking at its use in past art, particularly how it becomes a pretext for myriad details, observations and inventions: its ability to encompass metamorphoses. Myths, like that of Ariadne's spinning thread, as with fairy tales, fascinate not only because of their universal, labyrinthine resonances, but also because of their hugely metaphorical and yet still highly relevant content which relate to enduring human frailties, virtues and vices, from which even the gods are not exempt. Fantastic themes and improbable characters abound but, like all good stories, they enable us to suspend disbelief and so possess a singular power to engage and involve us on differing levels. Original sources and meanings may be lost in contemporary interpretations, but nevertheless, the stories are retold, go through embellishments and permutations as a result, and are then renewed and interrogated repeatedly, as is often the case in painting.

BODIES OF WORK

To perceive is to render oneself present to something through the body.

(Merleau-Ponty 1964: 18)

What does it mean to think in terms of 'bodies' of works, a series of paintings, which relate and develop over time? Inevitably, a kind of romance is involved, describing the work as having a life of its own, at times asserting, irritatingly to some, that they 'paint themselves'. However fanciful, these are the most direct ways of alluding to the nature of making, and the perceptions that instigate it. The idea of a *series* of work also brings to mind TV soap operas: a fabricated continuum or community where certain characters may come and go, perish or be killed off – a kind of reduced version of myth. Where painting is concerned, bodies of work are a record of the artist's search and the desire not to make just a single statement, but to test out a variety of

interrelated or even contradictory ideas, which evolve and are revised over a lifetime of practice.

For the painters discussed here, the importance of having no single point of focus is always of central concern. A large, nearly wall-sized painting involves the viewer, as well as the maker, in a physical exchange. Looking at a larger vista prevents the possibility of seeing things in one glance but, regardless of the size of the work, the concerns expressed here relate more acutely to questions of the *loss* of the ability to focus, and consequently confounds any possibility of objectivity:

When I visit the cinema I always sit near the front and in the centre so that I lose the edges of the screen. The shape dissipates to allow an experience of being closer to the film. The size of the paintings is important, and a feeling of moving closer and losing the image.

(Jo Bruton 2001)

For Jo Bruton and Katie Pratt, the importance of *not* seeing things or experiences in isolation reflects their own physical relationship with their work. In their paintings, there is a sense of vastness, whether literally or implied, which then becomes further enhanced by the awareness of the minutiae with which the bigger picture is populated. In the making of the work, this layering of events charges the sense of anticipation: that whatever the preparations, we can never predict what will finally emerge on the canvas.

Often in the making of work we rely on what I've come to think of as *peripheral vision*: something discernable only at the edges of our field of vision. For me, it acts as an apprehension and is not solely reliant on vision *per se*, but is fundamental to the ways in which ideas for a particular work are felt and acted upon:

When I think of peripheral vision, I think about making decisions in a subconscious manner. The way that I work in terms of starting with such a violent beginning (chucking paint) means that I cannot always immediately see a way in. It is important for me to spend some time looking without direct concentration.

(Katie Pratt 2001)

Through the day-to-day making of the work, we become acutely conscious of the physical nature of the activity. Attempts to track down relevant – or sometimes useless – materials, visits to particular places, the shifting around and making of stretcher frames – all those days spent stretching and sizing canvas, priming, and waiting. The impatience, the shuffling back and forth, bending, contortions; the anticipation when mixing colours, but then the tedious cleaning of paintbrushes, tools and palettes. There is a constant dance between and around events, even before the paint hits the canvas – between the conception of an idea, and its concrete realization:

> Peripheral is more to do with the spectacle of seeing, paradoxically, rather than seeing out of the corner of your eye. It also has a lot to do with movement. Of wanting and the problem of seeing the whole spectacle before you. I am specifically referring to the aspect of performance and showgirl line up. There are no focal points to the show, it takes place across the stage, dropping in from the ceiling, at the centre and from one end of the stage to the other, your eye is never fixed. This has a direct relationship to how I want my work to be viewed – where the eye/body is moving across the surface – and the viewer is caught within the act.
>
> (Jo Bruton 2001)

Questions of focus relate directly to an implicit acceptance of the embodied nature of experience. As we have seen, in order for work to emerge or be viewed, we all rely on senses, apprehensions and perceptions *other* than the purely visual. 'Looking without direct concentration' (Pratt 2001) and recourse to 'hearing, touch and movement' (Ungar 2002: 1) are vital components. Bodies of work indicate a desire to acknowledge the continuum between the artist's search and the paintings' eventual material findings.

HAPTIC CONFUSION

> Riegl borrowed the term 'haptic' from physiology (from 'haptein', to fasten), since the term 'tactile' might be taken too literally as 'touching'... He argued that subjectivity is involved in perception: perception

requires 'the supplementary intervention of thought processes'. Haptic
visuality is distinguished from optical visuality, which sees things from
enough distance to perceive them as distinct objects in deep space: in
other words, how we usually conceive of vision.

Optical visuality depends on a separation between the viewing subject
and the object. Haptic looking tends to move over the surface of its
object rather than plunge into illusionistic depth, not to distinguish
form so much as to discern texture. It is more inclined to move than to
focus, more inclined to graze than to gaze... He associated the haptic
image with a 'sharpness that provoked the sense of touch'.

<div style="text-align: right">(Marks 2000: 162)</div>

Dating from 1893, Alois Riegl's distinction between *optical* and
haptic vision continues to hold a particular significance for
contemporary criticism, as Marks outlines. Where filmic
conventions are concerned, the loss of the 'object' is apparent
through devices that make the narrative and the image more or
less obscure. Film-making techniques, such as changes of focal
length, graininess, effects of over- and under-exposure, or video
decay, directly parallel concerns of contemporary painters in
their grappling with representation. (fig. 13)

In her references to photography, Beth Harland's paintings
allude strongly to such haptic consequences. Her work
consistently relies on the failures and flaws in such supposedly
'objective' media and the techniques involved in transcribing
them in her work:

Laura U. Marks talks about a mimetic relationship with the world,
dissolving the hierarchical relationship between subject and object, an
immanent way of being in the world. Losing yourself in an image, losing
your sense of proportion. In most of my work there's a sense of the
figure being absorbed into the background, some traces remaining to be
deciphered.

<div style="text-align: right">(Beth Harland 2001)</div>

In a recent body of work, Harland collects and makes use of
images in a manner which evokes the searching for and piecing
together of forensic evidence. There is a sense of the detective
work involved in deciphering the paintings, where glimpses of
possible references are fleeting and ephemeral, as the possibility

Figure 13: Beth Harland, August 3, 1944, *Spring 2000, oil on canvas, 61 x 36 cm. Courtesy of the artist.*

of focusing is rendered momentary. Are these scenes of catastrophe or carnage? Could that be the curve of a head emerging from what seems like shrouds of material, a hand or foot protruding out of rubble? Inspired by archive material of Roman ruins, they turn out to be more like an archaeologist's than a pathologist's nightmare, though the echoes of newspaper footage familiar to us over recent years from scenes of warfare or natural disasters are obviously implicated. For Harland, photography is no document of 'fact'; its use in painting requires interpretation and elucidation; elicits questions, becomes a catalyst for examining and making sense of experience:

I'm interested in what the painting brings out from the photo – emotional content? A reflection of something sensed about an event that can't be seen? Or maybe it doesn't add so much as make more apparent that representation 'misses' experience? Alluding to the larger picture: 'the not-all of visual representation creates in the looker a sense that there is something "beyond" the picture (and the signifying system itself) that is not shown – that is, the subject her or himself. This belief maintains desire... it is that (internal/ized) absence that visual representation continually tries to recover.' (Phelan 1996: 25)

(Beth Harland 2001)

Figure 14: Nicky May, Carapace, *2002, acrylic on canvas/board, 213 x 305 cm. Courtesy of the artist.*

Nicky May's recent works reflect a continuing correspondence with geological/phenomenal processes, although their scale and more direct references to figure and ground imbue the dominant image with a distinctly object-like reference – in qualities reminiscent of rock fragments or fossils. (fig. 14) Where Marks refers to the distinction between 'haptic visuality' (the metaphorical caressing of the surface of an object) and 'optical visuality' (the tendency to read illusionistic depth into a work), May's paintings often appeal simultaneously to both aspects. Recent paintings appear to represent, far more acutely, a wider search for an appropriate language in painting with which to describe correspondences with the physical, sensory world. Paradoxically, while implying immediacy and materiality, these paintings also reference the absent and the diffuse, Peggy Phelan's 'not-all of visual representation': (Phelan 1996: 25)

It is a less than conscious decision/desire in my work to embrace this idea of the haptic while also employing illusionistic space and the figure-ground relationship in order to stimulate the optical experience. Structured chaos, the microscopic/macroscopic shift, the mark's re-lationship to the body and the experience of the expanse of the canvas up-close and more distant. Its presence implies the absent object.

Conscious accident? ... I have always felt that the painting's autonomy, becoming an object, allowing it to speak of absence, is made more possible by employing accident and chance (what is chance?) – the collision and contortion of surfaces and materials, mirroring the imaginings of the mind and, perhaps, of the soul.

(Nicky May 2001)

Writing about a parallel process within photography, Laura U. Marks refers to the fossil as being:

the indexical trace of an object that once existed... Fossils are created when an object makes contact with the witnessing material of earth... this contact transforms the material's surface so that it becomes a witness to the life of the object, even after the latter has decayed. But instead of disintegrating it solidifies and becomes transformed.

(Marks 2000: 84)

The implications of these observations provide us with compelling insights, echoing May's desire to allow the paintings 'to speak': in the end, the painting is a record, a witness, as Marks defines it, much in the way that a fossil is, of attempts at transformation.

MEMORY: AN UNRELIABLE WITNESS?

Memory is more like the melting and refreezing of a glacier than it is like an inscription on a rock.

(Edelman and Tononi 2002: 93, quoted by Beth Harland 2001)

Considering how importantly we rate memory as a corollary to fact, we are constantly reminded of its highly selective nature, of its closer relation to fiction. It seems that memory is strangely unrecoverable, if not downright invented, and is as verifiable as are our dreams. However flawed, this need not obviate its ability to furnish us with nuggets of refreshing insights. Memories triggered by old family photos are possibly the most unreliable, as too with stories told us as children. Do I really recall the time when I supposedly encouraged my younger brother to hurl eggs all around the kitchen while my mother

was languishing with the flu in bed? More worryingly, I have
no idea of my motive for that act, though such stories surely
become part of a lifetime of myth-making. Our perceptions/
interpretations inform and/or distort events to such a degree
that we are often compelled to make futile attempts at recording
– through objects, photos, paintings, for example. All of these
appear to be frail graspings after fugitive memories or absent
bodies, the somewhat desperate attempts to recuperate those
distant glimpses. They attempt to recall the touch of a hand, the
softness of a cheek, the weight of a chubby baby's warm body
clasped to your hip as you try to cook the evening meal.

 Beth Harland's *Lucid* series, made after her mother's death, is
powerful in its evocation of these mechanisms: the unique ability
of these objects – as with fossils – to contain or preserve time. In
Lucid VI, 1999, objects placed in rows on a table appear to loom
out of the still darkness of the room. The indeterminate forms
are, however, infused with a glowing aura emanating from what
must be a corner of a window. In this twilight world, whether
you are standing close or move back from the image, there is a
sense of disorientation, a blurring that prevents identification of
the objects. We are left to reflect on the presence and absence
which memory constantly attempts to conjure and re-conjure:

Looking into neurological explorations of the memory mechanism did
turn up one thing that seemed to relate to the making process – that
memory is not stored in some kind of representation, but is a dynamic
system, moulded by re-categorization, selection and degeneracy. These
three terms seem to apply in the process of re-inscribing the photo into
the painting.

(Beth Harland 2001)

Similarly, although with strikingly different results, Jo Bruton's
paintings access the domain of personal and cultural memory,
both in her choice of motifs and in her investigations into the
relationship of identity and light, as metaphors: (see cover image)

There is an accumulation of visual material that has been carried
through the work. Perhaps part of the need for control and construction
is to accommodate aspects of past work I want to keep... Those charact-
eristics of the painting process have recently led me to using ideas

around the 'female performer' and the spectacle of performance. The 'showgirl', whose elaborate costume has been described as moving architecture, is a kind of frame. A line-up of showgirls or cheerleaders all serve to frame an activity and elaborate identity, but they never take centre stage. I wanted to elaborate on the performative within painting by literally equating that with a kind of presentation and performance – 'visual gymnastics', as Barthes (1977: 4), described.

(Jo Bruton 2001)

Skylark (2002), from a recent body of Bruton's work, collectively entitled *Walk slowly towards the light*, directly addresses the nature of the 'performative'. In this series, which draws on material derived from a recent trip to Las Vegas, the very works themselves are presented as spectacle, as protagonists on the 'stage set' of the gallery. Commenting on these paintings, Sacha Craddock wrote:

The work has become so abstract... that the most worthwhile relationship with it has to be physical. Witness the paintings as they perform, as they project the unbelievable physical and mental strength necessary to keep that smile, wear the headdress and dance to perfection.

(Craddock 2002: 1)

Bruton's work is literally and metaphorically layered with associations, from the painstaking initial process of collaging, to the uppermost surface of paint and the use of fine grains of glass, normally used in road markings for their reflective property. The effect is to elicit an unusually active response: the iridescent and shifting nature of the surface requiring a reciprocal motion, to and fro, back and forth, from the viewer, echoing the 'showgirl line-ups' to which she makes reference. The 'gymnastics' at play in Bruton's paintings allude also to the pleasures and pains of schooldays, and concomitant heartbreaks. At the same time, they elicit a consideration of how identity might be consciously constructed, assumed or consumed, and how they are paralleled as such in the process of painting.

The locations and spaces alluded to by Bruton's work conjure the excitement of the stage and the constructed nature of performance. She makes use of motifs and details which are unapologetic in their frivolity. Her work makes me think of

Cinderella, in that very moment when the carriage threatens to turn back into a pumpkin. They also remind me vividly of the rare evenings when as a child my parents would go out to a party – probably on New Year's Eve – and I would watch as my mother transformed herself in a flurry of preparation: the Connie Francis songs which she would warble from the bath tub, the rich smell of her perfume, the silky feel of her shimmering Chinese dresses, the lipstick which left creamy apricot traces when she kissed us goodbye.

On closer inspection the viewer becomes acutely aware of the illusory nature of such perceptions: the fugitive nature of identity and identification become all too apparent. The performative is directly alluded to through the literal layers and the complexities in the making of paintings:

Through the use of the motif I am exploring a constructed female presence, by alluding to clothing and costume. The paintings are constructed in separate layers. A pattern is collaged on to the raw canvas, an image is then laid over this using fine glass beads. These are hardly visible, but act as a light source within the paintings... I am interested in the immediacy of the motif or image that locates itself within a range of associations. An open narrative. I enjoy taking the characteristics of the painting process – layering, reflection, light – and using those literally as a visual reference within the process.

(Jo Bruton 2001)

Layering, reflection, light – the focus on the details of the painting process completely contradicts the idea of art as being purely whimsical or inspired 'expression', arrived at in the moment. Planning, procedure, organization: all play a vital role, the 'to-ing and fro-ing' and dithering involved is as literal as it is metaphorical. Similarly, the 'subject' of focus, if it can be properly called such, remains theatrical. As Judith Butler identifies, these acts and gestures only serve to highlight the performative nature of identity:

Words, acts, gestures, and desires produce the effect of an internal core or substance but produce this *on the surface of the body*, through the play of signifying absences that suggest, but never reveal, the organizing principle of identity as a cause. Such acts, gestures, enactments, generally construed, are *performative* in the sense that the essence or

identity they otherwise purport to express are *fabrications* manu-
factured and sustained through other corporeal designs and other
discursive means.

<div align="right">(Butler 1990: 136)</div>

The '*fabrications*' at play here relate directly, it seems, to cultural
determinants. Significantly, the element of 'play' to which Butler
refers is now positively encouraged in children, but seriously
disparaged in adults. In painting, such fabrications may touch
on those inchoate, haptic memories and sensations, but it will
attempt to do so on the level of interpretation, precisely, as
Butler suggests, 'through the play of signifying absences that
suggest, but never reveal'.

DEGREES OF FOCUS

Very often we see things with a kind of mild tunnel vision, where we
are very focussed on one thing and ignore everything else around... This
kind of tunnel (or 'foveal') vision also seems to go with an inner tunnel
vision, where we get obsessed or fixated on something and lose con-
text... Peripheral vision is the opposite. It's about paying attention to
what's happening at the edges – the periphery – of your field of vision...
You may become more aware of movement. At the edges of your vision,
you may be less aware of colour and contrast distinctions...

<div align="right">(Smith 2001: 1)</div>

Riegl's notion of *haptic visuality* tantalizes in its suggestion that
the eyes themselves function as organs of touch. The haptic
provides us with tools for expanding the language of art by
emphasizing the interrelated nature of our perceptions,
questioning narrow definitions of 'vision'. In research on spatial
cognition in the blind or visually impaired, reference has been
made to the way haptic exploration (with hands and arms in a
small scale space) provides 'a stable egocentric frame of
reference'. (Ungar 2001: 2) Conversely, where exploration
involves moving (locomotor space), reference frames become less
reliable. In a similar way, psychologists have made use of the
terms peripheral and foveal vision, both in a clinical and
metaphorical sense, to highlight the ways in which degrees of
focus affect the way we think, feel and respond to outside

stimuli. In clinical terms, peripheral vision is seen as a 'normal' faculty, while the foveal, being obsessive, is less desirable. However, it seems that artists are continually moving un-consciously from the haptic to the foveal, the peripheral and the locomotor – in fact through the whole gamut of experiences, which have yet to be named – in the course of a working day.

The implications of these insights for painting lie not so much in the practice, but in the discourses and language that surround it. The notion of peripheral vision relates, in my view, to the way ideas or perceptions might occur, whereas the foveal and the haptic are integral to the working process, but enable the subsequent articulation of such processes without the need for overriding definitions. In another sense, the peripheral refers to what is not immediately visible or directly conscious, points to what we can only intuit, what is possibly not (yet) known. In painting, peripheral vision clearly works in conjunction with fo-veal detail and the haptic to indicate the possibility of suspending disbelief, of fabricating our own fables, of representing paradox.

The foveal is a vital factor in the performing of most tasks, whether it is Jackson Pollock dancing around canvas rolled out on the floor with a pot of paint and baster in hand, or simply putting dirty clothes in a washing machine, ensuring there isn't a stray bright red non-colourfast item in with the white shirts. The 'eye for detail', a by-product of the foveal, is a necessary factor for effective everyday functioning, though its association with the obsessive is viewed as indicating a kind of personality disorder.

In Katie Pratt's paintings, the investigation of the foveal is possibly at the heart of the work. (fig. 15) Yet this 'tunnel vision' requires massive changes in degrees of focus, both literal and implied: the invocation of a vast invented and inventive terrain inhabited by miniscule details which operate by turns as tracks, trails, boundaries; strange mappings of moments in time:

I think about comparing myself to a camera through working very close to the canvas and thereby having a very objective relationship to the decorative and image. I think about staccato time that interrupts memory so that each moment is dedicated solely to the job at hand at that instant. As I tend to work in many tiny strokes, there is a natural affinity between this way of thinking and – say – photographic film which is pixelated and each pixel is operating without consultation with its neighbours. So any

Figure 15: Katie Pratt, Dervishire, *2002, oil on canvas, 200 x 170 cm. Courtesy of the artist.*

image that emerges is rigidly, systematically objective. As far as focus and movement are concerned, I think about how shifts occur as you walk towards the work (especially when it has tiny detail on the surface). We can't see the whole surface at once in detail.

(Katie Pratt 2001)

This attention to detail promises a comforting sense of familiarity, in the same way that our confidence increases when we have a map of an area which we are exploring, and believe that we 'have the measure' of the route. We become convinced

that the attention to detail provides us with warning posts, alerts us to the dire consequences of what is often overlooked – the faulty tap washer, or the small flame still burning on the gas cooker when leaving the house. In this way we feel we can exercise some kind of control over the unpredictable. The actual experience of painting, however, as Katie Pratt demonstrates so prosaically, is that nothing should be taken for granted. Reference points may be illusory, and we may be forced to follow unfamiliar routes, only to realize that our eventual destination will be somewhere miles away from where we intended to go. In short, we may well get very lost.

MISREADING

Traditional criteria no longer hold sway: truth is no longer hostage to 'reality'. Modifying somewhat Judith Butler's theory, I'm thinking of the notion that identity is not fixed, but is fluid and performative, that we may well adopt personae as we adapt to the increasingly varying situations in which we find ourselves. The implications for contemporary painting are equally diverse. Narrative has been released from its modernist cage, and is no longer taboo; autobiographical elements are there to be divined without embarrassment; it is possible now to think of narrative and interpretation in entirely new ways.

I'm beginning to think that my obsession with 'language' in painting may well be herring-like, and that artists naturally find means to sidestep such anomalies, never mind the taboos, much as their work eludes and often exceeds the stated intentions of the artists themselves. Traditional definitions are in the process of being somehow redefined, regardless of academic tomes and the strictures they might impose. The 'silence' of painting, whether in the making or in its subsequent appraisal, is in itself a catalyst, in as far as it poses conundrums and questions which deny us the satisfaction of authoritative 'answers'. We are left with the possibility of interpretations which challenge to the core both our cognitive abilities and haptic sensibilities, all of which contributes to the sensation of being totally disorientated.

Perhaps the dilemmas referred to so far could be elucidated in a different way if we could only accept the 'slippery and

amorphous' nature of language, and the need for allusion and interpretation. Alice A. Jardine intimates, citing the writing of the French philosopher Jacques Derrida, that by embracing the elliptical, the neither/nor, the absences and silences, we may find that our fears are totally unfounded:

Writing is the 'general space' that disrupts all presence and absence and therefore all metaphysical notions of limits (as well as the possibility of transgressing any of those limits). Writing as spacing is... a kind of philosophy and reading impatient with those who feel entitled merely to save Time: 'Let us space. The art of this text is the air that it circulates among its partitions. The links are invisible, all appears improvised or juxtaposed. It induces by agglutinating rather than demonstrating, by placing things side by side or prying them apart rather than by exhibiting the continuous and analogous, teachy, suffocating necessity of discursive rhetoric'. (Derrida 1974: 88) This new kind of philosophy, in its rewriting, that is re-spacing, of all traditional notions of space and time – the co-ordinates of our intellectual word and world – inevitably reinvents those co-ordinates, re-marks certain spatial figures in order to disrupt any of our too well formed conceptual habits.

(Jardine 1985: 184–5)

In a parallel sense, the artist's search, in the awareness of precisely such constraints within language, does not end with the paintings' material findings, but proceeds through accumulations, by 'agglutinating rather than demonstrating', as Derrida so aptly describes. Through the making of the work, between the practicalities and the fantasies, we are often propelled in unexpected directions.

DANCING WITH PAINT[3]

Dis-cursus – originally the action of running here and there, comings and goings, measures taken, 'plots and plans'... These fragments of discourse can be called figures. The word is to be understood not in its rhetorical sense but rather in its gymnastic or choreographic accept-ation; in short, it is not the 'schema' but, in a much livelier way the body's gesture caught in action and not contemplated in repose: the body of athletes, orators, statues. The figure is the lover at work.

(Barthes 1977: 3–4)

Over a century ago, Riegl, a specialist in the history of ornament in Vienna, not only proposed the notion of the *haptic* to facilitate identification of particular artefacts, but, in related researches, argued the case that the appearance of ornament as found in items of weaving or wickerwork, was *not exclusively related to function*, however fundamental to basic needs. From his extensive researches he insisted, against prevailing opinion, that *creating* comes before reproducing and called for the recognition of the purely artistic essence of ornament, independent of function, technique and material. Referring in his book *Stilfragen* (1893) to studies he made of archaeological finds relating to the cave-dwellers of Aquitaine he wrote emphatically:

The impetus [for making these artefacts] did not arise from the technique but, on the contrary, from the particular artistic impulse. First came the desire to create the likeness of a creature from nature in lifeless material, and then came the invention of whatever technique was appropriate. A carved reindeer on the hilt of a dagger certainly does not make it any easier to handle. Therefore, it must have been an immanent artistic drive, *alert and restless for action,* that human beings possessed long before they invented woven protective coverings for their bodies, and that impelled them to carve bone handles in the shape of reindeer.

(Riegl 1893/1992: 30, my emphasis)

Fundamental to the act of 'making', as we have seen, is the body's gesture. Riegl drew many lines of investigation together – from the Egyptian lotus motif to the palmette, the acanthus and the arabesque. In *The Sense of Order* (1979), Ernst Gombrich quotes Riegl's stated aim to 'tie together the thread which had been cut into a thousand pieces'. As Gombrich acknowledged: 'It was the thread that linked the earliest Egyptian lotus ornament with the latest arabesque.' (Gombrich 1979: 183) The extensive and intimate study that Riegl made of the arabesque in Islamic art and architecture – in themselves fantastic testimony to the enormous physical endeavours of often nameless individuals – have had a far-reaching, though nowadays invisible, influence on the history of art and design.

 The arabesque itself, however exotic, is less amenable to the vagaries of criticism or fashion, does not offer instant or easy remedies or conclusions. Its connection with writing, as opposed

to 'image-making', is in itself paradoxical in the context of the architecture and art in which it figures so predominantly. The 'arabesque' immediately conjures an elegant move in ballet. Used as an adjective it refers to the flourishing element in Islamic design. Its dictionary definition characterizes it simply as: 'surface decoration composed of flowing line fancifully inter-mingled.'[4] For our current purposes, we can note only briefly here this 'fanciful intermingling,' which draws us together through centuries of broken threads. It is no heal-all, though it may remind us of our common roots, desires, memories.

In the artist's studio we witness an individual immersed in activity, whose movements become a dance conditioned by the exigencies of chosen methods, juggling materials which are by turns mixed, poured, pooled, thrown, coaxed and cajoled. Barthes referred to such actions and gestures as *'fragments of discourse'*, which *'can be called figures'*. (Barthes 1977: 4) In our everyday activities – forays to find particular paints, colours, brushes etc – we become acutely aware of the minutiae that determine our actions. We search for those 'fragments of discourse', the loops barely glimpsed, the whisperings. There will be countless other threads to mend or extend, more canvases to prime, future narratives to conjure, diversions and dead ends to contend with, 'plots and plans'. An endless list to sustain this thing we call work.

NOTES

1. I have known Jo Bruton, Beth Harland, Nicky May and Katie Pratt for some years; we have at times exhibited or taught together, but the opportunity to talk to them in the general clutter (or otherwise) of their studios in the context of writing this chapter was a rare event and greatly enjoyable. All quotations by the artists are taken from these conversations during 2001.

Jo Bruton's most recent solo exhibitions include: *Walk slowly towards the light*, Matt's Gallery, London, 2002; and *Silhouette*, The Winchester Gallery, 1997. She has exhibited widely in group shows around the world, most recently in *Warped: Painting and the feminine*, Angel Row Gallery, Nottingham and on tour; *Please – Jo Bruton & Katie Pratt*, 291 Gallery, London, 2000; and *In*

Front, Art Public, Barcelona, 1999. She lectures at Chelsea School of Art & Design and Winchester School of Art.

Beth Harland's recent exhibitions include: *After*, the gallery at Central School of Speech and Drama, 1999; and *Closer Still*, Artsway, 2001 and on tour, which she curated for Southern Arts touring. She has also exhibited in Rome and Naples in 2000 as part of a recent scholarship to the British School at Rome; and John Moores, Liverpool, 1999. She also lectures at Winchester School of Art.

Nicky May was born in Co. Derry, Northern Ireland. Solo exhibitions include: John Hansard Gallery, Southampton, 1990; Frith Street Gallery, London, 1991; Cornerhouse, Manchester, 1994; Victoria Miro, London, 1994, 1996; Proposition Gallery, Belfast, 1998; and 291 Gallery, London, 1998. His work has been exhibited internationally, most recently at PSI, New York in 1999/2000. He received a research award at Delfina Studios, London, 1998–2000, and an F.U.P., N. Ireland award, 2001–2.

Katie Pratt is currently AHRB Research Fellow at Winchester School of Art. She has exhibited extensively in London and internationally, winning the 2001 Jerwood Painting Prize. Solo exhibitions include: *Alluvium*, Houldsworth, London, 2001. Group exhibitions include: *Germinations 7*, Le Magasin, Grenoble, 1992; Budapest Galeria & Centre of Art, Bratislava, 1993; South London Gallery, 1999; and *Please – Jo Bruton & Katie Pratt*, 291 Gallery, London, 2000.

2. It may help to think of a useful distinction, whereby the term 'decoration' is seen as relating to the *use* of ornament on objects or in architectural details.

3. This relates to 'dancing brush': a technique in classic Chinese calligraphy; but it also refers to the relative autonomy of the materials.

4. *Oxford Reference Dictionary*, see under 'arabesque'.

CHAPTER 7

SEEING AND FEELING

Rebecca Fortnum

TELLING IT LIKE IT IS

Let me start with an anecdote. In 1994, I went to a talk at the Institute of Contemporary Arts in London by the American artist Kiki Smith. I had been both excited and disturbed by her work at the time, which included papier mâché body casts, often depicting women in positions of bondage or pain. At the talk, I asked her how she felt about exhibiting such images of women and whether she felt some responsibility for a viewer's pleasure in the spectacle of their suffering. Very clearly she stated that her responsibility as an artist was to make work from her experience – she was just telling it like it is. Now, not all artists make, or want to make, work that reflects their subjectivity so graphically, but Smith's statement does represent something of a dilemma, particularly for a woman artist. How can one make work that represents or originates in experience whilst attempting to be responsible for an audience's engagement with the work, planning how it might communicate and whom it may address? Recent years have seen the term 'audience' become an important part of the artist's vocabulary – and not just on grant application forms. Of course the work of the 'new art history', which examines and dismantles the political beliefs and ideological values inherent in cultural works, affects all artists working today.[1] But for women the stakes appear somewhat higher, absent as they are in all but image from art history until

very recently. Depicting female subjectivity then becomes both imperative and extremely problematic. What if, as in the case of Smith, this expression can provide misogynistic inter-pretations? Must 'self expression' be in 'quarantine' for women artists, as feminist critic Griselda Pollock has said?[2] As an artist, is it either possible or desirable to police one's own experience? Should work by women artists only offer pure interpretations, either critical or celebratory? As artists, must we take on more responsibility than we truly want, secretly sympathizing with the art student's plea when first called to account for their work: 'You can read anything into it you like, I just made it'?

This chapter examines how artists deal with the politics of their work. It looks at the work of three women artists, all members of a generation inheriting a feminist art movement that claimed the 'personal as political', to consider how their experience relates to their artwork. Whilst feminism or feminist art may have had varying degrees of influence on these practices, I feel it is important that its presence is acknowledged, for it provided a pathway where experience was not only valid as subject matter, but also offered the possibility of opening out beyond the self, of having wider political implications. I have chosen to explore the work of two British artists, Jane Harris and Sam Taylor-Wood, alongside my own, in order to draw out concerns which are similar but articulated very differently. Jane Harris (b.1956) is a painter who has been at the forefront of discussion about the viability of painting in the UK. Sam Taylor-Wood (b.1967) is an artist with an international reputation who principally uses photography, video and film. For Sam Taylor-Wood and myself, this investigation of subjectivity explores the 'truthfulness' of human emotion. For Jane Harris, the study is more oblique, ascertaining the limits of formalism as a vehicle for expression of many types of sensory and intellectual experience. In both practices, I look at how responses to a notion of subjectivity collide with issues of artistic responsibility in relation to audience. I examine how the viewer becomes the site of activity, where dilemmas (ways of seeing and understanding) are played out. I have deliberately chosen to place an artist using lens-based media alongside those using paint. Too often, art works are defined by media rather than content and in making connections between supposed 'new' and 'traditional' media,

which, in these practices at least, undoubtedly influence each other; I hope to challenge this perception. Indeed it is interesting to investigate how different media can be used to explore similar areas of enquiry. It seems to me that 'denunciations of painting as a corrupt bourgeois commodity' (Deepwell 1994: 15) still linger uncomfortably at the margins of any discussion regarding the viability of painting as well as unsubstantiated notions that time-based work is *in itself* radical. It seems to me all mediums have the *potential* to be critical.

I would argue that what Kiki Smith was doing in the works previously described was indeed radical. As a woman artist, she was occupying the position of both subject and object simultaneously, something largely unrepresented in our history of art. Although interpretations of her work may be many and varied, her figures are significantly different from male sculptors of the contorted female body, such as Reg Butler or Allen Jones. For example, the body type depicted, the materials the work is made from, its context within her oeuvre, all lead away from these depictions of women as 'the scenery on to which men project their narcissistic fantasies' and towards 'exhibiting [women's] own fears and desires'. (Mulvey 1973: 16) Smith may indeed feel rage against women, even against her own body, but should those feelings be censored?

GETTING 'INTO' THE WORK

What is the relationship between an artist and her work? This is fraught ground for the art historian or critic, for whom the 'death of the author' means referring to biographical information only when contextualizing the artist. It is difficult for the artist too, who often talks in terms of 'giving away' or 'covering up' information and explanation, as if this were a possibility. Sometimes an artist may be aware of autobiographical readings of a work, at other times they may be oblivious to any personal connotations. I see no point in trying to investigate the notion of subjectivity by attempting clumsily to psychoanalyse these artists via their work, tempting though it sometimes is. A more fruitful approach is to examine how the artists under scrutiny subvert accepted forms in a way that includes the personal, the idiosyncratic and the particular. What interests me is the way

these artists set about injecting known genres with unexpected moments; moments of pleasure and pain, recognition and rupture.

The artists do not make work purely for their own gratification or catharsis; for them, the emphasis is on how the viewer assimilates and understands the work. To return briefly to the art students' plea for multiple interpretations of their work, one must recognize it is based on certain assumptions, namely that an audience exists for the work and that this audience will invest time and energy in constructing an interpretation. However, for these three artists, the relationship between artist, artwork and audience is a considered one, as they recognize; that meaning is something constructed by *both* artist and viewer in the collaborative venture of making and looking. There is an understanding that, whilst an artist's intention is not necessarily the same as its meaning, the viewer/critic does not have absolute autonomy in dictating what something might be reasonably said to 'mean'. Rather, in these practices the artist seeks to set in place a number of possible viewing experiences, through which the viewer will not passively uncover meaning, but will actively construct interpretations. Indeed these artists set out to 'court', if not control, the viewer, placing her at the centre of the work, attempting to enact meaning through her experience of the work.

THE CHOREOGRAPHY OF THE VIEWER

I want now to look at the journey or movement of the viewer's body around the artwork as she looks at it, at her physical and perceptual relationship with the work. What becomes apparent during any reflection on this subject is that this 'choreography' operates on both temporal and spatial dimensions and, further, that these two aspects are complexly interwoven. Viewers examine the artwork *over time* (however short our contemporary viewing experience) and *in space*, as their investigations draw them to and fro around the work. These thoughts began as a reflection on my own position as a viewer and have been substantially helped by Norman Bryson's writings on 'The Glance and the Gaze', a discussion of the different types of looking that western painting has employed. Although his work deals specifically with representational painting, his reflections on the physicality of both the reception and making of painting

are extremely pertinent to the medium's more recent past. For Bryson, the trajectory of the history of western paintings has been from what he terms 'the Gaze' to the 'the Glance'. To simplify, 'the Gaze', as demonstrated in the early Renaissance, organizes its image around a fixed 'founding perception' in which the laws of perspective are obeyed and the viewer occupies the same position as the painter, sharing his fixed viewpoint of the proceedings. Bryson describes it thus:

[T]he Gaze of the painter arrests the flux of phenomena... in an eternal moment of disclosed presence... in the moment of viewing the viewing subject unites the Gaze [with the founding perception of the painter] in a perfect recreation of that first epiphany.

(Bryson 1983: 94)

The Gaze is 'prolonged, contemplative, aloof and disengaged'. (Bryson 1983: 94) Interestingly it relies on the viewer's bodily engagement with the work; it positions her if you like, even if its intention is to focus on the nature of the spiritual, 'the vanishing point is the anchor of a system which *incarnates* the viewer, renders him tangible and *corporeal*'. (Bryson 1983: 106, my emphasis) The physical nature of the artist's activity, his own movement around the canvas also becomes concealed as western painting develops. Traces and re-workings of brush marks are over-painted, so that the palimpsestic nature of the process is rendered invisible and the body of the artist becomes further removed from the artwork. These subsequent developments in painting lead Bryson to outline his notion of 'the Glance', which he demonstrates in the work of Vermeer. In work that employs the Glance, 'the bond with the viewer's physique is broken' for 'there is no single distance [where] the spectator discover[s] [the image's] global intelligibility'. (Bryson 1983: 116) Throughout the work, different parts of the painting are rendered with different levels of focus and are subject to differing treatments, some meticulously detailed, other areas rendered with sketchier broader brush strokes. The labour of the artist, his body as an extension of his brush is implied, yet the viewer's body is not now placed so tangibly. In the case of the Glance, 'the spectator is an unexpected presence' rather than a 'theatrical audience'. (Bryson 1983: 111) The viewer's gaze is

intermittent, broken, hence the word 'Glance'; her body is not placed so concretely in space. Because the painting, 'is conceived... as a plurality of local transcriptions... the viewer can try any number of points and distances away from the canvas, but *the image will never cohere*, singly or serially around them'. (Bryson 1983: 116, my emphasis)

Figure 16: Jane Harris, Come, Come, *2002, oil on canvas, 112 x 152 cm. Courtesy of the artist.*

These distinctions are pertinent to the works of Jane Harris. In the UK, the work of Jane Harris has been at the forefront of discussion about the viability of contemporary painting, prompting the artist and writer Nick de Ville to write an 'appreciation of Jane Harris' painting, which is also a dispute with Douglas Crimp's *The End of Painting* in which he asserts the codes of painting are bankrupt'. (de Ville 1994: unpaginated) Harris makes deceptively simple paintings within strict parameters, of ellipse(s) with fluted edges, using two colours and consistent brush strokes. However, what is exciting about these paintings is that, on examination, their ostensible simplicity gives way to an unfolding complexity. The paintings

carefully balance an interest in process and surface with an investigation on the spatial possibilities of the image of the ellipse. They may initially appear to offer spatial recession and yet the insistence of the material nature of the work, for example the carefully repeated brush strokes that almost 'knit' a surface, often contradicts the possibility of illusionism. In the printed image, the paintings become static, singular, but standing in front of them, walking around them, these are works in a constant state of flux. As the viewer changes positions, the light shifts and the paintings move through a series of subtle optical transformations. Charting the position of the spectator of her work, one not only realizes how well it demonstrates the characteristics of the Glance but, interestingly, that it also tempts us with the possibilities of the Gaze. Indeed, it initially proposes the straightforwardness of the Gaze with its simple shape and evenly rendered surface, which gives no hint of the layers of other colour beneath. The paintings might at first be understood as meditative, perhaps to be viewed with the same static relationship that Rothko proposes, hence the gallery seating often arranged in front of his paintings. However, as I have pointed out, a sustained viewing offers us instead the uncertainties of the Glance at its most extreme. They require a moving spectator; as Harris herself has said, 'you have to respond physically to them, they demand that you do that'. (Harris 2001) However, this movement means we simply cannot pin the image down, in Bryson's words, it *'will never cohere'*. In conversation, Jane Harris reflects on the original inspiration for her work, which gives us insight into her deliberate exploration of this mobile viewer. On completion of her postgraduate studies, Harris took up a scholarship to Japan to study formal gardens. She said:

I learnt that there are two main types of gardens: 'of sitting down type' and 'of walking around type'. In one you sit statically and contemplate the elements within the whole garden. In the other you are guided around in a specific way coming across prescribed viewing points, thus seeing aspects of the garden from different positions but never having a complete overview of it. I think that I think that is something that is really connected to my work that you can sit in front of it and you can walk around it. I wanted those two things to combine, gel.

(Harris 2001)

The mechanisms in Harris' painting that ensure this mobility take several forms; most importantly, there is the ellipse itself. The ellipse is the circle as sphere, rotating through space, hovering between two and three dimensions in a state of 'becoming'. It proposes a spatial possibility away from the flatness of the painted surface and thus becomes extremely problematic when subjected to the Gaze. Martin Hentschel explains, when writing of Harris' most recent work, 'because the ellipse has two focal points we are prevented from fixing our gaze on a certain spot'. (Hentschel 2001: 15) The viewer's eye is constantly drawn to and fro between these two points or axis from which the ellipse appears to pivot, searching for a privileged vantage point where the image can be seen as a whole. This refusal to provide a resting place for the spectator's vision continues to be explored within the paintings both inside and outside the ellipse itself. In some works this means a repetition of up to four ellipses and in all works it means that the ellipse is given a fluted edge, each 'petal' of which is part of a much smaller ellipse. The repercussions of the repeated larger shape are interesting, as it often draws on this sense of more than one focal point that the ellipse has already brought into play. This is particularly evident when two ellipses are employed side by side either vertically or horizontally. Godfrey Worsdale has written in relation to Harris' drawings of their inability 'to function as a plausible, singular and unified composition', (Worsdale 2001: 4) and for the viewer this rings true; there is a strong sense of the bi-ocular, almost as if viewing one ellipse with one eye, while simultaneously viewing the other with the second eye, and then trying to compare notes. Harris herself says of these works: 'They are ostensibly the same, the same form repeated, but they occupy different spaces on the canvas, so however much one tries to look at them as the same, they never are.' (Harris 2001)

As with the ellipse itself, one is aware of an almost physical to-ing and fro-ing between the images, adding to the paintings' sense of movement and inability to be viewed as a whole. In addition, the fluted edges, which often appear outside the ellipse on one side and inside on the other, enforce this sense of movement. The edging is no decorative flourish but is intrinsic in forming the ellipse itself.[3] It provides the edge between figure

Figure 17: Jane Harris, 10:9, 2001, *graphite on paper, 57 x 76 cm. Courtesy of the artist.*

and ground. Often, because of the shift in the size of these smaller ellipses and the way they are made with the brush, some positively, some negatively, from one side of the ellipse to the other, what appears to be a stable figure-ground relationship can be optically reversed; the ellipse 'sitting' on the coloured ground becomes a 'hole' in that surface. The way the surfaces are built with small uniform brush strokes also allows this to happen. As the light hits the brush marks, particularly in the works where both ground and ellipse are close in hue and tone, the figure-ground relationship can alter. As the body moves around the canvas, the eye is constantly moving between shapes, between sides of the ellipse, judging symmetry and spatial placing. One is made supremely aware of the activity of looking, of making visual distinctions. On a more subjective level, this sense is further enhanced by a figurative reading of the ellipse as an ornate mirror. Its reflection disturbs, a non-reflective pool, it erases the viewer who stares into its blank surface, vainly. It appears to offer the possibility of recession, escape, a meditative confirmation of the viewer, yet its mutable materiality both denies and insists on the viewer's physical presence, caught between the Gaze and the Glance.

In this work, one is made aware of looking as a serial activity. These pieces unfold over time rather than being simultaneously exposed as we may expect from works on canvas. Here painting is a material object existing in the same material space as the body of the viewer. We are made aware that the spectator's transaction with the work is active as well as passive and, more, that the work operates on a finely tuned balance between the two. What is remarkable is that Harris achieves this fundamental questioning with such precise concision. Although the paintings initially propose a notion of formal purity, they cannot be contained by it and instead reflect on Harris' empirical knowledge. Her work is fed by exchanges with the world, both visual and verbal, as her interest in formal gardens demonstrates. Harris mentally catalogues colours she sees and words read and heard for future reference in the making and titling of her paintings. By refusing the standard categories available to her, Harris makes works that constitute radical rather than pragmatic statements. In the same way that the ellipse fluctuates between being perceived as figure or ground and the paintings alternate between abstract and figurative categories, they are also neither purely formal nor purely conceptual. The painted canvas is not a stable object; rather it forces the audience into an interpretative act and thus acquires a political dimension. The work aims to ensure that the audience exercises its viewing responsibility.

THE BODY OF THE ARTIST

Sam Taylor-Wood's work also deliberates around engaging the body as well as the eye. The debt of her photographic and video work to painting is obvious, from her use of the narrative device of the predella and her photographic transcriptions of Old Master paintings to the 'painterly eye' employed to compose her sitters, which appear with the sense of stillness required by an observational painter rather than a documentary photographer. I begin by examining a very early work, *A Gesture Towards Action Painting* (1992), which tackles this relationship to painting directly and, in doing so, explores notions of time, the body and performance, to which she returns in greater depth in subsequent works. The series of colour photographs were made at a time when Taylor-Wood was an emerging artist and they

Figure 18: Sam Taylor-Wood, A Gesture Towards Action Painting, *1992, colour photograph. Copyright the artist; courtesy of Jay Jopling/White Cube (London).*

recreate the famous Hans Namuth 1950/1 photographs/film of the abstract expressionist Jackson Pollock making huge dripped canvasses, but with herself in the title role. Taylor-Wood recognizes the significance of Pollock, not only his position of influence on succeeding generations of artists, but of his image as an icon of 'modern' genius. Perhaps the most obvious interpretation of this work revolves around issues of gender. As has been discussed elsewhere, these images attribute to Pollock qualities of strength, virility, masculinity.[4] To reposition the body of a female artist at the heart of this creative production implicitly refers to this reading of the image. The work is both piss-take and 'homage', in a cheekily bold statement of ambition, the artist assumes the place of the 'modern master' whilst undoubtedly questioning his authority. What is also interesting here is the use of the artist's own image in this and other early works, which suggests a personal engagement or sense of disclosure that never fully materializes. Although Taylor-Wood

has said of the early 'self-portraits', 'I wanted to expose myself
in all my ugliness and discomfort', (Celant 1999: 256) for her,
like Cindy Sherman before her, the self-image becomes a way of
questioning, rather than revealing, identity. This ambivalent
stance is surely made possible by early feminist investigation
of gender roles and stereotypes, but this interesting set of
photographs goes further in its critique of painting and its
history, whilst examining the roles of artist and audience.

One of the exciting aspects of Pollock's work was his break
with the direction of western painting towards the Glance in
favour of returning to the Gaze. Indeed his painting as a self-
revealing tracing of the movements of the artist's body
demonstrates Bryson's definition with startling accuracy. He de-
scribes it thus: 'it addresses vision in the durational temporality
of the viewing subject; it does not seek to bracket out the process
of viewing, nor in its own technique does it exclude the traces
of the body of labour'. (Bryson 1983: 94) The viewer tends to
step back to allow a large canvas into her sight, to view the work
as a whole and, although she may step forward to examine areas
more closely, the paint drips and marks gain no great clarity on
closer scrutiny, there is no 'plurality of transcriptions' or sense
of detail in this self explanatory process, where all marks require
the same focus. Standing in front of these paintings, walking
along them, the viewer yearns for the same epiphany that the
artist undoubtedly experienced during their making.

There is little doubt that knowledge of Pollock is framed by
the Hans Namuth film. The vision of energetic (male) bodily
engagement with abstraction is perhaps one of modernism's most
enduring images. The film/photographs naturally propose
themselves as secondary to the experience of being there,
watching 'genius' unfold over a blank canvas. Even the painting
itself appears as a relic of the performance, a recording of the
moment when creativity happened. The 'real' artwork is the
theatre of Pollock's movements and marks, the primary event,
and any debate around the works is usually eclipsed by
discussion of this process. But this event is elusive. Just as
Pollock himself found it difficult to perform for the camera,
history intervenes and we move further and further away from
the moment we hope to capture. The photographs then give us a
hint of the immediacy and directness of the activity. The

paintings engage us physically as we stand or walk in front of them we re-live their making, whilst the photographs hang suspended in time, forcing the works outside 'the somatic time of their construction'. (Bryson 1983: 94) This dilemma seems to be what Taylor-Wood responds to. Her set of photographs reinforces the predicament in which Namuth places us. They acknowledge Namuth's tantalizing hint at the genuine, albeit transitory, physical engagement they appear to document, yet accept that the artist and his work are subsumed in the re-creation, ultimately the fiction. Taylor-Wood's interest is in what the works have come to mean, rather than in what they may have been at the moment of production. She accepts that the photographs withdraw from the 'physical continuum' (Bryson 1983: 89) of painting and embraces that sense of loss as an emotional truth. All Taylor-Wood's work pivots on such a dilemma between the physical and fictional showing us how fiction can sometimes *feel* more authentic than reality. As Michael Archer has written, the early works are, 'the laying bare of herself and her desires in front of art's and the world's operational dynamics prompted by the need to investigate the limits of such concepts as intention, responsibility and effectivity'. (Archer 1993–4: 19)

In later works, Taylor-Wood investigates these ideas more dramatically. Often the pieces have an overt emotional content depicting human interaction at moments of extreme experience. For example, a recent exhibition – *Mute* at the White Cube Gallery, 2002 – contained a projection of a girl crying and another of a contemporary *Pieta* scene. This highly charged content allows Taylor-Wood to address her audience directly, questioning how they relate to such material. Do we engage with the emotions of others with compassion, empathy or sympathy, or do these emotions slide into a compelling voyeurism for others' pain and distress? Indeed, is the notion of 'good' and 'bad' viewing an irrelevant concept, as 'looking' is an amoral activity? These are timely questions in a society, which currently indulges in reality TV's confessional *Oprah* and *Big Brother* programmes. Taylor-Wood uses a number of strategies to draw her audience's attention to their part in the viewing process. For example, the status of her 'characters' is unsettling. The use of trained and untrained 'actors' in her video works blurs the line between fiction and

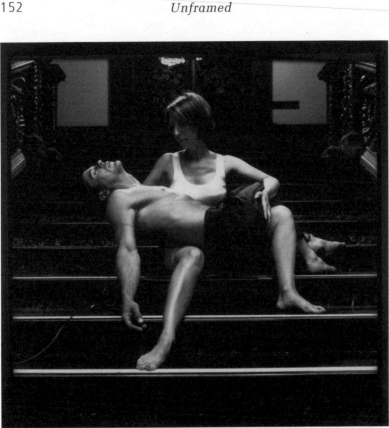

Figure 19: Sam Taylor-Wood, Pieta, *2001, 35mm, duration 1*
minute 57 seconds. Copyright the artist; courtesy of Jay Jopling/
White Cube (London).

reality. This is also seen in the film, *Method in Madness*, where a
method actor emotionally breaks down for the camera. These
strategies create a similar sense of disturbance that a viewer might
feel if, on switching on the TV, they were unable to distinguish
between a documentary and a drama – a nicety becoming harder
to perform. Taylor-Wood capitalizes on the moral confusion that
this engenders – should we watch differently, feel more, if we
are watching real, rather than acted, trauma? She appears doubtful
of our ability to make such distinctions in our emotions, or of
making a 'responsible' response.

 Another strategy is her use of celebrities to pose in both video
and photographic works. For example, the 'Christ' figure in *Pieta*
is the actor, Robert Downey Jr., while Taylor-Wood is 'Mary'

and other works have included well-known singers and actors such as Kylie Minogue, Ray Winstone and Elton John. In these works there are none of the obvious moral dilemmas that accompany looking at the images of 'ordinary/extraordinary' people such as those taken by Diane Arbus or, more recently, Richard Billingham. These are people whose job it is to be looked at and we are encouraged to do so with the same moral impunity, or at least distance, as a reader of *OK* magazine. But what is interesting here, as tabloid exclusives continually remind us, is the desire to find the 'real' person within the celebrity public or 'fictional' persona. Indeed Robert Downey Jr. is a good example of this dramatic slip between the glittering 'public' acting career and the catalogue of gossip column inches picturing a 'private' life of despair and addiction. This perception of a truthful, 'inner' self is useful to Taylor-Wood, as it is deliberately unclear which of their identities is being performed in her work. Are these celebrities acting or being themselves, or is it futile to attempt such a distinction? Perhaps they are acting at 'being themselves'? These strategies of disruption allow Taylor-Wood to draw her audience's attention to their part in the contract: the act of looking and the responsibilities it may, or may not, carry.

Taylor-Wood, like Harris, 'choreographs her viewer', making her physical placement vital to the experience of the work. She opens up the space of photography and film to the possibilities of painting, most specifically the Gaze, which is simultaneously longed for and debunked. The video projection installation *Travesty of a Mockery* (1995) quite literally places the viewer 'in' the drama as the viewing space becomes the distance between the warring couple who occupy two separate projections. In *Pent Up* (1996), the viewer must walk from character to character in order to hear their speech and thus physically make sense of their dialogue. Different ambulations will result in different experiences of this dialogue and it is unlikely that any two people will experience the work in the same way. Like other types of performance, most particularly dance, the audience has to make choices about where to look resulting in endless permutations of the audience's experience. Similarly, her panoramic photographs require the viewer to walk the length of the image, experiencing it sequentially. Although it is difficult to register the work from a single vantage point – at 25 feet in

length one is forced to move to examine it – the image itself very precisely situates the viewer as the central point from where the activity depicted occurs in a 360-degree revolution. In this sense, the audience is embodied, occupying the position of the '*founding perception*', where the artist's body (her 'I') and the camera's 'eye' converge. Taylor-Wood disrupts the notion of photography as outside the 'physical continuum', and expands it to function 'in the somatic time of [its] construction', (Bryson 1983: 94) as the title, *Five Revolutionary Seconds*, demonstrates. Indeed a clue to the importance of the artist's body is to be found in the many photographs that document her physically making her work, directing or behind the camera.[5] Her published iconography shows her as active, 'in' the work, rather than directing from the sidelines. It is through this reinstatement of the body, both the artist's and the viewers', that the theatre of performance can be punctured, however slightly. *Pieta* occupies the place of a painting – a silent, two dimensional wall-based image. The audience is positioned in the scene at the foot of the stairs, gazing up towards the figures as one might with a Masaccio altarpiece. Yet its muteness, the inscrutability of the passion depicted, is challenged by the smallest of slippages, the breathing and slight bodily adjustments of the artist and her 'model'. I believe it is in these slight physical awkwardnesses, where the 'performance' breaks down, that we find the longed for intimate, yet elusive, authentic experience.

SEEING AND BEING

Lastly, I shall write about my own work with reference to the ideas explored above. When writing about my own work, many anxieties present themselves. Foremost of these is a sense of 'talking for' the work, rather than allowing it to speak for itself. My fear is that intention will conflate with meaning and the art's possible autonomy will be lost. For me, there is always a sense of not being able to write 'enough' as it were; for every aspect 'pinned down' another floats away, unarticulated. However, I have found it useful to site my own work amongst other practices as a way of engaging in a dialogue with the concerns of other artists, creating an exchange which I feel allows the work a certain currency for me as a practitioner. But

I am in no way a disinterested critic and imagine that my prejudices will become most apparent in this last section. I write from within the practice about the works in the order they were made, explaining developments as they occurred and I noted them.

Born in 1963, I am placed between the two artists chronologically and my work shares concerns with both practices. As a student, I became interested in how an artwork might bridge a cultural producer's politics and experience, that is the conflict between what an artist wants and knows to be. Drawn to feminism, I soon realized that the making of a coherent polemical work required a far more analytical approach than I was interested in developing. I used my art as a way of reflecting and understanding my place in the world. I forfeited its didactic possibilities for what it could teach me. That is not to say that I don't have a clear intention for the work, it's just that I enjoy the fact that art has the ability to surprise even its maker. Making is a curious process, the idea and its physical realization are in constant dialogue, often shaping each other in a mutual interrogation.

My early interest in women's writing and contemporary dance led to imaging the corporeal, close up and subjective. Paint was worked to form a 'skin', colours, most particularly 'blood' red, referenced an internal body. Later works lost these overt references and substituted a muted palette of grey, white and black, yet retained an interest in the materiality of both the painting and the body and now the body of the viewer became important. These were large-scale paintings (between seven and eight feet in height), and viewers came physically to orientate themselves in front of them. Grid-like structures echoed the gallery space, forming spaces, doorways and columns whilst the impastoed paint surface required the viewer to walk in close and examine the sense of detail. John Gillet, writing in the catalogue for *Contra Diction* at the Winchester Gallery, described them thus:

Apertures appear, suggest opportunities for entry, exit, illumination, enlightenment, escape; hair lines cross, locking the scanning inner eye on its target, and simultaneously barring the way forward or out of here. For this is what and where we are.

(Gillett 1993: unpaginated)

Here was a sense of bodily engulfment, where it seemed that language was muffled to the point of silence: 'Black is perhaps the most difficult colour to articulate. Here it suggests both depth and silence with a richness of underlying colour, which spills through in cracks or lines that open up the painted surface.' (Betterton 1994: 24)

In 1996, I exhibited a number of works under the title *Third Person* in the Kapil Jariwala Gallery, London. In these works, handwritten texts were inscribed into the columns of impastoed paint. These texts were edited versions of diary entries, unwanted or unconsidered writings that sprang from joy and despair, representing several male and female voices of different ages and social positions. They were placed alongside fields of colour 'dyed' into the surface of the canvas that contained minimal perspective lines. Of these 'spaces' Greg Hilty wrote:

They forcefully convey psychological space as a counterfoil to the activity implicit in the texts: a space that is naked, sketchily rendered, flat and uninflected, contradictory, semi-rational, mysterious, banal, infinite in its implications and totally restricted in fact.
(Hilty 1996: unpaginated)

These works anticipate how a spectator might receive them. I imagine how, at first glance, the viewer will see the work as a whole yet be enticed to walk in to examine the surface, being rewarded with the detail of their making and the 'text', which becomes readable. Viewing the painting up close fills all peripheral vision, this nearness creates a sense of intimacy, enhanced by the reading of 'private' words. The act of looking has been superseded by the act of reading, both of them quite different experiences. The viewer would then draw back, balancing what she has read with what she has seen, which will be different for each viewer. As with both Harris' and Taylor-Wood's work, the spectator is the site where the work happens, in which the different elements coalesce or are held in balance as discreet entities. The moving to and fro, in and out, in front of the canvas is important; the text cannot be read from far away nor can the whole text be read close to. This constructs a mobile and engaged viewer. The slowness of the text's making (they are built up with layers of paint and washes) contrasts with the

immediacy of the text's tone and calls into question their 'truthfulness' – they seem written from the heart but perhaps they are fictions? They share with Taylor-Wood the problem of depicting 'genuine' emotion. These 'spaces' often shift vanishing points from one side of the canvas to the other and thus draw 'the viewer's space into the equation, as if they must consciously reorientate themselves' (Hilty 1996: unpaginated) as they walk around the work. Like Harris' paintings, the relationship with the work changes as the viewer moves. The theorist Diane Hill argues this further, when she talks of the viewer's experience of the textual content leading her to re-orientate herself:

'within' each work – that is, within the duration of experience of that work... Thus, the experience of art becomes plural and emphatically durational – shifting but emphatically situated – both physically and conceptually. Here we have a situation where we seem both to be beyond time, drawn into a contemplation of visual particularity and specificity in an engagement reminiscent of modernist notions of contemplation beyond time yet simultaneously drawn back into temporality... These works could be said to re-embed the act of visual contemplation, which is traditionally conceived as transcending time and place, into the complex matrix of lived raw experience.

(Hill 1999: 152)

My most recent body of work, *Solipsist*, shown at the Angel Row Gallery, Nottingham in 2000, is more explicit in the investigation that the earlier works sets up. In this series of large works on canvas, lyrics from Indie band songs are inscribed in the columns. The 'spaces' are also retained and are now more obviously rooms: the home, studio, gallery. These hugely popular bands – Radiohead, Manic Street Preachers, Everything But The Girl, The Charlatans and The Verve – write more considered lyrics than an average pop group. They are both meaningful, to those that listen to and love the music, and meaningless, being played incessantly in shopping malls and radio stations throughout the country. They allude to emotions, perhaps even provoke memories of heightened experience yet, when written down, stripped of the melody, diminish to bad poetry. The poverty of the experience, or at least its lack of uniqueness, is also increased as we are aware how quickly such

Figure 20: Rebecca Fortnum, 'It's a bitter sweet symphony...',
2000, oil on canvas, 2440 x 3047 cm. Courtesy of the artist.

songs 'date'. Often they are associated with certain memories,
set in the particular time of the recording's release. It had become
clear to me that the earlier paintings were usually only partially
'read', because of the physical effort of looking at a large paint-
ing. The use of lyrics thus seemed appropriate as we often only
hear or remember snatches of words when listening to songs,
yet they still evoke memories and feelings. The song's emotion-
al content, coupled with the emotion the song produces in the
listener, hovers between private and public worlds. As with
Taylor-Wood's work, the performative nature of feeling is alluded
to: do emotions exist if we don't 'perform' them to another?

The 'rooms' are drawn on a scale that encourages the notion
of walking into the works, testing the body against them. The
fields of colour that in earlier works offered escapist possibilities
are now 'real' places, although the marks of the painted surface
still contradict this spatial depiction. In the two largest
paintings, '*It's a bitter sweet symphony...*' and '*Just when you're*
thinking things over...', it is the gallery that is reflected in the

Figure 21: Rebecca Fortnum, 'Just when you're thinking things over...', 2000, oil on canvas, 2440 x 3039 cm. Courtesy of the artist.

work. Like Harris' ellipse, the painting becomes a mirror that fails to reflect. As the lyrics evoke an absent melody, so the viewer is implicated but fails to materialize. The rooms are free from habitation. In the catalogue, Kirsty Ogg describes them thus:

The sense of absence is a significant aspect of these works. the paintings show practically empty rooms. There are no people represented, but there are traces of human occupation... Sometimes they show the corners of rooms, places to take refuge and wallow in your misery. Some are domestic settings, where you can still feel the reverberations of angry voices and slamming doors. Some are the Angel Row Gallery itself. These works were devised to be hung opposite the spaces they represent, mirroring the venue. The image continues across the panels of the painting, broken up by the text, with slight jumps and discrepancies in continuity. These paintings become representations of a memory of a space – that never quite accurately remembers a flow of details – rather than an accurate record. The human presence is again absent, in this case the viewer.

(Ogg 2000: 10)

These paintings propose a gaze, where the viewer searches for the right spot, the 'founding perception', where the perspective mirrors what she can see behind her. But the perspectives shift, and so the viewer moves too, perhaps becoming agitated as she tries to make sense of what she sees. Walking to and fro, shifting focus between reading and looking, trying to see, as it were, 'round' these textual columns, it is now the Glance that is implicated. The title, *Solipsist*, is a challenge to the notion of the artist, or indeed anyone, living an internalized life. The painter in particular exemplifies this existence, alone in her studio, perhaps listening to music and experiencing emotion, which is then transmitted to her canvas. Yet the paintings reach out to a common experience to which the audience can relate, surely everyone has had these feelings, sitting in rooms, indulging certain emotions? The viewer may substitute her experience as a way of putting herself 'in' the picture. Ogg concludes her essay by writing, 'The joy of these works is that they prompt your own connections between memory, images and music, creating your own personal back catalogue of songs'. (Ogg 2000: 11) Like Harris and Taylor-Wood in their very different ways, these works set out to involve the viewer in the making of their 'meaning'.

For all these artists then, their work exists in deictic time, at the moment when and wherever it is viewed, engaging the viewer directly, both physically and emotionally. This reinvestment in the here and now, this 'interactive' viewing experience, revitalizes the idea of the personal, while removing it from any notion of the confessional. In these works 'self expression' allows space for others to enter, and acknowledges that this is a dynamic relationship; the artists are the first spectators of their work and the spectator is creatively involved in 'making' the work's meaning. And, in *telling it like it is*, or at least how we see and feel it, we begin the important job of communicating and so connecting with the world.

NOTES

1. See Jonathan Harris (2001).
2. Fortnum (1991).

3. 'I prefer the word ornamentation to decoration; the work is ornamental I think, but ornament is there for an intrinsic purpose, not as an add on.' Jane Harris, unpublished interview with Rebecca Fortnum, 12 September 2001.

4. See Shirley Kaneda (1991) 'Painting and its Others', *Arts Magazine*, vol.65, no.10, pp.58–64; and Jill Morgan (1991) paper given at the *Hysteria* Conference, Tate Gallery Liverpool.

5. Fondazione Prada (1999) *Sam Taylor-Wood*.

CHAPTER 8

RESTRETCHING THE CANVAS

Pam Skelton

This dwelling in loss, rather than in a richly detailed space reconstituted through memory, is another term for what Deleuze and Guattari call 'deterritorialization'. This deterritorialization is not just limited to the sociological fact of migration, not just the experience of being uprooted, but an overcoming of the fixation on the metaphor of roots. Their analysis suggests that Kafka, having shed any expectations either of organic identification as a Jew or of fitting with the non-Jewish German literary world, was freed to outline not just a 'minor literature', as they call it, but more precisely a minor ethnography. Kafka's ethnography writes a people's experience in history without presuming to circumscribe that experience, without turning persons into exemplars of a reified culture. Refusing rigid identifications between tradition and place, treating space and time in the same phrase, he knows that a world can disappear in the village just when its echo is heard in Prague.

(Boyarin 1991: 23–46)

HISTORY PAINTING...

Boundaries, temporalities, identities, spaces, territories and subject positions, together with the desire to explore interdisciplinary art practices, characterize the work that I will be discussing in this essay. It will also reflect my concerns and interests in painting, video and digital arts. The shift from painting to new media, together with the desire to retain painting as an option, is particularly relevant to my concerns here. For despite being edu-

cated in a painting department that shunned ideas, I still cannot quite let go of the idea that painting too is capable of communicating contemporary concerns in exciting and moving ways. Ideas in art and the languages and tools that artists use, create meanings that have to be negotiated and tested. I have chosen to look at works in both painting (material) and time-based (virtual) practices made by artists who, like myself, have worked as painters for a considerable length of time before taking up other media.

The work that I shall be looking at is made by artists who have grown up in the changing cultural landscape of post-Second World War England and whose concerns reflect an interest in exploring identities, subjectivities and histories in and around what could be understood as the post-Holocaust Jewish psyche. I am interested here in what Griselda Pollock refers to as 'the revelations of the problems of memory and what has been called an interpenetrated subjectivity – a transgenerational transmission of trauma'. (Pollock undated: 60)

In Britain, the post-World War II generations of children of Jewish descent, to which I belong, grew up in a society which for the most part lived in denial of the genocide that had taken place just a few years earlier and at the same time was largely oblivious to the experience of significant numbers of traumatized Central and Eastern European Jewish refugees who had settled in Britain during and after the war. The green and pleasant land of Britain was a place that had escaped the fate that the rest of Europe had endured and, while British Jewry attempted to disassociate themselves from their Eastern European past, they knew full well that they had narrowly escaped the jaws of death, miraculously sidestepping the unimaginable. My own vague memory as a child was that something hideous had happened that could not be spoken about but, whatever it was, it was indelibly linked to a little blue and white tin box with the Star of David on the front and a slit on the top where the money was put; a familiar sight in every Jewish house in the 1950s. Britain was indeed a safe haven but it was also a place of amnesia where little Jewish girls such as myself knew that they were different, without wanting to be different, and being not at all sure what to do with that difference. It was a difference that was not always visible, it might not show, and therefore could be hidden. What

could be hidden from others, but not from the self, was as I
perceived it then, the stigma and (even) shame of being Jewish.

In the 1980s, artists such as Sonja Boyce, Sutapa Biswas, Chila
Kumari Burman, Lubaina Himid, Keith Piper, Rasheed Araeen
and Eddie Chambers helped to create a space for the reception
and dissemination of a critique of British colonialism and
racism. Yet in Britain, while issues of multiculturalism and
ethnicity opened important questions in relationship to raising
awareness of and giving visibility to 'other' voices and subject
positions, parallel investigations between racism and anti-
Semitism did not occur. The reasons why they did not happen
are complex, but perhaps are located somewhere within an
ambivalence or oscillation between self-denial, total assimi-
lation, fear of exposure and vulnerability on the part of Jewish
people. It is a fact that artworks that addressed Jewish identities
in Britain were either slow to surface or even failed to surface
at all, and therefore it is far from surprising that an art critical
framework to support such art practices, also failed to emerge.
Issue-based art of the 1980s had already come and gone together
with a curatorial interest in identity politics and so, by the early
1990s, when work on these issues was emerging, there was no
critical platform for showing it.[1]

DISTURBING HISTORY

It is in this post-Auschwitz figure, activated through her/his gaze
toward the surface/depth of the painting that the gaze of the artist and
the viewer meet or, rather, merge. In this instance the transparency of
the human body is not a visual metaphor for an alluded fragmentation of
the self but rather for the 'position' of the historical subject that seems
firmly grounded but actually floats within the field of the artist/viewer's
vision.

(Dimitrakaki 1997: 43–57)

Angela Dimitrakaki's discussion here of a series of paintings I
made in the mid 1980s suggests a Foucauldian reading that
considers the concepts of archaeology and genealogy as a method
of approaching the type of history painting that I was engaged
in making. In these paintings, artefacts and figures were buried

in horizontal bands, stacked as if they were geographic strata in an archaeological dig. The painting, *Sumerian Chariots and Space Shuttles* (1985), was representative of a body of work made in this way and was an attempt at self-location and perhaps re-location into a cultural and historical space, in which I saw myself as an onlooker.

Following from the layer paintings, the autobiographical memory works of the *Groundplans* paintings were organized in very different ways. (Skelton 1989) *Groundplans*, made in 1988 and 1989, touched the still sensitive scars of adolescent memory and tried to give form to places that were re-remembered and events that were replayed in my mind. Retrospectively, I understand that they were mainly about the trauma of losing the family home where my mother and I lived when I was 16, a loss that could never really be repaired. The paintings used line as a notation and colour as a resonance or texture, but the subtext to the work was submerged within and through the architectural boundaries of the buildings I remembered, houses and flats I had lived in from childhood onwards. The depiction of the linear female form moving in and through the paintings was certainly a formal device used to organize pictorial space within the area of the ground plan. The space outside was both amorphous and threatening yet at the same time intriguing and inviting. This was an unknown area, a ground ready for a particular and specific exploration.

I had been researching the migrations of Eastern European Jews of the late nineteenth and early twentieth centuries and had collided with the events of the Second World War and the Holocaust, a catastrophe that redefined and irretrievably altered the course of European history. While I was acquainting myself with the history of Eastern European Jewry, I happened to come across a second-hand bookshop in Hendon that no longer exists. I remember the name clearly, 'Sentient Books'. I was rummaging in the cellar, where the mustiest of the books were stored, looking for titles that I had identified as warranting interest when, inadvertently, I brushed against a stack of books that tumbled to the floor. I stooped to replace them on the shelf and noticed that one had fallen open, revealing on the yellowing paper a dedication to my grandmother, Anne Labovitch. *The*

Dangerous Places was first published in 1951 and was a tale of escape and survival. The story begins in a bombed-out cellar in the Warsaw Ghetto where Elsie, an English woman, finds herself trapped beneath the rubble. There she hears cries that lead her to rescue Mila, a young Polish girl who provides Elsie with a reason for redeeming herself, for Elsie is a woman in denial:

I knew what a lump of filth I was all the time I was Frau General, Aryan and German, lawfully wedded wife of Willy von Brockenberg, Hitler's man, Goerings's man... Just as I've known since the moment I came to myself down here that I'm Elsie Silver, Elsie Silver, Elsie Silver, the trollop who betrayed the Jews, her people, and England her country.

(Golding 1951: 8)

From Warsaw, the story follows the journey of Elsie and Mila as they escape through occupied Europe. The book was written by a well-known Jewish novelist of the time, Louis Golding, and is significant to me for a number of reasons, not least because of the strange and very timely coincidence of finding my grandmother's name staring me in the face, but also because this novel alerted me to consider what the lived reality was for Jews in England in the wake of the Holocaust.

The Dangerous Places was probably well read in the Jewish communities in England in the early 1950s, and perhaps provided the necessary palliative for a traumatized community. The picture painted here is itself a sugar-coated fantasy that nevertheless poses interesting questions to do with identity, desire and homecoming. Elsie's journey is one of making amends, of coming to terms with her past, while Mila, the girl from the Warsaw Ghetto who has lost everything, is Elsie's vehicle for change. Elsie has emerged as a heroine who is in the process of trying to redefine herself but, finally, the tough reality of her situation confronts her and she realizes that that she no longer belongs anywhere despite her professed allegiance to England: 'The Jews, the Western Allies, the Russians, the Germans, for one reason or another they would all be happy to see her head on a charger'. (Golding 1951: 295) Whereas Mila, who really is displaced, with no family or home to return to, will find a home in the Zionist dream of Eretz Israel (The land of Israel).[2]

The displacement of vast numbers of people and the redrawing of the boundaries of nation states resulted in a huge European Diaspora in the post-war period, altering and reshaping what could be understood by 'home' in numerous ways for millions of people, and continuing to have far-reaching repercussions and resonances throughout the twentieth century and into the twenty-first. Dislocation and homelessness, relocation and homecoming originate in the upheavals that took place in and between the two world wars of the last century and left a legacy of instability in a racially antagonistic Europe.[3]

TIME TRAVEL IN PAINTING AND THE MOVING IMAGE

The very fabric of time is the medium that the artist Suzanne Treister has employed both as a vehicle and material means from which to explore the twentieth and twenty-first centuries. From the mid 1980s to the early 1990s, Suzanne Treister became increasingly known for her vibrant figurative oil paintings. The repertoire of images that inhabit her paintings suggest partial narratives, moments in history, isolated objects brought together, choreographed into painterly displays conjuring up a semblance of Gothic imaginary. Some of the objects that appear in her paintings might well have turned up in some second-hand shop, such as an art nouveau candelabra with a nude posed perilously on the centre stem, an upholstered Queen Anne chair, richly embossed books, a line of candles, a model of an Indian elephant, or fragments of elegantly moulded picture frames. These images of objects of aristocratic finery are carefully displayed together with a much more mundane collection of practical and ordinary items – scissors, light bulbs, paper clips – that could be found in any contemporary home or stationery department.

In some of the earlier paintings, the images take on the nostalgia of lost items adrift in tiny painted fragments of streets or views of the cities of Europe, or in a Romantic painted landscape of castles, lakes and cliffs. In other works, violently coloured skies and rich velvet drapery provide the backdrop to leather-bound book spines, hinges, chains and bolts. The pictorial space becomes more and more shallow until finally it is replaced by grid-like shapes in the form of bolts, chains and bookends placed on bright flat surfaces. Robert Collins points

out in Treister's 1990 catalogue that her most recurring structural
image is the maze:

> [A] maze is an adventure game whose counterparts in literature are the
> detective and mystery genres. A parallel can be drawn between Eco's
> labyrinthine maze in the library in *The Name of the Rose* and Treister's
> mazes: both are allegorical depictions of philosophical enquiry and both
> are allusions to the work of art itself.
>
> (Collins 1990: 18)

The titles in Treister's paintings offer particular, if conflicting,
readings: *The Last Supper* (1987), *Video Game for Primo Levi*
(1989) and *Koons, Kiefer Video Game No. 1* (1989) reflect a
certain preoccupation with the chronicling of literary and
visual forms of testimony surprisingly in connection with video
games. The *Kitsch'N Shrink* paintings up to 1996 were the last
large-scale paintings that the artist made and which were later
to become incorporated into the multimedia work that she was
to develop. (fig. 22) The paintings depict the lavish baroque
interiors of the Konigsschloss Neuchwanstein, a Bavarian castle
built by King Ludwig and, as in her earlier paintings, they
contain numerous textual and visual references. The Schloss
is reminiscent of a cinematic fantasy space of mystery films or
Hammer horror kitsch, suggesting references from Disney to
Lara Croft. But Treister carefully prepares her vocabulary of
images in relationship to their historical significance, the
castle, an image of German romantic folklore and fascist
mythology and Bavaria, the heart of Nazi ideology. It is also
significant that the Konigsschloss Neuchwanstein was the
actual castle on which Disney used to base his own cartoon
versions of castles.

In 1992, the artist moved to Australia, where her nomadic
lifestyle had a direct influence on her practice, and, in 1995,
she invented the fictional character Rosalind Brodsky, Treister's
alter ego, who was to become an important vehicle in a
succession of forthcoming works in installation, video,
performance, music, computer-generated works and publishing.
Brodsky is a 'delusional', time-travelling, super-cool heroine, a
modern woman, whose research into twentieth-century history
has been facilitated through time travel. Time travel is central

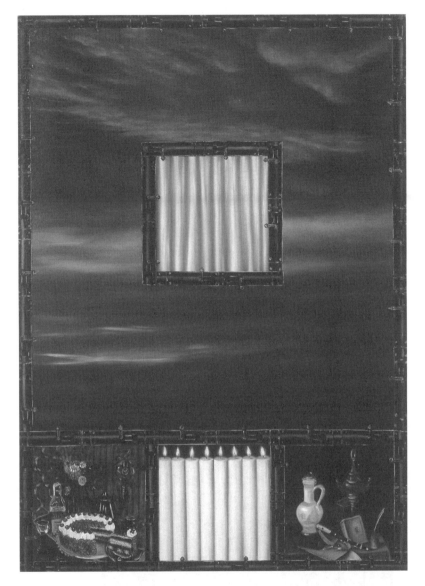

Figure 22: Suzanne Treister, Greetings From the Black Forest,
1988, oil on canvas, 213 x 152 cm. Courtesy of the artist.

to Treister's thesis as a vehicle of return and, as such, a means
of investigation traversing the history of Eastern Europe, the
Holocaust, the 1960s and the Russian Revolution. (Treister 1999)

It is therefore not surprising that Brodsky is drawn to seek coun-
sel from the key psychoanalytic figures of the twentieth century,

Freud, Jung, Klein, Lacan and Kristeva, who take her on as their
patient, each providing a diagnosis of her symptoms according
to their own particular canon. The endless barrage of mediated
histories and the schizophrenic nature of Brodsky's lifestyle are
reminiscent of the type of psychopathology that has become as-
sociated with the postmodern condition of advanced capitalism:

The schizophrenic is not, as generally claimed, characterized by his loss
of touch with reality, but by the absolute proximity to and total instant-
aneousness with things, this overexposure to the transparency of the
world. Stripped of a stage and crossed over without the least obstacle,

Figure 23: Suzanne Treister, ... No Other Symptoms – Time
Travelling with Rosalind Brodsky, *1999, digital image from CD
ROM. Courtesy of the artist.*

the schizophrenic can no longer produce himself as a mirror. He be-
comes a pure screen, a pure absorption and resorption surface of the
influent networks.

<div align="right">(Baudrillard 1988: 27)</div>

In *...No Other Symptoms – Time Traveling with Rosalind
Brodsky*, (fig. 23) major catastrophes may share the same
currency with favourite cooking recipes, but the clichés here
are drawn from a century of excess and redeemed by the tragic
comic intensity that pervades the glitzy, digital interactive
interface established between screen and user. It is this tragic/
comic effect that is at once absurd and touching with the
interweaving of family histories and the collapsing of time in
both fantasy and lived reality that links the work to carnival.
The art historian Angela Dimitrakaki explains what can be called
carnivalesque time:

a temporary reconciliation of two very different views of the present as
expressed by Luce Irigaray and Fredric Jameson. Irigaray sees the present
as the utopian state of the subject's articulation whereas Jameson relates
the present to the chaotic temporality of the schizophrenic. In carni-
valesque time, as suggested by Bakhtin, the narrative of the image is
structured through a moment of disruption.

<div align="right">(Dimitrakaki 1998)</div>

Time travel has a tempting allure as it provides Brodsky with
the opportunity to repair what has been broken and undo what
has been so violently done, for the work is resonant with
references to family history. Treister's father had been brought
up in Ilawcze, a village in Poland, now part of western Ukraine.
At the outset of the Second World War, he was studying in Paris
and shortly afterwards he joined and fought with the French
Resistance. Later on he joined the Polish Army based in
Scotland; in 1944 he was relocated to London, where he had
been invited to join the Polish government-in-exile and, after
the war, he settled in England. He never saw his parents again;
'they were taken to the Tarnopol ghetto, then to Theresienstadt
[Hitler's model concentration camp in the Czech Republic] and
then on to another camp, possibly Auschwitz'.[4] Treister has
adopted and adapted the name of her murdered grandmother,

Rosalind Blum, for her alter ego, and it is especially poignant that one of Brodsky's time-travel preoccupations is to go back in time to save her grandparents. Dressed in a time-travelling costume consisting of a long silver gown and helmet, she made many failed attempts at locating them, either ending up in deserted villages or concentration camps and, on one occasion, materializing on the film set for *Schindler's List.* (Treister 1999)

PAINTERLY ABSTRACTION AND THE CRISIS OF STEREOTYPES

The tragic/comic character of Rosalind Brodsky sees the artist Suzanne Treister exploring various personae as she travels through time and space as comfortably as if she is trying on frocks. Rachel Garfield, on the other hand, is an artist and writer whose work focuses on the politics of Jewish identity, prejudice, and stereotype. (Garfield 2001: 63–70)

A critique of racism through European history provides the context for *Assimilations* (1998; fig. 24), a series of large-scale paintings in which Garfield pushes the boundaries of painting by confronting her audience with anti-Semitism. Garfield has chosen to use texts from the writings of philosophers and psychoanalysts, Kant, Voltaire and Jung, bringing the words of these intellectuals together with examples of contemporary neo-Nazi propaganda. In these large canvases, organized as diptychs, the historical texts are bled through layers of paint, which appear as palimsestuous traces through which the past and present converge. These texts taken from the western canon appear in contrast to the contemporary neo-Nazi propaganda, which are unmediated and transcribed directly onto the canvas. At first glance, or from a distance, the paintings are reminiscent of painterly American abstraction, but that reading rapidly dissolves when the viewer gets closer and reads the repugnant material that is inscribed onto their surfaces.

In these paintings, the artist is concerned with exposing the historical precedents for contemporary racism and bigotry by revealing examples of western intellectual racism, embedded deep within the emancipatory project of the Enlightenment and its utopian claim to deliver equality, freedom and justice to all people. The Enlightenment project proclaiming that 'human

beings are rational agents of morality' has been severely
compromised and discredited, particularly by post-structuralism

Figure 24: Rachel Garfield, Assimilations 1, *1998, oil on canvas,
122 x 152 cm and 122 x 91.5 cm. Courtesy of the artist.*

in the second half of the twentieth century. (Zuidervaart 1994:
50–1) The work can also be read as a critique of 1950s post-war
American abstract painting, in which the cultural underpinning
of the formal and minimalist paintings of Barnett Newman and
Mark Rothko lie not only in modern painting, but also in the roots
of their cultural and religious otherness, as Jewish immigrants.

Rachel Garfield's paintings may well have been a valiant
attempt to push painting to a point that she felt she could not
enjoy; but her intention was to make a political intervention
that would make people think. Whether or not work such as
this can sustain an audience without scaring them away is of
course debatable in a milieu in which art practice, in particular
painting, recoils from subjects that seriously provoke and
question the foundations of European culture.

Garfield's subsequent video work reinscribes history in very
different ways by shifting the boundaries to look at a play of
affiliations of ethnicity and belonging. Her work also contributes
to debates about cultural ownership, which are explored by
bringing narratives together that question a fixed view of
identity, looking at identity as an unstable ground and in this

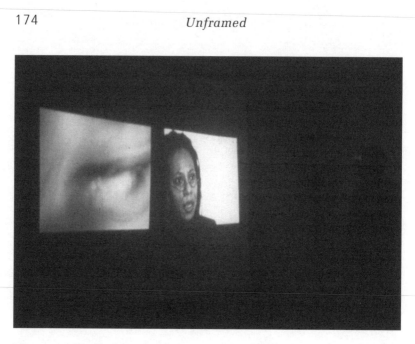

Figure 25: Rachel Garfield, So You Think You Can Tell, *2000,*
view of installation. Courtesy of the artist.

way disturbing racial and religious taboos. *So You Think You
Can Tell* (2000), is a 20-minute video work on two monitors that
tells the story of two women's lives in five chapters: 'Back-
ground; Stepping in/stepping out; Men; The Children; Final
Word'. (fig. 25) These chapters are delivered through the
narratives of the two women, one black and one white, as they
recall the circumstances that led them to shift their allegiances
and move from one community to another. They tell their stories
in intermittent video monologues as the dialogue shifts from
one monitor to another and as one image is frozen while the
other plays. In this way, the two narratives operate as
independent voices revealing the choices that these women have
made, as well as their attitudes to life. The video gradually
begins to break down stereotypes by inverting both notions of
'Black' and 'Jewish' identity, challenging prevailing opinions
and positions, particularly those of cultural purity. The choices
that the two women have made and the reasons why they made
them are teased out in Garfield's video sequences that gradually
unfold to give a picture that disorientates expectation. Each of
the narratives creates a series of challenges to the stereotypes
that are normally associated with both cultures. The black

woman's commitment to raising her daughter within the Jewish faith is understood as an identification and passion for its rituals and traditions, but also an adherence to and preference for white middle-class culture. This position is juxtaposed with that of the daughter of an orthodox rabbi. Brought up within a sheltered and strictly regulated social microcosm, her story reveals the desire to break away from a culture and religion that she experienced as confining and restricting. Without any animosity towards Judaism, her desire to live her own life, to become her own woman, has resulted in finding fulfilment, freedom, love and acceptance within the black community.

So You Think You Can Tell is a controversial work because it appears to overstep the boundaries of racial and religious stereotypes. It also upsets and challenges normative notions of purity and contamination adopted both by ethnic groups and bystanders by refusing to make moral judgements, judgements that adhere to standardized meanings of what is permissible or acceptable.

THE BODY IS A SIGNATURE

Genetics is a subject that is constantly in the news in ways that are both gruesome and intriguing. DNA is the bricks and mortar of the biological body and is itself a reliable indicator of the genealogy of our species. The history of the human kind is indelibly recorded in our DNA, and the study of genetics threatens to disclose not only our familial origins but also many other things, including evolutionary splits from other species. The body itself is therefore the most enduring marker and monument to our history and prehistory, for it is all recorded in our genes. But it should not be forgotten that modern genetics is the scientific child of eugenics and ethical issues are never far from the surface of this controversial subject. Genetic fingerprinting is currently used for identification purposes, and perhaps one day our genes will be used to identify us in ways that we cannot imagine. In so doing, we may be exposed to new dangers as well as old.

Pamela Hurwitz and her friends is a series of paintings that were generated by using DNA provided by five donors, stimulated by the curiosity to see what difference looks like, in

Figure 26: Pam Skelton, ACF Karyo 3 (Tony Fletcher), *2000, acrylic on canvas, 61 x 61 cm and 122 x 152.5 cm. Courtesy of the artist.*

biological terms. (fig. 26) Before beginning the work, I had to select a particular group of people to work with, as this would be fundamental to how the paintings would be understood. In each case the meanings generated by the work would be different. In the end, I chose to invite friends whose countries of origins covered a wide geographical area: Greece, Estonia, India, Britain and Jewish Ashkenazi. What takes place on the surface of each of the five canvases is a double portrait, one depicting the chromosomes of the individual sitter and the other a portrait of their face taken from a photograph. I worked with the chromosomes as they appeared, I did not attempt to decipher the script of the DNA or any genetic information that they might contain. Therefore the forms that the chromosomes took could only be treated as rhythms and patterns, tones and colours organized in formal arrangements as painted images. Yet, the chromosomes in one painting can, in the end, be viewed as comparable with each of the others and in this way can be recognized as similar.[5]

Although the differences in each of our chromosomes looked quite slight, it was interesting to look at their shape, size and form in relationship to the others and compare the sum of each

of the parts. The chromosomes appear as segments of light and dark bands, the dark bands containing 'relatively little' active gene material while the light bands contain about 80 per cent of the active genes, including what are known as the 'housekeeping genes'. (Connor 1997: 33) The matter-of-fact attitude that increasingly surrounds the subject of medical genetics is in part to do with the increasing familiarity of being identified as a synthesis of biological parts with particular genetic expressions. We can now see ourselves in new ways and hope that this latest way of 'looking' will not create a new wave of discriminations.

GHOST TOWN

In Warsaw the spirit of ghetto history appeared to recede further and further from view, becoming more and more inaccessible while all the time remaining in close proximity.[6]

In my work, I struggle between the states of remembering and forgetting. Ruined buildings and semi-derelict spaces hold a fascination, they seem to act on the imagination as a graveyard might, in stimulating the desire to recover something that has passed, a glimpse of the history of a place and time of the people who once had lived there. Here, the human subject is understood as a disputed site, a location where histories, desires and conflicts reside. The interactions that take place between place and subject constitute lived experience evidenced in space as well as time. In recalling past time, one becomes aware that the buildings of a city are always in the process of changing their function or falling into disrepair and, while decay may be arrested, time makes the urban landscape temporary, leaving vast tracts of desolation and wasteland. Within this incessant cycle of urban decay and renewal neighbourhoods are transformed, communities are lost and histories are erased. *Ghost Town* (2000–2) is a video work that investigates a traumatized place, the site of the Warsaw Ghetto. (fig. 27) The work uses video footage shot in Warsaw in the summer of 1993 and the autumn of 1996. The architecture of the ghetto becomes the material of the work where buildings and spaces are understood as evidence

Figure 27: Pam Skelton, Ghost Town, *2000–2002, video still. Courtesy of the artist.*

of semi-enduring three-dimensional inscriptions of past events and lives lost.

When I first visited Warsaw in 1993, I was struck by the fact that the ruins of part of the ghetto lay beneath a housing development. The rubble of the ghetto buildings provided the foundations for the homes that were built in the 1950s on top of what had been the central ghetto area, and it was this rather macabre realization that drew me back to Warsaw again in 1995 and 1996. I was intent on investigating what remained of the ghetto architecture and, with the easily obtainable ghetto map, it was possible to wander within the huge swathes of the city that had been both prison and home to over 400,000 people. The names of the streets and the words of the authors of the ghetto diaries helped me to orientate and locate myself and I was surprised at how many of the crumbling remnants could still be found, especially as I had been led to believe that nothing of the ghetto had survived.

The Umschlagplatz is situated on the edge of the ghetto. This is the place of deportation, where thousands upon thousands of people boarded trains, which were to take them to Treblinka.

Next to the Umschlagplatz monument on Stawki Street is the Mikolaj Kopernik Gymnasium of Economy, a school that had been used during the Second World War as a waiting room for the people awaiting deportation. Overlooking the Umschlagplatz, on the opposite side of the road, was the SS Ghetto Headquarters, a sombre grey building that since 1968 has been home to a university faculty, the Institute of Psychology. Whichever way I looked at it, this awkward occupancy of time and space marks an odd liaison between education and genocide and, more than that, reveals a deep rupture in social memory and history. How do the current occupants of the buildings understand its history? The people I spoke to told me that the former SS Headquarters had been bombed and rebuilt from the basement upwards after the war. However, archive photographs of the Umschlagplatz taken during the deportations strongly suggest that it is the same building with the conglomeration of buildings remaining uncannily unchanged and the architecture of the adjacent SS Headquarters appearing to be identical.

A short distance away from the Umschlagplatz in Stawki Street, a grassy common defines the epicentre of the battle where the Ghetto Uprising was fought and lost in 1943. Placed at regular intervals in the leafy streets of the housing estate that surrounds the park built in the 1950s, inscribed blocks of granite commem-orate the ghetto fighters, women and men who died defending their right to die as fighters rather than as passive victims.

SECTION 1: HOME

Once again the eyes go searching. They recognize every spot. Even bombed out blocks. The piles of rubble cannot hide the streets and houses that used to stand here. Over there was Dzielna Street, and further on Pawia and Gesia and Nalewki.

(Meed 1972)[7]

Soundtrack – piano note E. A street sign over a courtyard doorway reads, 64 Zelazna Street. The camera descends a dark staircase of an apartment block and takes in the crumbling remnants of the elegant stucco ceiling of the vestibule and out into a deserted street with grey façades and rusty iron awnings.

No. 46 Krochmalna Street. The camera rests on a miserable ribbon blowing in the breeze, tied to an old lamp fitting high up on the corner of the building. The camera follows the contours of the building and the sequence fades to the face of an old woman, my Aunt Dolly, who takes a drag of her cigarette as the image fades into 27 Chlodna Street. The camera pans across a wide road, taking in the old tramlines, the cobbles and new office blocks. A single window high up in a partially demolished building very gradually opens and closes. No. 7 Prozna Street, the entrance of a courtyard tenement building, bullet-damaged façade, scaffolding in place, ready for renovation or demolition? Wooden cobbles and paint peeling doorframes. Apartment blocks sandwiched between newer developments, condemned, moribund and burnt-out shells.

SECTION 2: DEPARTURES

Soundtrack – the high-pitched tone of a tram approaching and receding. The camera scans the Umschlagplatz monument and cuts with jerky movements to Stawki Street, where the view from the road frames the buildings of the school and the university. Graffiti covers the side wall of the school, a drawing of a head with a hatchet embedded in it, drops of milk falling from a drawing that looks like a cow's udder, the Polish football team insignia. The camera traces the entrance of the Institute of Psychology and cuts to the sombre grey façade of the functional 1920s architecture. The student cafeteria in the basement of the building is empty except for a young man who walks through. Net curtains, the view of the windows of the school and the street below from an office on the fourth floor. In the street the students congregate by the entrance chatting in small groups, a tram passes, and a woman approaches, she pauses, placing something into a waste bin on the pavement and walks on.

SECTION 3: ARRIVALS

Soundtrack – sounds of an urban summer. Zamenhofa Street. A young girl in front of an apartment block is lost in concentration playing with a huge beach ball. The girl moves effortlessly as she bounces the ball on the ground. A hand turns an empty

memorial candle container as if inspecting it. The camera cuts to the ghetto park. It is a hot weekend and the park is quite full with people making the most of the sunshine, two men seated on a park bench are passing the time of day, while their two huge dogs rest underneath. The camera takes in the circumference of the park coming to rest on the people who are sunbathing, reading or resting and the section ends with a panorama of the park receding into the distance.

CONCLUSION

My intention in this chapter has not been to reconcile painting with the moving image, but rather to explore how ideas may manifest themselves as art practices. My interests have been linked to particular histories, spaces, enquiries and journeys, not only with ideas but with materials too. Working with different tools encourages other ways of thinking and looking, but the motivation to stray into new territory is best served by a curiosity to disturb, uncover and reveal. I believe that painting has a role in this and can still be used in innovative ways as well as being ambitious and inventive, but I do not think that painting is best served by isolation or a rigorous adhesion to the way things used to be. This is not to say that I consider my own painting to match up to this ambition, but it is nonetheless something that I would like to pursue and encourage others to do so.

As for me, it has been important to get out of the studio to gather and research material that informs my work. It has been extremely exciting and often uncomfortable learning to adopt new working methods and learn new skills. I have found it extremely difficult to juggle or interchange the different activities of painting and video at will. This is in part due to the amount of time and focus needed in sustaining a momentum when one is deeply involved in making a work. At face value, it may seem that the material qualities of paint and the virtual qualities of video could not be further apart, yet many artists are challenging that assumption. Artists can take for granted certain kinds of procedures and ways of working and occasionally it is useful to remind oneself that art practices evolve in ways that can never be entirely anticipated. In my case, I suspect that I needed to slip away from painting so that I could reevaluate

my practice and what I wanted to do and say with it. Perhaps it is only in this way that renewal takes place?

NOTES

1. It is still my experience that most curators feel unable or were unwilling to deal with or consider work that tries to work through and with the complex post-genocide Jewish experience. Notable exceptions have been shown in this country, such as the work of Lily Markiewicz, a German artist living and working in London. There were two large group exhibitions curated by Monica Bohm Duchen in the mid 1990s, one on the theme of the Holocaust and one on Jewish female identity. *After Auschwitz: Responses to the Holocaust in Contemporary Art* (1995) at the Royal Festival Hall and *Rubies and Rebels, Jewish Female Identity in Contemporary British Art* in 1996 with co-curator Vera Grodzinski. *After Auschwitz* was the more ambitious of the two shows. It was a large international survey of art made up by subsequent generations of artists whose work addressed the Holocaust providing a broad overview of art works made since the Second World War. While there were extremely strong works in both shows, the exhibitions suffered from a general and inclusive approach to curation and as such lacked a critical or discursive focus.

2. The State of Israel was established in 1948. 'The *Yishuv*, where the European immigrants were the majority and sovereign, was transformed into a nation state, while a people was driven out, defeated, denied and dispersed.' (Halevi 1987: 195) Halevi refers here to the displaced Palestinian population.

3. 'As a result of World War II there were in May 1945 in Europe alone 40.5 million uprooted people. In nineteen forty seven the de-colonization of India created 15 million refugees, and as a consequence of World War II, 5 million Koreans were displaced following the Korean War. After the establishment of Israel, another after effect of the war, about 1.3 million Palestinians were registered with the United Nations Relief Agency, (UMWRA); conversely by the early 60s 1.2 million Jews had migrated to Israel, the majority of these also as refugees'. (Hobsbawm 1994: 51–2)

4. Suzanne Treister, in an email conversation with Pam Skelton, 10 January 2002.

5. I had to find a medical laboratory to work with, and Cyrogenetic

Services in London offered to assist me in providing chromo-
some analysis. This involved each participant visiting the clinic
and undergoing the discomfort of providing a blood sample. The
blood cells were then incubated in a culture that encouraged
division. It is at the point of division, when one cell splits into
two that the DNA organizes itself in the form of the chromosome.

6. From Pam Skelton's diary, 1995.
7. Vladka Meed (Fejgele Peltel-Miedzyrzecki) lived in the Warsaw
Ghetto and in the Aryan side. She worked for the Jewish
organizations as a courier and helped people to escape.

CHAPTER 9

INSIDE THE VISIBLE
Painting histories

Lubaina Himid

For the past 20 years or so, the work I have made has been engaged with a revealing or uncovering of sometimes hidden, sometimes neglected history. A new series of paintings has always to be another window or insight into previously unexplored territory – unexplored by me, that is. This new kind of history painting is an exploration of the inside of the invisible. First you have to know that it is there, because you cannot see it. Then you have to get inside it, because you do not know where it begins or ends. Then you have to ask questions, listen to answers and take endless notes, both visual and textual. You can then emerge, lay your information on the table and begin to make connections between the visual, the hidden, the invisible and the re-remembered. Colours must mix and merge with texts and set off a series of thoughts and memories in the viewer, which they then try to bring to the work. Imperative to the process is this dialogue with the audience: there is no history painting without it; it is about the people who are looking at it. Obviously, it can exist without the viewer, but it does not then progress, proceed, change or develop. This new kind of history painting must do all of these things, if it is not to be about presenting a given past to a passive recipient.

In a recent series, *Double Life*, the early lives of my mother and aunt in their parents' pub in the north of England, were revealed on 24 canvases and 12 brass plaques, which were

shown in Bolton at the museum a few miles from where they were born. In the exhibition *Plan B* at Tate St. Ives, England, painted texts were used to speak of an engagement with an exterior dangerous terrain, while painted interiors depicted supposed safe zones. The written texts could have been diary entries, slave narratives or letters home. For the exhibition *Inside the Visible*, the words of eighteenth-century Norwegian leprosy patients, written on small luggage labels, were juxtaposed and fixed to 100 small patterned canvases, which were then hung in the rooms where they lived in the hospital in Bergen, now a leprosy museum.

My next major work will explore an imaginary but possible dialogue between the cotton workers of Manchester and the slaves of South Carolina. In a series of 100 small black-and-white patterned canvas works with accompanying engraved metal texts, these early 'e-mails' will talk of food, work, family, politics, clothes, escape, punishment and hope. The following essay will speak in detail about each of these bodies of work, how they came into being and how they were received.

DOUBLE LIFE

In *Double Life* (2001), tiny snatches from the early lives of my mother and my aunt, now in their seventies, recalled my grandparent's public house in Farnworth, near Bolton in Lancashire. For nearly 50 years, these two women have talked to me about their times as children before the Second World War, comfortable, cosseted, sheltered daughters of intelligent and ambitious publicans, living and working in the heart of the poverty-stricken streets of a small town. Their world mingled with that of their parents' customers only rarely, but the memories of the smells, sounds, colours and patterns, both hilarious and wistful, contradictory and yet in tandem, often included some reference to the world of money, beer, back-breaking work, dire unemployment and drunkenness that surrounded them. They had a nursery with toy-town wallpaper, a nanny who fed them plaice sandwiches, a car driven by the coalman, a donkey they feared would be eaten by the miners, fur-trimmed bridesmaids' dresses, a piano with rose catalogues for music, an allotment with Rhode Island Reds. We discovered

that they remembered differently: my aunt can recall sound and smell, my mother the precise detail of a coloured silk or a pair of shoes. They sometimes agree to differ and sometimes each simply thought the other mad or too old to be sensible, or too young at the time to have been aware of the nuances. Many of the tales were short and bright; all were laced with opinionated and rather sharp observations:

They gave us a penny when we wore green

He would not be allowed now...

The Pack Horse was very posh...

Our great uncle Joe, a bookmaker, was very mean...

(written text from *Double Life*)

I wrote pages of notes, they wrote pages of letters, we talked on the phone, in restaurants, in each other's houses, both in London and in the north of England, where I now live and where they were born, but rarely visit. They searched in boxes, in attics, cupboards and drawers to find visual evidence. There were three-pronged forks from the first pub, there was a bracelet from the cruise ship voyage to the Baltic just before war broke out, and a brooch from the wedding, the night that Boots the Chemist burned down.

For a couple of years, I tried to work out how to tell the story from three angles at once, theirs and mine. There were several false starts including an idea that each piece would be three paintings, my mother's view, my aunt's and then my view of theirs, but this would have been deeply labour intensive and rather dry. Some things remained that were there from the start: a patterned surface to juxtapose against a narrative, the reference being to my mother's career as a textile designer. This multi-purpose agenda set the criteria and drove the project. It was important that the words were theirs, but that the paintings were mine. It was difficult to resist painting what they might have painted, but, then again, that was impossible. It became important that their words had a dynamic presence, which is how they came to be engraved on six-foot-long, thin and elegant brass plaques. Each of these was then placed underneath a pair of three-by-three-foot paintings, so that the three of us spoke

together, if not exactly in harmony. The paintings were made so that young children might find things to make them laugh: crazy chickens, plates of food, a donkey, an ocean liner, but also so that an audience might think that children had painted them, as indeed they had in a way. The colours were loud and strong, one of each pair a bold patterned surface; a close up alongside a long-shot narrative on canvas.

In the event, the local population visiting the show engaged immediately with my mother and my aunt. They all began to exchange their own versions of the two women's memories. Resolutions were made to note down tales of starling pie consumed during the General Strike and Black boy moneyboxes sitting in the front parlour. Whether the paintings prompted this ease of dialogue or whether it was the short edited texts engraved on the brass, does not really matter. The combination of the two means of communication allowed several sets of people to relate to locations they knew and to add their own layer of experience to that laid down by the work.

PLAN B

Plan B, shown at Tate St. Ives from November 1999 until May 2000, in the high, top-lit gallery for contemporary shows, was an exhibition of ten canvas works, each four feet by nine or ten feet. Four paintings combined text and image, and the remaining six were images only. The working process, two years from spring 1997 to spring 1999, started with small felt tip drawings of highly patterned furniture in small and strange interiors that I made in a sketch book, coupled with copious reading. I read Gertrude Stein's *Wars I Have Seen* (1945), in which she describes her life with Alice B. Toklas on a farm at Billingin near Lyons; they had servants and food – food most of the time. However, it was not Paris and it was the Second World War in which the Vichy French had entered into a pact with Nazi Germany – and both women were Jewish. Gertrude Stein drove an ambulance, wrote and waited for it to end – it did in 1945, but she died in 1946. I read books by Martha Gellhorn, the journalist, as she describes in detail everyday life during the Spanish Civil War: women attempting to buy shoes and, as bombs explode outside, they moved to the back

of the shop. Holes were ripped out of the roof by bombs going off the night before; the concierge showed Gellhorn around anyway. Virginia Woolf, having left Gordon Square, could still hear the bombing of her house in London from her house in Lewes, 50 miles away. She returned to see her front wall gone and rooms exposed, books and furniture destroyed, a way of life threatened and ultimately crushed. She committed suicide in 1942 only weeks after this.

I wanted to find out how these women experienced being in the danger zone, which was supposed to be safe. How did women cope with being in their homes or at places of work during a war, without the means of defence or of attack? What was London like during the 75 consecutive nights of bombing? In *Few Eggs and No Oranges*, Frances Hodgkin describes the night that Virginia Woolf's house was bombed. While I was making this work the western allies were bombing Baghdad and Belgrade, there were earthquakes, floods and revolutions and women were in the midst of it all.

This series of paintings is an attempt to make decisions about how to proceed with a life that is clearly being lived in a very safe and comfortable-looking danger zone. How do people escape from danger when they are already in a safe place? The written texts, of which there are about a hundred, did not match, nor were designed to match, the 100 or so paper works, which were developed in the studio in St. Ives. I was never an artist-in-residence at the Tate, merely an artist visiting and working for two one-month stints over two years. It was essential to read and hear accounts of this coastal area during wartime. Laura Knight painted with her back to the sea, so as not to be arrested for spying. An artist working in the next studio to Frances Hodgkin, after his disappearance, turned out to be just that, a spy mapping the region for a strategy of invasion. Three hundred wrecks lie under the water around the coast of Cornwall, now a benign spot associated with British painting and ice cream.

This work tried to uncover an experience of war/conflict and to highlight the possibility of friendship, while operating a plan for escape: 'Plan B'. The colour and light, which poured into the Lifeguard's Office where I worked, from the sky and sea changing every moment over long ten-hour days of continuous

painting on paper, provided the tools and equipment for building the 'light aircraft' made from paint, wood and canvas, which were in the end the works for the exhibition itself, made in the large and warm, but dark and brooding studio in Preston.

We grew rapidly more exhausted as the endless days of running and hiding continued. Some of us became dangerously disheartened and began to hear strange terrifying noises all around, wailing, screaming, moaning far away, yet near at hand. We wasted precious time standing still trying to fathom their origins. Our fear was unbearable. After many terrible nights of this we slowly began to remember the glorious words of our old songs. This united us and we had the strength to see that we could indeed survive long enough to enjoy our freedom.

(Written text from *Plan B*)

INSIDE THE VISIBLE

The last leprosy patients in Norway died in 1946. They were Europeans. Leprosy is a disease of poverty, neglect and terrible living conditions; this was the reality for many Norwegians until the end of the nineteenth century. *Inside the Visible* was an exhibition made for the St. Jorgen's Leprosy Museum in Bergen, Norway in 2002, for which I painted 100 small works on raw linen, each with an English and Norwegian text. Imagine your warmest jacket has stitched inside it, close to your heart, a patterned patch, five inches by five inches. It reminds you of life before you were struck with a disease that took away pieces of your flesh, your foot, your hand, your nose, your ear. You look at your piece of fabric now and again just to remember. Most of the leprosy patients in Bergen were fisherman-farmers who worked in conditions of 20 degrees below zero on the high seas in very, very wet weather, mostly in the dark. They lived for much of the time on the beach and slept under their boats in vile and inhumane conditions. Some patients or inmates were members of the clergy, musicians, painters, builders, clock-makers, as well as farmers or boat-builders. There were women who, in their former lives, cooked, mended, washed, nursed, gave birth and prayed, as well as all the usual childrearing and food growing and attempting to keep warm and dry that was the norm. They too were infected with leprosy.

I wanted to make a series of works that might give these people
a voice. They were individuals, real, idiosyncratic, sexual, think-
ing people. They had memories, hopes, families. In the same
way that slaves were more than slaves, lepers are more than
just people with bits of their bodies missing through disease.

The museum, an eighteenth-century wooden church and
wooden buildings was reconstructed in 1706 after a fire, at first
to separate and segregate the diseased from the clean, then as a
place to experiment to find a cure and then to house people
who were cured but unacceptable to society. There is a lodge, a
barn, two wards on two levels, two large kitchens with open
ovens, a herb garden and a courtyard. Those who visit today are
very interested in Hansen, the doctor who, with a colleague,
identified the leprosy bacteria. They look at his room, his
instruments and his belongings.

Each painting has a different pattern in many colours. A
yellow background might have orange swirls or blue spots or a
green check. A blue background could have purple triangles and
orange lines, a green background could have yellow ticks or
white circles or brown lines. Each one was always five inches
square painted in the centre of a canvas eight inches square.
You look at the pattern, see it, read the text, 'This is my boat,
my brother helped me build it', and either see the boat or do
not. Someone who did not see the object, however hard she
looked, decided that the owner of the pattern/object did not want
her to look into this private memory, it therefore remained
hidden. Each text was handwritten on a tiny card luggage label
in Norwegian on one side and in English on the other. This was
then attached with string to the back of the painting and hung
down. You could read whichever side you wanted to. Each work
existed as a memory, a secret, a history, a fact. Now it has gone.
At the end of the nineteenth century, those who contracted
leprosy could be cured, as they can be cured today, but patients
usually lost a physical part of themselves. The leper was still
thought of as dirty, disabled or not whole, thus invisible.

When you enter the main hall, it looks the same as ever, dark,
polished and quiet, with no sign of the sick, sore and rotting
people sleeping three to a room. The work was placed in the
small rooms in the kitchens and on the stairwell:

These are my dancing shoes, I do not need them now.

I used this tureen on Sundays.

This is a special hook for mending nets.

These oars were made by my uncle.

<div align="right">(texts from *Inside the Visible*)</div>

I hoped that the Norwegian audience would try and see the objects, invisible in the paintings, many of which related to fishing and farming, but some that referred to family life, creative life and a more contemporary working life. It was meant to respond to the place as well as the people, to help make visible to the Bergen visitors a piece of economic history somewhat buried in a new wealth. I also wanted to be part of making the former hospital less frightening and yet more real. A place of beauty and inner calm beyond the outer terror of a slow, stinking death, on the one hand, while remembering that it then became a place for the cured, but neglected and rejected, almost a prison. In that new place, new family and friends could perhaps be made and a new future possible.

For the past six months I have been working on a project designed to make real the notion of dialogue and communication, links, exchange and collaboration. In response to a commission from the University of Manchester's Architecture and Art History Department, I am participating in a project concerned with the history and sociology of architecture in Manchester. One of the sets of buildings being investigated by the group is the now almost derelict Ancoat Mills. Their history and function is inextricably connected to the wealth of the cotton industry in nineteenth-century Britain. My monument to dialogue, similarity and difference, partly inspired by the mill-workers' letter to Abraham Lincoln during the American Civil War, will be 100 black-and-white patterned paintings accompanied by small plaques bearing texts. The work will imagine a series of 'e-mail' conversations between the cotton workers, weavers, carders and spinners of Manchester and the cotton field black slaves of South Carolina, the hoers, the sowers and the pickers who provided free labour so that their British counterparts could live in dire poverty for the profit of a very few millionaires.

They will tell each other about their working conditions, diseases, holidays, food, family, the weather and their bosses. They even exchange plans for escape. One hundred ten inch square canvases with a hundred brass plaques will hang down the wall from the ceiling to the ground and out along the floor in a cacophony of synchronised political banter:

My sister who is a little crazy makes shoes in the loom house, she does not have to work in the fields.

My cousin was whipped yesterday and she is bleeding badly, a pint this morning.

Out on the plantation we get bacon and meal; a peck of meal and three pounds of bacon per week.

We do not have money, but we get trinkets from pedlars in exchange for skins or eggs or feathers.

I am interested in the power that a painting, however small and domestic, can have. I engage with location; public space, private space, the obsession with the control of space, of land, of the sea, and of people.

CHAPTER 10

REVISITING ANN HARBUZ
Inside community, outside convention

Joan Borsa

I was introduced to Ann Harbuz's work through my family. My mother and Ann Harbuz were raised in the same community and are of the same generation. After curating several smaller exhibitions of Ann Harbuz's artwork and struggling to situate a practice that seems to occupy a critical no man's land, I decided a few years of research and a much larger exhibition and exhibition catalogue were in order. In this project, *Ann Harbuz: Inside Community, Outside Convention*, I was both curator of the exhibition and editor of the exhibition catalogue.[1] The following essay is a revised version of the original text.

Born in 1908 in Winnipeg, Manitoba, to parents who had emigrated from Ukraine, Ann Harbuz (née Napastiuk) spent most of her life in the district of North Battleford, Saskatchewan. After a life of caring for others (siblings, husbands and children), working as a housewife and mother, running a small store and doing odd jobs to supplement her income, at the age of 53, Ann Harbuz began her first series of fine art paintings. By the time of her death in 1989, she had produced well over a thousand paintings and painted objects, most of which she sold or gave away as gifts. The documentation on this work (including its whereabouts) is sketchy, and the range of styles and quality of execution uneven. As more people passed through Ann's studio-home she received requests for paintings based on family photographs and commercial reproductions. Making money was a novel experience and Ann was not averse to these commissions.

All of these works are now in the public domain and it certainly complicates how we perceive her practice, illustrating how important the editing process has been in establishing an artist's professional reputation.

I first met Ann Harbuz in the 1970s. We were both beginning our art careers, she was in her early sixties and I was in my early twenties. During my first visits to her studio, I was intrigued by her unorthodox approach to painting and by her eclectic mixing of media, methods and materials. Having studied painting at the University of Saskatchewan, I thought I was somewhat versed on Saskatchewan art, but work like Ann Harbuz's had not been part of my formal studies and it was difficult to know how to deal with her obvious difference. Harbuz's paintings did not adhere to the picturesque vistas, nor to the technically proficient, modernist styles to which I had been introduced, yet I felt more kinship with her methods and her point of view, with her inclusion of cultural activities and historical references set in specific geographical locations. In Ann Harbuz's paintings the landscape was not only inhabited, but also abundant with settlement and social exchange. Her representations included individual and communal space as if simultaneously assessing and representing the inner and outer workings of a world she shared with others. In the company of Harbuz's images I experienced a knowing landscape, where nature and people's lives were up close, not always beautiful, and laboriously in-process.

This was the beginning of my involvement with Ann Harbuz's art and it was not without complication. I liked the work and its innovative mixing of conventional and non-art media and methods, but I was concerned about the implications of curating an exhibition of this type. I was well aware of Harbuz's oddball status; she painted on objects and surfaces that ranged from old vinyl records, kitchen cupboards, dust pans, birch bark logs, metal cream cans, wooden panels, fences and tissue paper glued onto card-stock, to properly gessoed and stretched canvases. Within her images and within the execution of the work were signs of awkwardness, of not quite matching the status quo. Her frames were homemade or purchased at Zellers, the shapes of her canvases were slightly crooked, her technical skills were not refined (in the art school way) and her subject matter led

into narratives about classed, labouring bodies which seldom experienced leisure, let alone the sublime. Her production was steeped in marginalized stereotypes; she was an older, rural, ethnic, self-trained, female artist; she made work about prairie settlement, physical labour, agrarian experience, Ukrainian-Canadian culture, rural communities, motherhood, local history and women's lives. I understood that in many professional art contexts this would be considered 'small town' art, marked by the conditions of its own disempowerment. It was not destined for the National Gallery of Canada, Documenta, *Flash Art* or the Venice Biennale. In short, in an art world infested with hierarchies, sex appeal, exoticism and the race for the new, Ann Harbuz, her world and her work would not ignite enough sparks. Why, I asked myself, in the midst of my increasing obsession with contemporary art and theory, was I drawn to work that seemed mostly about the past and connected to an ethnic and cultural enclave I thought I was leaving behind? It was time to look more closely at the categories, documentation, exhibitions and commentary which surrounded Ann Harbuz's art, to see what was getting in the way of articulating the complexity that had originally attracted me to her.

Despite Harbuz's questioning of classification systems, almost all of the documentation on her work repeated the well-worn labels of folk, naive, and primitive. In conversations, Ann frequently took issue with these terms and felt constricted and diminished by their scope. She was equally sceptical of an exaggerated or essentialized Ukrainian context. If most of the definitions suggest that folk art features traditional decoration and functional forms specific to a cultural or regional group, why were we calling a painter who produced imaginative visual representations of identity, location and difference, a 'folk artist'? I thought of painted furniture specific to Mennonite, Norwegian or Ukrainian craft traditions. I thought about woven or hooked rugs from certain regions of Quebec, stylized weathervanes and whirligigs perched on maritime or prairie fence posts, or painted Ukrainian Easter eggs. But Ann Harbuz made unique paintings, some of which depicted folk art, and she also reminded us of the difference. Referring to the tradition of Ukrainian embroidery, Harbuz commented: 'I liked embroidery but instead of embroidery as other ladies, I painted.'[2]

Harbuz's paintings and her art in general, seemed intent on communication, on staging and interpreting the particularities of her observations, on making public what she had witnessed, lived through and thought about. Regardless of Harbuz's self-trained status and the labels, which surrounded her practice, the bulk of her paintings were characterized by social exchanges, daily experience and local knowledge. Clearly these were social landscapes[3] from the perspective of someone who not only understood what it meant to live, work and survive within the land they represented, but who also longed to record and articulate the economic, climatic and psychological extremes which had frequently tested their limits.

I had originally thought that Ann Harbuz's work would be best understood closest to home, that her references to local history and issues of identity required some first-hand experience with these sites. But the further away I got from the contexts and locations that saw her as a folksy, prairie, rural, Ukrainian woman, the more I thought about Ann Harbuz's strengths as an artist – her conceptual mapping of time and space, her expressive range of colour, her inventive approach to materials, her complex rendering of a psychic interiority. Quite quickly I discovered that not everyone saw the culturally specific (Ukrainian, prairie, rural) references and nuances as the prominent features of her artwork. I began to research parallels in other disciplines and other art forms, searching for models of analysis that would productively lead me astray. And so I moved away from my arguments with folk art/outsider art literature and into a zone where novels, the social history of art, cultural studies, feminist art and theory, exhibitions, interdisciplinarity and contemporary art practice could offer perspectives.

It did not take long before I was immersed in Carol Shields's writing, in particular her book *Swann* (1993), which addressed the blind spots within our critical responses to unorthodox or marginal forms of expression. It became clearer that the most obvious communities and designations surrounding an artist's work do not necessarily yield the most appropriate or productive interpretations. Like Ann Harbuz, the central character in Shield's book, Mary Swann, lived in relative isolation in a rural community. She is portrayed as an obscure and closeted writer who has left behind challenging prose and poetry, which fall

outside conventional genres and modes of literary expression. As various writers and literary critics became interested in Mary Swann's writing, they sought out individuals in the community where Swann had lived, hoping to unearth details that would offer important clues. But as the novel proceeds we discover that few people understood what Mary Swann had been up to: 'They had not – not even – discussed her deeply felt feelings about literature, or about families or about nature... It is a myth that people in rural communities are all acquainted with one another and know all about each other's business.' (Shields 1993: 152)

Shield's book offered valuable insights into the many reactionary and dismissive comments I had heard within the communities with which Ann Harbuz had been closely associated. It was not uncommon to hear that Ann was considered somewhat of an oddity, that she was not a 'real' artist, but a primitive. Her involvement in art was frequently seen to be a role outside her class, education and life experience. It *was* unusual for a woman of her generation and social position to paint. However, it is not Ann, but her conviction and prolific output that seem peculiar, given the conventions and restrictions of her day. It became apparent that the existing perspectives on Harbuz's artwork would need to be put under a microscope – the important clues were within the work and it was my job as a curator to pay attention more carefully. As I read Jeanette Winterson's book *Art Objects: Essays on Ecstasy and Effrontery* (1995), I was reminded, once again, that all art is much more than its subject matter or medium, and much more than its point of origin:

It is not necessary to be shut up in one self, to grind through life like an ox at a mill, always treading the same ground. Human beings are capable of powered flight: we can travel across ourselves and find that self multiple and vast. The artist knows this.

(Winterson 1995: 116)

In Ann Harbuz's art we do see many images where her Ukrainian background and rural, prairie experience is accounted for and held in full view, but often as an interactive element within more expansive parameters. For example, in her paintings of domestic interiors where women care for many children, prepare large meals and seem inundated with chores, Ukrainian references

abound. One notices the highly patterned embroidered tablecloth or blouse, the style of homemade furniture or the freshly made *varenyky*[4] prominently positioned on the table. These symbolic, expressive details direct the visual narrative, but it is the subdued blue atmosphere, the compression of multiple activities in a one- or two-room house, the scratchy painted surface, the individual woman isolated in an endless cycle of domestic labour, and the distant view through a kitchen window which haunt the viewer's memory.

Figure 28: Ann Harbuz, Ten Weddings, *1978, acrylic and pen on masonite, 60 x 90.4 cm. Collection: Dorothy Charabin, North Battleford; photo credit: Grant Kernan/AK Photos, Saskatoon.*

In several of her best known works – *Ten Weddings* (1978)[5] and *The Start of the Ukrainian Library in Mike Stashyn's Country Store, Whitkow, Saskatchewan* (1975) – the obvious starting-points are rituals associated with traditional Ukrainian wedding receptions and the building of a Ukrainian library and cultural centre. But the scanning of social geography and the mapping of specific life events quickly move beyond the more immediate cultural innuendoes and geographical sites. In *Ten Weddings,*

(fig. 28) the children not only grow up, marry and start lives of their own, they leave parents and grandparents, small towns and rural communities behind. The procession of newlyweds, all bound for the skyscrapers looming in the distance, also comments on the process (and price) of widespread urbanization, which Ann Harbuz would have witnessed first hand.

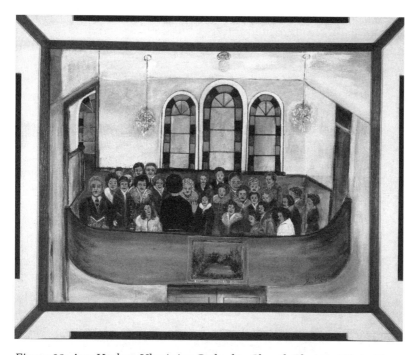

Figure 29: Ann Harbuz, Ukrainian Orthodox Church Choir in Wintertime, *1976, oil on canvas, 65.8 x 86.4 cm. Collection: Mendel Art Gallery, Saskatoon; photo credit: Grant Kernan/AK Photos, Saskatoon.*

In *Ukrainian Orthodox Church Choir in Wintertime* (1976), a group of adults and teenagers is represented within a small, enclosed balcony. (fig. 29) While the image recreates a ritualized communal space, it is the pronounced features of the individual choir members, their assorted winter attire (despite the interior setting) and the implied range of unrehearsed voices attempting to carry the melodic refrains which rally for attention... resulting in more of a *carnivalesque* spectacle than a formalized cultural

moment. Within the ordered rows, individual choir members have been painted in exaggerated scale – some diminutive, some larger than life – perhaps in accordance with egos and musical abilities. As in the photographic work of Diane Arbus, where the staging of ordinary people in cramped interiors calls attention to awkward, imperfect sights, Harbuz plays with the theatrics of display. She paints both to be seen and to be caught in the act of looking. But, unlike Diane Arbus, it is her own world upon which Harbuz casts a critical gaze – not to judge, nor as a distancing manoeuvre, but to make visible people, events, histories and interactions whose marginal status all too easily casts them aside.

Figure 30: Ann Harbuz, July 25, 1920, 1978, acrylic and ink on masonite, 30.8 x 41 cm. Collection: Saskatchewan Arts Board, Regina; photo credit: Saskatchewan Arts Board.

In these and other paintings, we continually see how Ann Harbuz's artistic vision exceeds her points of origin – how she moves away from reductive readings of art as merely a reflection

of an artist's life or the sum total of its subject matter, technical execution or narrative structure. In her work, a seemingly straightforward social landscape or domestic interior becomes an animated setting where relationships between people, social conventions, time and space are carefully brought into focus. Memory and imagination lead – schools, farmyards, towns, families, social and cultural histories are rearranged and compressed into half-real, half-invented topographies. Specific vignettes and subtexts are frequently buried in the overall composition as if to flag more repressed or complicated speech. As Chilean art critic Nellie Richard has suggested, artists are not always overt in their use of social and political commentary. Images can be layered and may carry subtle cultural codes as away of obscuring difficult personal circumstances or traumatic events. (Richard 1986: 30, 65) Within the spatial ordering of Harbuz's two-dimensional works we frequently see an interior/exterior divide as well as a suspended or traversing perspective. As if opening up or exposing interconnected elements, she appears to 'freeze frame' and then ponder the nuances of particular situations. For example, in the painting *July 25, 1920*, an interior space of domestic grief functions like a cut-out, inserted into a larger prairie topography. (fig. 30) The stark appearance of the central male figure, his riveting gaze, his hands clasped in prayer and the noticeable absence of an adult female figure in a home with six young children, speak to the solemn and psychologically charged occasion of a mother's death. Outside the home the physical environment is equally turbulent – colours that jar and set the nerves on edge. A scratchy surface quality reminiscent of pelting rain projects an unsettling reverberation. And one cannot help but notice the horse-drawn wagon containing a coffin – the only other sign of activity within the sparsely populated landscape. But it is not only the news of a mother's death that impacts. The evidence of geographical isolation, in combination with the minimal furnishings of the one-room home, exaggerates the scene within.

Similarly, in *Ten Weddings*, one of Harbuz's most animated and ambitious paintings, a series of events particular to one family history is condensed into concentrated units of space/time interplay. Bringing together a timeframe of approximately 40 years and a radius of about 100 miles, Harbuz humorously

reassembles the weddings of ten siblings into one compact landscape. But next to the diagonal line of traditional wedding receptions is a smaller more private scene that one could easily miss. Near one of the houses, quite centrally located, a man holds a horsewhip, his arm raised and directed at a young woman within his immediate reach: supposedly, a father responding to the news of his 'unwed' teenage daughter's pregnancy. This seemingly innocuous insert, and its proximity to the sanctioned space of family convention, complicates the conceptual underpinnings of this work. Here and in other paintings, multiple views of a common theme are frequently juxtaposed, as if establishing elements of a larger debate or acknowledging the complexities of factors affecting individuals and their every-day lives. It would be simplistic to describe *Ten Weddings* as a documentation of Ukrainian customs and prairie communities, a record of one particular family and their ten children, or a prairie landscape. It is all of these, but the scope of its address expands further. The procession of young people walking towards the distant skyscrapers points to the challenge of assimilation and urban development: it is a highly analytical response to the interplays between private and public realms, and to the enforcement of 'acceptable' behaviour; it is an exposé of social codes and conventions; and it is a portrayal of the ordering of social life around the institutions of marriage, family and heterosexuality.

In another painting, entitled *Coming Home From Church* (1976), we see another version of Ann Harbuz's use of subtexts and double-entendre. A woman in her Sunday finery walks alone behind a horse-drawn wagon, where another adult and several children ride. Around her is a calm, detailed landscape depicting a barbed-wire fence, prairie grasses, a modest farmyard, a slough and an expansive uninterrupted sky. In the distance is an onion-domed Ukrainian Orthodox church. At first, this painting seems to be in the realm of a historical document, providing a record of the role churches played in newly settled prairie, Canadian communities, how people travelled to church, what they wore, where churches were located. But it is the woman walking alone, quite literally placed in the centre of the composition that in time gains prominence. Why is she walking when everyone else is riding? What is her relationship to the people in the wagon?

Although one can imagine extenuating circumstances and patriarchal factors, an elderly female friend had quite a different response. In contrast to the compressed space of the domestic interiors where women are surrounded by children and work, she suggested this may be a seized opportunity, or an imaginary projection – in either case designed to create a rare moment of peace, allowing the woman some time to herself. My friend's response caused me to look for other signs of respite, whether real or imagined. And find them I did.

There are several interiors where a 1950s semi-idyllic version of domestic life has magically eradicated all the work and instead, a very tidy, nurturing Mom in a very orderly, cheerful environment lingers affectionately over her interactions with her child. In contrast to the bulk of Ann Harbuz's images, where women are surrounded by children of all ages, multiple responsibilities and minimal resources, in these works something has changed. A sense of optimism and control prevails as the woman bathes her child or tucks her into bed. A similar carefree atmosphere is evident in several self-portraits.[6] In one (undated) image, *Untitled (Woman on Shore)*, a young woman deep in concentration, sits all alone on a riverbank writing or sketching in a notepad. In another painting, *The Artist* (1977), a woman works at an easel in an outdoor setting. In these paintings, the woman is not isolated but alone, deeply absorbed in creative activities and at a distance from other responsibilities. In a third, rather flamboyant image, *Untitled (Woman in Hat)*, also undated, a portrait of a middle-aged woman is surrounded by an electrifying field of yellow and purple rays. Energy radiates outward, the hat she wears is boldly eccentric and the woman exudes a confidence – proudly she faces her audience, as if suggesting that something she is up to is worthy of attention. In pointing so specifically to the rare moments women enjoyed on their own and to the thrill of immersing oneself in creative activity, Harbuz underlines the incongruities facing most of the women in her representations.

As Griselda Pollock has suggested, both men and women artists have 'the right to enjoy being the body of the painter' at work in their studio, but not all bodies are equally positioned or enjoy situations which allow the time and energy to actualize active artistic and creative practices, in or out of studios.

(Pollock 1992: 140) Ann Harbuz was never able completely to leave her domestic responsibilities behind, nor did she live under conditions where making art and, in particular, her approach to making art, was highly valued. Nonetheless, in her early sixties, as she turned more fully to her art practice, she found ways of integrating her art into the rest of her life. Easels of half-finished paintings were in easy reach of the dining room table, the television set, or a pot of soup simmering on the stove. Clearly her dynamic home environment was multi-purpose, but the sheer volume of paintings, hung salon style, everywhere visible and always changing, announced her art was finally taking precedence.

Figure 31: Ann Harbuz, Across the Country of Saskatchewan, *1981, acrylic and fibre-tipped pen on masonite, 44 x 140.4 cm. Collection: Mackenzie Art Gallery, Regina; photo credit: Don Hall, Regina.*

In many of Harbuz's paintings, intimate domestic scenes and the distinct private and public spaces that women occupied are foregrounded. For example, in one of her more ambitious paintings, *Across the Country of Saskatchewan* (1981), (fig. 31) I notice how carefully she establishes the phases of settlement and development within a land mass called Saskatchewan, but increasingly it is the small domestic interior inserted into one corner of the large rectangular painting which holds my attention. This juxtaposition establishes a significant tension as if to suggest that although the activities within this modest house may at first appear incidental, mundane and most often invisible, they too are integral components of a much larger picture. In some ways the intimacy of the domestic environment

seems 'outside' the painting's focus, in other ways its presence seems strategic, as if establishing a counter perspective which actually interrupts the exterior public domain, the linear chronology and the more predictable, historical overview. Over and over again the traces of people's lives, communities and customs, and the representation of distinct spatial, cultural, social and temporal divisions point to what it means to inhabit specific bodies and locations. But in making these sites visible, in giving socially constructed experience such concrete form, Harbuz also creates the potential to re-imagine oneself in relation to these spaces.

In scene after scene, painting after painting, labour is what Harbuz highlights. We witness the time, energy, skill and sweat required to haul logs in wintertime, tend enormous gardens, run large households, pick stones, milk cows, wash diapers by hand, carry water from wells, plaster houses, bake bread, build rural communities and care for others. It is not only the amount of labour or its constancy that is pointed to, but also the resourcefulness, creativity and self-sufficiency of these individuals as they perform the rituals and rhythms of daily life. Within a visual art context, many contemporary artists have also explored how social relations, economic realities and material conditions impact on people's everyday lives. Increasingly there are contemporary artists who insist on a space for the maternal[7] – a central metaphor in Ann Harbuz's work and a primary condition of her life and art. Her own mother died in childbirth when Ann was 12 years old and her first-hand experience of motherhood was as a 16-year-old girl who, quite literally, had been pushed into a marriage contract. I am reminded of Susan McEachern's photo-based work on child-rearing and the distribution of labour within the home; Suzanne Lacy's ambitious community-based projects on women and aging, and Jin-Me Yoon's photo-based work on the invisible labour of childrearing as the milk from a lactating mother quite literally spills over onto her briefcase, messing up the domain of public and professional life. Further comparisons between Ann Harbuz and these and other contemporary artists are important in developing other ways of understanding the links and affinities between practices from different generations, places, cultural and personal circumstances.

In considering such comparisons, I became curious about the correlations between Harbuz's conceptual orientation and those of a much younger and more urban generation of artists. For example, Canadian artist Germaine Koh (about 60 years Harbuz's junior) has been knitting a blanket started in 1992 that she plans to knit for the rest of her life. About this project Koh says: 'I was thinking about how people labour for their whole lives and don't see the result of it.'[8] In *Knitwork*, a blanket with a beginning but no end, Koh utilizes the process of knitting as a tangible record of daily time. As a part of the gallery installation, Koh sits in the gallery space with her evolving blanket, actively engaged in the knitting process; her presence (or performance) connects the convention of knitting, the women who knitted and the time and labour devoted to knitting, to a space of display – a space which both commemorates and legitimizes cultural value.

I was reassured to see that the material conditions of everyday life in so many of Harbuz's images and painted objects[9] are also evident in Koh's *Knitwork*. Ann Harbuz referred to her representations of endless acts of labour as her 'busy pictures.' Germaine Koh suggests her more performative, repetitive, knitting actions are a 'recuperation not only of traces of human lives and customs, but also and above all the recuperation of time'.[10] In Ann Harbuz's images we are confronted with questions of free time, time alone. When does the knitting, the art-making get done? If you are not one of the artists to whom Griselda Pollock refers, who can enjoy being the body of the artist at work in their studio, who can distance themselves from the many demands on their time – if your bread is still baking, if the frozen-stiff wash has to be brought in from the outdoor winter clothes line, if the evening meal needs to be prepared, if you have smaller people dependent on a parent for most things, everyday, most hours of the day, if you have to work both inside and outside the home to cover the bills – when is there time to make art? In Ann Harbuz's work, as in Germaine Koh's *Knitwork*, the time required to make art is placed against the time left to make art. Perhaps this is what appeals to me about Koh's materializing blanket (in 1996, it was 150 feet long), which recycles used sweaters, mittens and scarves and whose form will continue to evolve at its own pace and in its own way.

Whereas Ann Harbuz moved at an accelerated pace so that she would have something of value to leave behind, Koh connects the process of knitting with an attempt to slow time down. In the medium of painting (significantly, a 'fine art' tradition) Harbuz found a form that could validate her 'undisciplined', 'self-trained' and 'unorthodox' style. In the medium of knitting, Koh found a form and an activity that is regarded to be outside the fine art tradition, in fact reminding us of people like Harbuz whose labour and practices are easily forgotten. For both artists contact with the gallery system was an important step in establishing a context of cultural value. In Koh's *Knitwork*, it is not the finished artwork, a product or entity unto itself, which constitutes cultural value – the processes and time involved in the making of art (or an art object) are also integral components of its worth. Harbuz, on the other hand, recuperates the endless moments of unacknowledged labour and through painting gives them a tangible new form. Through her appropriation of a fine art convention, as well as through subsequent exhibitions, Harbuz found a forum where her ideas, her unique vision, her particular form of articulation gained recognition and currency.

Throughout the process of curating this exhibition, I was reminded that Harbuz occupied a critical no man's land, that she was almost an artist or not quite an artist. Remarks like, 'Are you still fooling around with that folksy stuff?' and 'That work makes me feel like someone has scratched their fingernails on a blackboard', have helped me clarify that indeed something in Ann Harbuz's work irritates some people. It has taken me a long time to reconcile that this irritation has many precedents and correlations, occupying the same zone of irritations that Simone de Beauvoir referred to over 50 years ago in *The Second Sex*. (de Beauvoir 1988/1949: 689–724) Certain voices and forms of art appear discordant, either because we are not used to hearing from them or, because what they do and how they do it does not have much cultural currency or cultural capital. It is their difference that we hear first; how this difference is perceived against hierarchical and standardized measures frequently makes it more difficult to absorb the significance of what is being said, and to value what they have to offer.

At the start of this essay, I referred to inside and outside, to the interior and exterior spatial divisions within Ann Harbuz's work that are specific to the social, geographical and cultural terrain that she occupied. I began by focusing on how she represented, assessed and understood a social world and her place in it, and I suggested that Harbuz was able to participate in the making and building of her immediate communities yet maintain an independent and analytical perspective on the events, social activities and interactions that surrounded her. 'Outside convention' was initially a reference to her position in the art world, to the inadequacy of art classification systems and her tenuous relationship to those systems. Having had more time to reflect on her practice, I know there is much more for me to comprehend. As writer Myrna Kostash has suggested: 'Harbuz did not dream so much of reconciliation with the other but of the cultivation of what poet, Eli Mandel, called the inter-face of cultures. At the interface, ambivalence, ambiguity, and porousness are the point, not resolution.' (Kostash 1997: 73)

Despite a profound psychic interiority functioning within her work, Ann Harbuz also engaged with the outside influence of the public sphere; responses to the impact of capitalism, central-ization, bureaucracy, urbanization and feminism are evident as contemporary currents within what initially registers as autobiographical work. Throughout her production, a form of x-ray vision seems to be at work. We are able to see close up, inside a situation, yet the long view, the overview remains. It is as if this view has multiple vantage points, over time and distance, providing a suspended traversing and a comprehensive perspective that sets in motion a picture even bigger than what is portrayed. In combination, Ann Harbuz's life experience, her painterly facility, her conceptual orientation, her ability to re-stage and interpret past events and her cinematographer's gaze, play with the boundaries of time, space and memory – challenging us to see beyond the inside or outside of a situation and instead to consider the multiple and interconnected zones in-between – the often invisible boundaries that mark our differences.

It has been a full decade since I began the research for the exhibition *Ann Harbuz: Inside Community, Outside Convention*, and four years since the exhibition completed its six-venue tour. One of the main questions I am left with is how do we come to

recognize a critical practice? What do we think it will look like, where do we imagine it will be found? I am reminded of the many visiting curators who pass through Canadian cultural geography, stopping in Toronto, Montreal and Vancouver, convinced they have done justice to this enormous country or, worse, believing nothing of critical value exists outside of our three most major urban centres. I understand the pressure this approach to curatorial practice places on artists to either ditch or hide their quirky, risky, evolving or uneven work. From a Canadian perspective, I also understand that international exhibitions which continually recycle Jeff Wall, Stan Douglas, Michael Snow (to name but a few) as the Canadian representatives are a by-product of this one-day-per-each-major-city curatorial method. This tendency to showcase the tried and true exemplifies the power relations curatorial careers must come to terms with. As artists and curators navigate their way through the 'professional' domain of art and culture, how do we avoid performing within terms that become stiflingly homogeneous? Why are the messy bits, uncertainty or unevenness so often eradicated before we enter art into the more official public domain? At what point do we give up or transform a project into a more acceptable form? When is the environment 'safe' or the context 'appropriate' to test what we perceive to be the risky limits of our practice? What do we release for peer consumption and review?

I raise these questions as part of my ongoing interest in the ways contemporary curating works with increasingly heterogeneous art practices, but also as a footnote to the complications I experienced in producing the Ann Harbuz exhibition. Throughout this project, I feared being too closely aligned with an artistic practice whose credibility originated from a displaced zone. As a curator raised in Saskatchewan, who shared Harbuz's Ukrainian, rural background I saw the danger of being reduced to a Sask. folk art curator. And, as I discovered, many of these concerns were well founded. After the exhibition had travelled to its six venues I realized that despite all my efforts to push Harbuz's connections to discourses surrounding new internationalisms, local knowledge, the politics of location, critical subjectivity, mixed media practices, spaces of belonging and to move across designations such as artistic training, cultural

boundaries and art classification systems, most of the galleries I worked with wanted to return to the tried and true frameworks which had always surrounded Harbuz's work – her connection to folk art. Clearly there is a novelty factor in letting an untutored quaint artist into the contemporary gallery. But how do we interrupt this predictability and develop ways of understanding the different forms criticality takes? How can curatorial practice move away from the notion of programming (filling the gallery space) and more fully explore the realm of producing one-of-a-kind, context and site specific, cultural texts?

If, in fact, the gallery is one of the safe places where different cultures, artists, practices and audiences can come into contact, I feel more experimentation on the part of the institution is in order. Although curatorial practice is by nature a space of negotiations, as an independent curator I often feel the pressure to lean in the direction of institutional procedure. Certainly we are all discovering that simply installing an exhibition in an art gallery does not on its own generate a critical dialogue or facilitate interaction with an audience. In many ways, the Harbuz exhibition became a ready-made, a product that was parachuted into distinct communities with little consideration of the ways her practice would interface with each locale. If I were to curate a follow-up show I would concentrate on developing links and affinities between Ann Harbuz and other artistic and intellectual practices. I would cross over historical and contemporary divides, national and cultural boundaries, art-making media, traditions and forms. More importantly, I would spend much more time in discussion with each host institution to develop the ways the project or 'exhibition' might meet its audience on more equitable terms. As an active part of the curatorial process I believe a greater commitment is needed to connecting the content and form of specific projects to the particularities of the sites (communities) where they are staged. The point is not about novelty but about a more critically reflective practice and profession where we attempt to come to terms with the implications of the strategies and methods we employ.

NOTES

1. Other contributors to the catalogue were scholars, writers, and local historians: Frances Swyripa, Andriy Nahachewsky, Myrna Kostash, Alice Kowalsky and Olga Borsa. Betsy Warland was the editorial consultant. The exhibition opened at the Dunlop Art Gallery, Regina in 1995 and, during the period 1996–98, travelled to the Mendel Art Gallery, Saskatoon, the Canadian Museum of Civilization, Hull, the Glenbow Museum, Calgary, the Ukrainian Cultural and Educational Centre, Winnipeg and the Art Gallery of Windsor, Windsor. The exhibition and exhibition catalogue were sponsored and produced by the Dunlop Art Gallery, Regina, under the directorship of Helen Marzolf.
2. This quotation appears in Ann Harbuz's unpublished diaries housed at the Canadian Museum of Civilization Library in Hull, Quebec. The diaries are part of a larger research project undertaken by curator Magnus Einarsson.
3. I have used the term 'social landscapes' to extend descriptions and interpretations of art that to date has largely been categorized as folk or self-taught. In landscapes by many Saskatchewan-based artists such as William McCargar, Ann Harbuz, Molly Lenhardt and Frank Cicansky, landscape takes on complicated social meanings, a space touched by intimate exchanges, daily experience, history and local knowledge.
4. *Varenyky* are boiled dumplings, usually filled with mashed potatoes and onions, mashed potatoes and cheddar cheese, mashed potatoes and cottage cheese or sauerkraut. They are served with condiments such as sour cream and sautéed onions and are one of the most popular and basic Ukrainian foods.
5. Ann Harbuz produced five paintings titled *Ten Weddings*. Each painting is unique, but all five versions contain the same compositional structure highlighting a diagonal row of ten outdoor wedding receptions. In this essay, I discuss only one of these five paintings, the *Ten Weddings* dated 1978 in the collection of Dorothy Charabin. Several other paintings share the same basic composition and content, varying slightly in scale and coloration.
6. I refer to this small group of works as self-portraits, although the titles do not use the term self-portrait. In each work, there are autobiographical references. 'Ann Harbuz, 1967, Ponoka' is inscribed on the back of a depicted easel; Ann wrote and sketched and sewed many of her own clothes, such as the hat represented in one of these images.

7. A group exhibition, *Fertile Ground*, Agnes Etherington Art
 Centre, Kingston, 1996, explores the legacies and labours,
 repressions and wisdoms functioning within the realm of the
 maternal. In addressing a topic so full of cultural denials and
 stereotypes, curator Jan Allen points to the difficult negotiations
 the artists take on.

8. Elissa Barnard, 'The 250-pound blanket', *Halifax Chronicle
 Herald*, 9 February 1996, p.83.

9. In this essay, I have concentrated on Ann Harbuz's two-
 dimensional paintings. However, she painted on many different
 surfaces and found objects including the inside of her kitchen
 cupboards, ceramic mushrooms, vinyl records, walnuts, cream
 cans, fungus, birch bark logs, her old dustpan and papier-mâché
 vases. Ann Harbuz also made stencils to decorate her walls and
 painted several outdoor murals. In addition, she loved using a
 camera and compiled many photo albums and a photomontage-
 style autobiographical bookwork.

10. Jennifer Couëlle, 'Il était une fois le temps qui fuit', *ETC
 Montreal*, 25, 15 February–15 May 1994, pp.42–3.

BIBLIOGRAPHY

Abel, E. (1989) *Virginia Woolf and the Fictions of Psychoanalysis*, Chicago and London: University of Chicago Press

Archer, M. (1993/94) 'Piss and Tell', *Art Monthly*

Art Gallery of New South Wales (1998) *fluent: Emily Kame Kngwarreye, Yvonne Koolmatrie, Judy Watson* (catalogue of the Australian entry, 1997 Venice Bienalle), Sydney

Austin, J.L. (1961) *Philosophical papers*, Oxford

Backen, R. (1999) 'The Holy Face', *Art and Australia*, vol.36, no.3, pp.348–9

Bal, M. (1991) *Reading Rembrandt: Beyond the Word-Image Opposition*, Cambridge: Cambridge University Press

Bal, M. (1994) *On Meaning Making*, Sonoma CA

Barthes, R. (1977) *A Lover's Discourse*, London: Penguin

Barthes, R. (1981) *Camera Lucida: Reflections on Photography*, New York

Battersby, C. (1998) *The Phenomenal Woman: Feminist Metaphysics and Patterns of Identity*, Cambridge: Polity Press

Baudrillard, J. (1988) *The Ecstasy of Communication*, New York: Semiotext

Bell, A.O. (1977) (ed.), *The Diary of Virginia Woolf*, vol.1, London: The Hogarth Press

Benjamin, A. (1996) 'Matter's insistence: Tony Scherman's Banquo's funeral', *Art and Design Profile*, vol.48, no.5/6, pp.46–53

Benjamin, W. (1978) 'On the mimetic faculty', *Reflections*, trans. Edmond Jephcott, New York: Harcourt

Bennett, A. (1923) 'Is the Novel Decaying?', *Cassell's Weekly*, 28 March

Betterton, R. (1994) 'Verticals vs. Horizontals', *Women's Art Magazine*, January

Betterton, R. (1996) *An Intimate Distance: Women Artists and the Body*, London and New York: Routledge

Betterton, R. (1999) 'A Conversation with Susan Hiller', Sheffield: Site Gallery

Blanchot, M. (1995) *The Space of Literature*, trans. & intro. Ann Smock, University of Nebraska Press

Bohm-Duchen, M. (1995) (ed.), *After Auschwitz*, Sunderland and London: Northern Centre for Contemporary Art, Sunderland in Association with Lund Humphries Publishers Ltd

Bohm-Duchen, M. and G. Grodzinski (1995) (eds), *Rubies and Rebels: Jewish Female Identity in Contemporary British Art*, London: Lund Humphries Publishers Ltd

Bois, Y.A. (1986/1992) 'Painting: The Task of Mourning', reprinted in F. Frascina and J. Harris (eds), *Art in Modern Culture: An Anthology of Critical Texts*, London: Phaidon Press Ltd

Bois, Y.A. (1998) 'Cézanne: words and deeds', *October*, no.84, pp.31–43

Bolt, B. (2000) 'Shedding light for the matter', *Hypatia*, vol.15, no.2, pp.203–216

Bolt, B. (2000) 'Working hot: materializing practices', in P. Florence and N. Foster (eds), *Differential Aesthetics: Art Practices and Philosophies: Towards New Feminist Understandings*, Aldershot: Ashgate

Bond, A. (1998) 'A paradigm shift in twentieth century art', unpublished conference paper presented at the Australian Association of Art Conference, Adelaide

Boomalli Aboriginal Artists' Cooperative (1993) *Wiyana/Perisferia*, exhibition catalogue, Sydney: BAAC

Borsa, J. (1997) (ed.), *Ann Harbuz: Inside Community, Outside Convention*, Regina: Dunlop Art Gallery

Borzello, F. (1998) *Seeing Ourselves: Women's Self-Portraits*, London: Thames and Hudson

Boyarin, J. (1991) *Storm from Paradise: The Politics of Jewish Memory*, Minneapolis: University of Minnesota Press

Brett, G. (1996) 'The Materials of the Artist', in Tate Gallery Liverpool, *Susan Hiller*, Liverpool: Tate Gallery

Bryson, N. (1983) *Vision and Painting: The Logic of the Gaze*, Basingstoke: The Macmillan Press

Buchanan, I. (1999) 'Deleuze and Cultural Studies', in *A Deleuzian Century?*, Durham, NC and London: Duke University Press, pp.103–18

Butler, J. (1990) *Gender Trouble*, London: Routledge

Butler, J. (1993) *Bodies That Matter: On the Discursive Limits of 'Sex'*, London and New York: Routledge

Carter, P. (1996) *The lie of the land*, London

Celant, G. (1999) 'Interview with Sam Taylor-Wood', in *Sam Taylor-Wood*, Milan: Fondazione Prada

Cherry, D. (2002) 'She Loved to Breathe: Pure Silence', Association for Art Historians Annual Conference, Liverpool

Chisholm, C. (1995) 'The "cunning lingua" of desire: bodies-language and perverse performativity', in E. Grosz and E. Probyn (eds), *Sexy Bodies: The Strange Carnalities of Feminism*, London

Collins, R. (1990) *Suzanne Treister*, London: Edward Totah Gallery; Birmingham: Ikon Gallery

Colomina, B. (1992) (ed.), *Sexuality and Space*, New York: Princeton Architectural Press

Connor, M. and M. Ferguson-Smith (1997) *Essential Medical Genetics*, Oxford: Blackwell Science

Cornford, F.M. (1991) *From Religion to Philosophy: A Study in the Origins of Western Speculation*, Princeton

Couëlle, J. (1994) 'Il était une fois le temps qui fuit', *ETC Montreal*, 25, 15 February–15 May, pp.42–3

Craddock, S. (2002) 'Painting installation', catalogue introduction to Jo Bruton's *Walk slowly towards the light*, London: Matt's Gallery

Culler, J. (1975) *Structuralist Poetics: Structuralism, Linguistics and the Study of Literature*, London

de Beauvoir, S. (1949/1983) *The Second Sex*, Harmondsworth: Penguin

Deepwell, K. (1994) 'Paint stripping', *Women's Art Magazine*, 58, pp.14–6

de Lauretis, T. (1987) *Technologies of Gender: Essays on Theory, Film and Fiction*, Bloomington: Indiana University Press

Deleuze, G. (1981) *Francis Bacon: Logique de la Sensation*, Paris

Deleuze, G. (1989) 'Francis Bacon: The logic of sensation', in G. Politi and H. Kontova (eds), *Flash Art: Two Decades of History, xxi years*, Cambridge

Deleuze, G. (1990) *The Logic of Sense*, London

Deleuze, G. (1994) 'He stuttered', in C.V. Boundas and D. Olkowski (eds), *Gilles Deleuze and the Theater of Philosophy*, New York

Derrida, J. (1974/1986) *Glas*, University of Nebraska Press

Derrida, J. (1987) *Truth in Painting*, Chicago: University of Chicago Press

de Ville, N. (1994) 'An appreciation of Jane Harris' paintings', *Jane Harris*, London: Anderson O'Day Gallery

Didi-Huberman, G. (1988) 'The Index of the absent wound (monograph on a stain)', in A. Michelson, R. Krauss, D. Crimp and J. Copjec (eds), *October: The First Decade, 1976–1986*, Cambridge

Dimitrakaki, A. (1998) 'The Experience of the Present: Patterns of Narrative/ Disruption and the Female Subject in Painting', *Painting and Time* conference, Hull School of Art & Design, 17–18 April

Diprose, R. (1994) *The Bodies of Women: Ethics, Embodiment and Sexual Difference*, New York and London: Routledge

Eco, U. (1979) *The Role of the Reader: Explorations in the Semiotics of Texts*, Bloomington: Indiana University Press

Einzig, B. (1996) (ed.), *Thinking About Art: Conversations with Susan Hiller*, Manchester: Manchester University Press

Elkins, J. (1998) *On Pictures and the Words That Fail Them*, Cambridge

Fer, B. (1994) 'Bordering on Blank: Eva Hesse and Minimalism', *Art History*, vol.17, no.4, pp.424–49

Fisher, J. (1994) 'Susan Hiller: *Elan* and other evocations', in C. de Zegher (ed.), *Inside the Visible: An Elliptical Traverse of 20th Century Art, in, of and from the Feminine*, MIT Press: Cambridge, Massachussetts and London

Fisher, J. (1997) 'Relational Sense: Toward a Haptic Aesthetics', *Parachute*, no.87, pp.4–11

Florence, P. and N. Foster (2000) (eds), *Differential Aesthetics: Art Practices, Philosophy and Feminist Understandings*, Aldershot: Ashgate

Fortnum, R, (1991) 'Sindy the artist', *Artists Newsletter*, April

Frascina, F. (1993) 'Realism and ideology: an introduction to semiotics and cubism', in C. Harrison et al (eds), *Primitivism, Cubism, Abstraction: The Early Twentieth Century*, New Haven

Freadman, A. (1986) 'Structuralist uses of Peirce: Jakobson, Metz et al', in T. Threadgold, E. Grosz, G. Kress, and M.A.K. Halliday (eds), *Semiotics, Ideology, Language*, Sydney

Freud, S. (1973a) 'Introductory Lectures on Psycho-Analysis' (1916–7), in J. Strachey (ed.), *The Standard Edition of the Complete Psychological Works of Sigmund Freud*, vol.16, London: The Hogarth Press and the Institute of Psycho-Analysis, 5th edition

Freud, S. (1973b) 'Beyond the Pleasure Principle' (1920), in J. Strachey (ed.), *The Standard Edition of the Complete Psychological Works of Sigmund Freud*, vol.18, London: Hogarth Press, 1955, 7th edition

Fried, M. (1967) 'Art and Objecthood', reprinted in G. Battcock (1968) (ed.), *Minimal Art: An Anthology*, New York: Dutton

Fry, R. (1924) *The Artist and Psycho-Analysis*, London: The Hogarth Press

Fry, R. (1928a) 'The French Post-Impressionists', in *Vision and Design*, London: Chatto and Windus, 1920; London: Phoenix Library edition

Fry, R. (1928b) 'Art and Life', in *Vision and Design*, London: Chatto and Windus, 1920; London: Phoenix Library edition

Garfield, R. (2001) 'Ali G: Just Who Does He Think He Is?', *Third Text*, vol.54, pp.63–70

Gatens, M. (1996) *Imaginary Bodies: Ethics, Power and Corporeality*, London: Routledge

Gillett, J. (1993) *Contra Diction*, Winchester: Winchester Art Gallery

Golding L. (1951) *The Dangerous Places*, London: Hutchinson & Co Publishers Ltd

Gombrich, E. (1979) *The Sense of Order*, London: Phaidon

Greenberg, C. (1961) *Art and Culture*, Boston: Beacon Press

Greenlee, D. (1973) *Peirce's Concept of the Sign*, The Hague

Grosz, E. (1994) *Volatile Bodies: Towards a Corporeal Feminism*, Bloomington and Indianapolis: Indiana University Press

Grosz, E. (1995) *Space, Time & Perversion: Essays on the Politics of Bodies*, New York and London: Routledge

Guattari, F. (1995) *Chaosmosis: An Ethico-Aesthetic Paradigm*, Sydney

Halevi, I. (1987) *A History of the Jews: Ancient and Modern*, London and New Jersey: Zed Books

Haraway, D. (1991) 'Situated Knowledges: The Science Question in Feminism and the Privilege of Partial Perspective', in *Simians, Cyborgs and Women: The Reinvention of Nature*, London: Free Association of Books, pp.183–201

Harris, J. (2001) *The New Art History: A Critical Introduction*, London: Routledge

Heidegger, M. (1977a) *The Question Concerning Technology and Other Essays*, New York

Heidegger, M. (1977b) *Basic Writings*, San Francisco

Henschel, M. (2001) 'Transforming Geometry and Ornament – on the Paintings of Jane Harris', in *Jane Harris*, Southampton: Southampton Art Gallery

Heron, P. (1987) 'Painting is Silent', *Art & Design*, London, June

Hill, D. (1999) 'The Real Realm: Value and Values in Recent Feminist Art', in I. Heywood and B. Sandywell (eds), *Interpreting Visual Culture*, London: Routledge

Hiller, S. (1983) *Sisters of Menon*, London: Coracle Press

Hiller, S. (1991) *The Myth of Primitivism: Perspectives on Art*, London: Routledge

Hiller, S. (2000a) Plenary Lecture, Association for Art Historians' Annual Conference, Edinburgh

Hiller, S. (2000b) *Psi Girls*, Sheffield: Site Gallery

Hilty, G. (1996) *Third Person*, Norwich: NSAD Press

Hobsbawm, E. (1994) *Age of Extremes, The Short Twentieth Century, 1914–1991*, London: Michael Joseph

Holder, J. (1995) 'Casula Powerhouse Regional Arts Centre', *Art and Australia*, vol.33, no.1, pp.40–1

Irigaray, L. (1998) *This Sex Which is Not One*, trans. Porter and Burke, New York: Cornell University Press

Jardine, A.A. (1985) *Gynesis: Configurations of Woman and Modernity*, New York: Cornell University Press

Johnson, T.H. (1960) (ed.), *The Complete Poems of Emily Dickinson*, Boston: Little, Brown

Johnson, V. (1992) 'Upon a Painted Emotion: Recent Work by Judy Watson', *Art and Australia*, vol.30, no.2, pp.238–40

Jones, L.C. (1993) 'Transgressive Femininity: Art and Gender in the Sixties and Seventies', in J. Ben Levi, C. Houser L.C. Jones and S. Taylor (eds), *Abject Art: Repulsion and Desire in American Art*, New York: Whitney Museum of American Art

Kaneda, S. (1991) 'Painting and its Others', *Arts Magazine*, vol.65, no.10, pp.58–64

Kettle's Yard (1978) *Susan Hiller Recent Works*, Cambridge: Kettle's Yard

Kostash, M. (1997) 'Ann Harbuz: Thoughts About Nostalgia', *Ann Harbuz: Inside Community, Outside Convention*, Regina: Dunlop Art Gallery

Krauss, R. (1988a) 'The im/pulse to see', in H. Foster (ed.), *Vision and Visuality*, Seattle: Bay Press

Krauss, R. (1988b) 'Notes on the index: seventies art in America', in A. Michelson, R. Krauss, D. Crimp and J. Copjec (eds), *October: The First Decade, 1976–1986*, Cambridge

Krauss, R. (1994) *The Optical Unconscious*, Cambridge, Mass. and London: MIT Press

Lee, H. (1996) *Virginia Woolf*, London: Chatto and Windus

Levinas, E. (1978) *Existence and Existents*, trans. Alponso Lingis, The Hague: Duquesne University Press

Lippard, L. (1976a) *Eva Hesse*, New York: New York University Press

Lippard, L. (1976b) *From the Centre*, New York: Dutton

Lippard, L. (1986) 'Out of Bounds', in *Susan Hiller*, London: Institute of Contemporary Arts

Lloyd (2000), in F. Carson and C. Pajakowska (eds.), Feminist Visual Culture, Edinburgh: Edinburgh University Press

Lynn, V. (1996) 'Judy Watson', in *Judy Watson*, catalogue, Epernay, France: Moët & Chandon, pp.5–16

McCormack, P. (2000) 'Faciality', Body, Gender, Subjectivity: Crossing Borders of Disciplines and Institutions Conference, Bologna

McNeillie, A. (1988) (ed.), *The Essays of Virginia Woolf*, vol.3, London: The Hogarth Press

Marion Young, I. (1990) *Throwing Like a Girl*, Bloomington: Indiana University Press

Marks, L.U. (1998) 'Video haptics and erotics', *Screen*, Winter, pp.331–48

Marks, L.U. (2000) *The Skin of the Film*, Duke University Press

Meed, V. (1972) *On Both Sides of the Wall*, first published in Yiddish by the Educational Committee of the Workmen's Circle, New York, 1948

Merleau-Ponty, M. (1964) *The Primacy of Perception*, Chicago: Northwestern University Press

Merleau-Ponty, M. (1993) 'Cézanne's doubt', in M.B. Smith (ed.), *The Merleau-Ponty Aesthetics Reader: Philosophy and Painting*, Evanston

Mitchell, W.J.T. (1994) *Picture Theory*, Chicago: University of Chicago Press

Mitchell, W.J.T. (1996) 'What Do Pictures Want?' *October 77*, summer, pp.71–82

Morgan, J. (1991) Paper given at the Hysteria Conference, Tate Gallery Liverpool.

Morgan, S. (1996) 'Beyond Control: An interview with Susan Hiller', in Tate Gallery Liverpool, *Susan Hiller*, Liverpool: Tate Gallery

Mulvey, L. (1973) 'You don't know what is happening, do you, Mr. Jones?', *Spare Rib*, reprinted in L. Mulvey (1989) *Visual and Other Pleasures*, Basingstoke: The Macmillan Press

Nemser, C. (1970) 'An Interview with Eva Hesse', *Artforum*, 9 May

Neret, G. (1993) *Twentieth-Century Erotic Art*, New York

Newman, M. (1994) 'Avis Newman', in C. de Zegher (ed.), *Inside the Visible: An Elliptical Traverse of 20ᵗʰ Century Art, in, of and from the Feminine*, MIT Press: Cambridge, Mass. and London

Nicolson, N. (1976) (ed.), *A Change of Perspective: The Letters of Virginia Woolf*, vol.3, London: The Hogarth Press

O'Connell (now Zagala), S. (2001) 'Aesthetics: A Place I've Never Seen', in G. Genosko (ed.), *Deleuze and Guattari: Critical Assessments of Leading Philosophers*, London and New York: Routledge, pp.946–69

Ogg, K. (2000) 'Old songs stay to the end... Sad songs remind me of friends', *Solipsist*, Nottingham: Angel Row Gallery

Olkowski, D. (1999) *Gilles Deleuze and the Ruin of Representation*, Berkeley

Ondaatje, M. (1992) *The English Patient*, London

Osbourne, P. and L. Segal (1994) 'Gender as performative: an interview with Judith Butler (London October 1993)', *Radical Philosophy*, vol.67, pp.32–39

The Oxford Reference Dictionary (1986) Oxford: Oxford University Press

Peirce, C.S. (1931–8) *Collected Papers of Charles Sanders Peirce*, Cambridge

Peirce, C.S. (1955) *Philosophical Writings of Peirce*, New York

Perkins Gilman, C. (1981) *The Yellow Wallpaper*, London: Virago

Phelan, P. (1996) *Unmarked: The Politics of Performance*, London: Routledge

Pollock, G. (1992) 'Painting, Feminism, History', in M. Barratt and A. Phillips (eds), *Destabilizing Theory*, Cambridge: Polity Press

Pollock, G. (1999) *Differencing the Canon: Feminist Desire and the Writing of Art's Histories*, London: Routledge

Pollock, G. (2001) *Looking Back to the Future: Essays on Art, Life and Death*, Amsterdam: Routledge

Pollock, P. (no date) 'The Presence of the Future, Feminine and Jewish Difference', *Issues in Architecture in Art & Design, Gender & Ethnicity*, vol.5, no.1

Reff, T. (1978) 'Painting and Theory in the Final Decade', in W. Rubin (ed.), *Cézanne: The Late Work*, London: Thames and Hudson

Richard, N. (1986) 'Margins and Institutions: Art in Chile Since 1973', *Art & Text*, 21, pp.30–65

Riegl, A. (1893/1992) *Stilfragen*, trans. Evelyn Kain as *Problems of Style*, Princeton University Press

Robins, C. (1979/2001) 'The Women's Art Magazines', in H. Robinson (ed.), *Feminist Art Theory: An Anthology*, Oxford: Basil Blackwell

Ruff, C. (2002) 'I sing for my land', *Weekend Australian Magazine*, 27–28 April, pp.34–6

Ryan, J. (1997) 'Abstraction, meaning and essence in Aboriginal Art', *Art and Australia*, vol.35, no.1, pp.74–81

Saussure, F. de (1996) *Course in General Linguistics*, New York

Shields, C. (1993) *Swann*, Toronto: Stoddart

Smith, A. (2001) 'The Power of Peripheral Vision', http://www.trance.dircon.co.uk/index.html

Stott, R. (1992) '"Inevitable relations": aesthetic revelations from Cezanne to Woolf', in S. Reagan (ed.), *The Politics of Pleasure: Aesthetic and Cultural Theory*, Buckingham and Philadelphia: Oxford University Press

Sylvester, D. (1987) *The Brutality of Fact: Interviews with Francis Bacon*, 3rd edition, London

Tate Gallery Liverpool, *Susan Hiller*, Liverpool: Tate Gallery

Taussig, M. (1993) *Mimesis and Alterity: A Particular History of the Senses*, New York

Thomas, N. (1999) *Possessions: Indigenous Art/Colonial Culture*, London: Thames and Hudson

Treister, S. (1999), *...No Other Symptoms – Time Travelling with Rosalind Brodsky* London: Black Dog Publishing

Treister, S. http://ensemble.va.com.au/Treister

Ungar, S. (2001) 'Cognitive Mapping without Visual Experience', in R. Kitchen and S. Freundschuh (eds), *Cognitive Mapping: Past, Present and Future* London: Routledge

Vasseleu, C. (1998) *Textures of Light: Vision and Touch in Irigaray, Levinas and Merleau-Ponty*, London: Routledge

Vendler, H. (1995) *The Breaking of Style: Hopkins, Heaney, Graham*, Cambridge, Massachusetts and London: Harvard University Press

Voight, A. (1996) *New Visions, New Perspectives: Voices of Contemporary Australian Women Artists*, Roseville East, New South Wales

Watling, S. (1998) 'Pauline Boty: Pop Painter', in S. Watling and D.A. Mellor (eds), *Pauline Boty: The Only Blonde in the World*, London: Whitford Fine Art and The Mayor Gallery Ltd

Weiss, G. (1999) *Body Images: Embodiment as Intercorporeality*, London and New York: Routledge

Welchman, J.C. (1995) *Modernism Relocated: Towards A Cultural Studies of Visual Modernity*, St. Leonards, NSW

Whitford, M. (1991) *Luce Irigaray: Philosophy in the Feminine*, London: Routledge

Wiethaus, U. (1993) (ed.), *Maps of Flesh and Light: The Religious Experience of Medieval Women Mystics*, New York: Syracuse University Press

Wilde, O. (1980) 'The Picture of Dorian Gray', in *The Complete Works of Oscar Wilde*, New York

Wills, C. (1989) 'Upsetting the public: carnival, hysteria and women's texts', in K. Hirschkop and D. Shepherd (eds), *Bakhtin and Cultural Theory*, Manchester: Manchester University Press

Winterson, J. (1995) *Art Objects: Essays on Ecstasy and Effrontery*, Toronto: Alfred A. Knopf

Woolf, V. (1924) 'Character in Fiction', *The Criterion*, July

Woolf, V. (1977) *To the Lighthouse*, London: The Hogarth Press, 1927; 18th edition, London: Grafton Books

Woolf, V. (1989) 'A Sketch of the Past' (1939), reprinted in J. Schulkind (ed.), *Moments of Being*, London: Grafton Books

Woolf, V. (1969) *Roger Fry: A Biography* (1940), 3rd edition, London: The Hogarth Press

Woolmer, J.H. (1976) *A Checklist of the Hogarth Press, 1917–1938*, London: The Hogarth Press

Worsdale, G. (2001) *Jane Harris*, Southampton: Southampton Art Gallery

Yale University Art Gallery (1992) *Eva Hesse*, New Haven: Yale University Press

Zuidervaart, L. (1994) *Adorno's Aesthetic Theory: The Redemption of Illusion*, Massachusetts and London: MIT Press

INDEX